Insider's Guide

# Insider's Guide

## Top Wildlife Photography
## Spots in South Africa

Shem Compion

Published by Jacana Media (Pty) Ltd in 2010

10 Orange Street
Sunnyside
Auckland Park 2092
South Africa
+2711 628 3200
www.jacana.co.za

ISBN 978-1-77009-835-0

Set in Sabon 10.5/15pt
Job No. 001119
Printed and bound by Creda Communications

See a complete list of Jacana titles at www.jacana.co.za

# Contents

**To my grandfather Neville Manyard Charles Cooper**

"Gramps" was a pure naturalist with the gentlest approach to birds I've ever known. He opened my eyes to nature and taught me how to see.

# Acknowledgements

A book such as this cannot be produced without the generous and selfless help of many people. Thank you to Lance Groenewald, Basie van Zyl, Kirsten Frost, Villiers Steyn, Isak Pretorius, Mark Dumbleton, Wynand van Wyk and Hougaard Malan for all your specialised input into the specific areas of this book. Your help and generous sharing of knowledge in many areas is greatly appreciated. It is comforting to know that such a strong sense of community exists within the nature photography fraternity.

To my mother and sister Ruth and Sara, thank you for your support and love.

Thank you to Minette van den Berg who kept my life organised while I worked on this book, as well as working tirelessly at editing the text for which I am grateful. John Power helped a great deal with statistical information on Kruger and Pilanesberg. This information was invaluable – thank you.

A special thank you goes to Martin Withers, who encouraged and inspired me to start with this project. Thank you to the Jacana team of Bridget Impey, Jenny Prangley and Kerrie Barlow for pushing the concept and making me meet my deadlines. You were all wonderful to work with.

André Cloete and Greg du Toit both contributed an enormous amount of moral support and fielded many late night phone discussions around this project. Thank you both for your friendship, support and hours on the court. Thank you Henrich van den Berg for your time and words in the Foreword – I appreciate them greatly.

My thanks to Zendré Lategan my partner, whose support keeps me going in the late hours. Your love is a great light for me. Thank you.

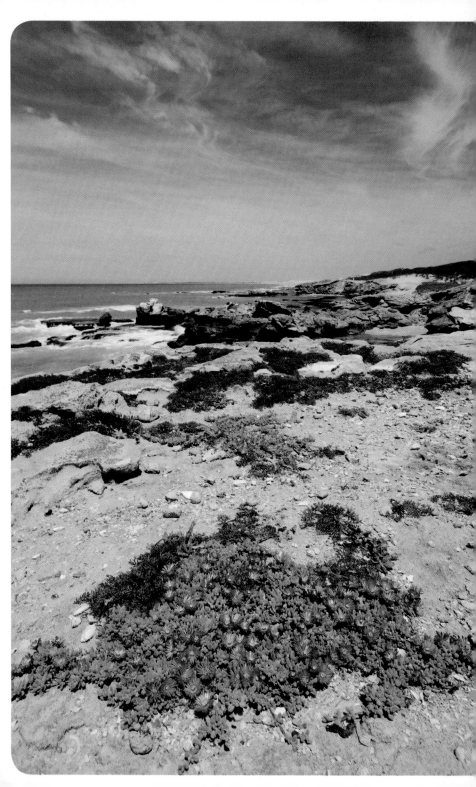

# Foreword

South Africa is any wildlife photographer's dream. Yet strangely enough, many South African wildlife photographers don't realise that they are living inside a dream. Often I meet photographers who spend thousands of rands travelling all over the world to photograph wildlife, taking off from the same airport where thousands of foreign photographers are arriving to photograph the beautiful South African wildlife!

We have it all. We have the dry and dreamy landscapes of Kgalagadi Transfrontier National Park where any subject looks great against the uniform, pastel background. We have Kruger National Park and Sabi Sand Game Reserve where you can dream up any kind of photograph of almost any kind of creature that exists in South Africa. We have the intimate hides of Giants Castle, Mkuze Game Reserve, Rietvlei and Marievale where you can almost touch the wild. We have the alternative birds of the Western Cape, and the massive pachyderms of Addo Elephant National Park. And we have wild places like Mapungubwe and Richtersveld that, for me, will always feel like dreams from long ago – dreams filled to the brim with the joys of nature and photography.

Today in South Africa we have more budding wildlife photographers than ever. *Insider's Guide* is a great help in navigating these dreams, both for the beginner and established wildlife photo enthusiasts. This is a book that will open many eyes to the dream destination that we find ourselves in.

◀ South Africa offers exceptional outdoor and nature photography.

And what better wildlife photographer to show us the way than Shem Compion. Unlike some wildlife photographers that became interested in wildlife because they liked photography, Shem did it the right way around. He has a passion for wildlife, having grown up in the bush. He studied nature conservation, and once he picked up a camera, the two passions combined and he was hooked.

He has also hooked many others in the last six years since he became a professional photographer. He has many supporters who have followed him around with their cameras to destinations like Kenya, Namibia, Botswana, Madagascar, and even Japan, on his well-known specialist photo safaris, being the founder and owner of C4 Images and Safaris.

Yet he is not only a good teacher. He is an exceptional photographer himself, having garnered many awards, including the BBC Wildlife Photographer of the Year and the Fuji Film/Getaway Wildlife Award. He is widely published in magazines around the world and Insider's Guide is his second book, the first being A Landscape of Insects, published in 2009.

This kind of book is long overdue. I hope that it will not only reveal the best photo spots in South Africa, but also Shem's personality, and his appreciation for what there is to photograph in this remarkable photographer's dream, called South Africa.

**Heinrich van den Berg**
*Wildlife photographer and*
*owner of HPH Publishing*

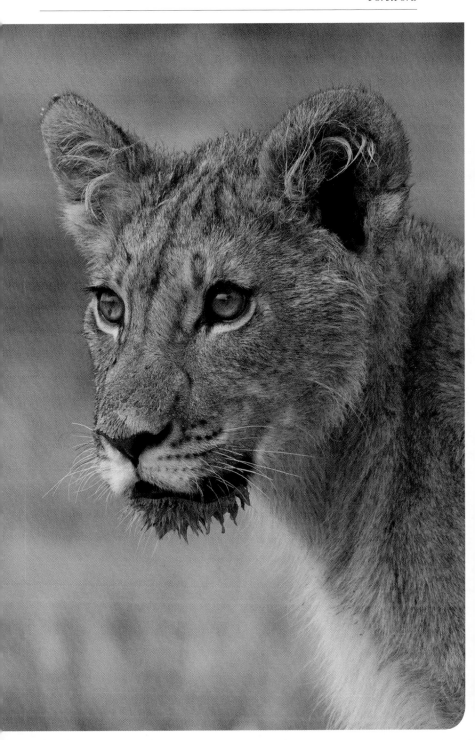

# Introduction

My life is centred around sharing information. I believe the more you give away in life, the more you will receive. I take great delight discussing why we are heading to this particular waterhole, where the best elephant herds are in South Africa, or what is the best season to photograph Cape foxes at the den. I'm naturally curious: something that has led to my lifelong fascination with nature. My life is devoted to photographing the best natural history phenomena in Africa and this has naturally led to an accumulation of knowledge that I just had to share. I suppose you could say I have been subconsciously collecting data for this book since I became interested in nature at the age of nine.

Why has wildlife photography become so popular? Firstly, digital cameras have made photography so much more accessible, resulting in more people photographing. Secondly, South African culture revolves in part about relaxing in nature. The nett result is that more people are spending time in nature with their cameras. However, it takes a certain understanding of your camera and the added elements of light and composition before you get good results.

There are many resources that will teach you about the fundamentals of photography, yet none shows the best places to visit. This is the first time a book of this kind has been compiled. With the rise in popularity of digital photography, more photographers need information on where to go and take photographs and what subjects to take photos of. This

◀ Free-roaming wildlife is abundant in South Africa – we are blessed to have such a wealth of wildlife, both in and outside reserves.

book is intended to be a one-stop source of information for those photographers wanting to take impressive photos of nature, wildlife and landscapes in South Africa.

Using the provinces of South Africa for easy reference, each chapter focuses on giving you all the necessary information to plan your photographic trip to perfection. I discuss what equipment is required and why it will be useful to you. There are tips on bird photography, techniques to use for specific subjects, and tricks that will allow you to get better images of wildlife subjects.

It is my hope that this book will be of use to aspiring wildlife photographers, advanced photographers who need helpful information on where to photograph wildlife, and tourists visiting South Africa who want to take first-class photos of nature.

Besides being a guide book that is quick and easy to reference, I hope that it will inspire people with the beauty of South Africa's wildlife, and will encourage them to spend more time in South Africa's wonderful natural heritage. Wildlife photography is an incredibly rich and rewarding experience, and I hope this book will enrich that experience.

Shoot straight.

**Shem Compion**
*2010*

▲ Drakensberg mountain rainbow sunrise

▼ South Africa has some of the best suricat viewing in Africa.

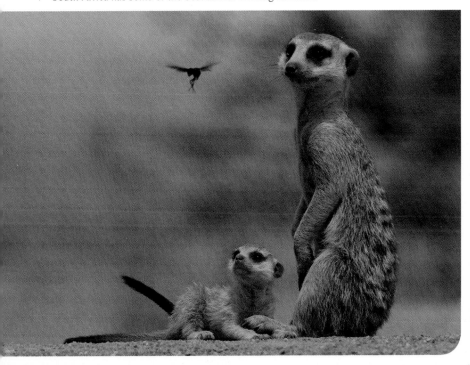

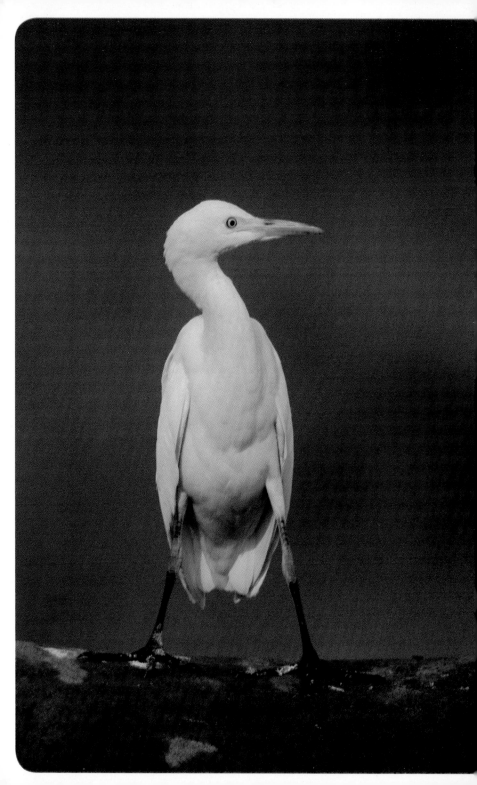

# Preface

It all started one morning at Okaukeujo, Namibia. I was leading a group of photographers and was telling them what they could expect during the morning's session.

I told them to start by locating a pygmy falcon at the sociable weavers' nest at dawn when the waterhole was normally quiet. Then, after a quick breakfast, they should head to the waterhole, where I described the sort of images they might find. I mentioned that at 09:30 the sandgrouse would come to drink and if the photographers position themselves with their backs to the prevailing east wind, they would be perfectly situated to catch the birds flying overhead. I also said that although the light would be getting harsh, they should stay a while, as the elephants come at about 10:30 on the warm days…

Somehow, everything worked like clockwork. I was as stunned as my clients at my good timing. Martin Withers, an acclaimed photographer, came to me later that day and told me in no uncertain terms that I needed to document this. I needed little further inspiration and this book is the result; the first in a series that will later include Namibia and Botswana.

It seems we always have limited time to be in nature photographing. So many times we return from a photo holiday saying, "If only I had a few more days to get that special photo". This book will help you have

◀ The beauty of nature photography is the joy it gives us – the pose of this cattle egret gave me great pleasure.

more productive photo hours when you are on holiday. Its aim is to get you photographing and to get you to places where you will get the best results.

I've placed a strong emphasis on making it as easy as possible for you to find what you want to photograph. You simply research your desired subject and then plan your trips accordingly, allowing yourself to concentrate on getting great images, saving you a lot of physical and mental energy.

With wildlife and nature photography becoming such a popular pastime, this book is the perfect companion for photographers who want to be able to maximise their opportunities when out in nature. South Africa has an extremely high diversity of natural heritage. The wildlife viewing is excellent, bird photography is world class and the landscapes are stunningly dramatic. This abundance might feel overwhelming when planning what to photograph. This book guides you in finding what you would like to photograph; telling you what time of year to go; and then how to find your specific subject. It takes all the guesswork out of a nature drive, allowing more time for good photography.

This book is best used as an addition to field identification guides along with maps of the areas you are visiting. It describes areas in a clear and concise manner so that you are able to easily find the references within the reserves and photo locations.

I have detailed 18 main locations where you can get out and photograph excellent wildlife. Within these chapters, I also cover smaller locations and local specialities. In Gauteng and Cape Town, a number of places are listed together under one chapter.

It must be remembered that these chapters are only the starting point for good wildlife photography. South Africa has many hidden gems when it comes to wildlife and nature. The beauty is that they are all easily accessible. All you need is to get out and explore a bit. This book could be the start of your journey into the world of wildlife photography.

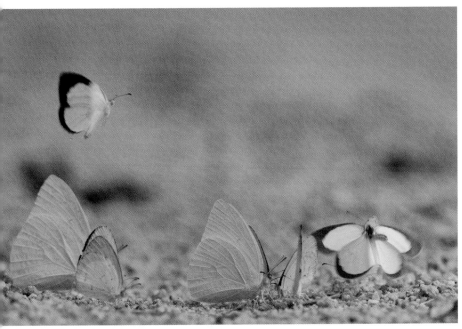

▲ Butterflies mud-hopping provide a beautiful alternative to the large and hairies.

▼ The west coast of South Africa offers some wild and untouched places – a perfect place to get new images.

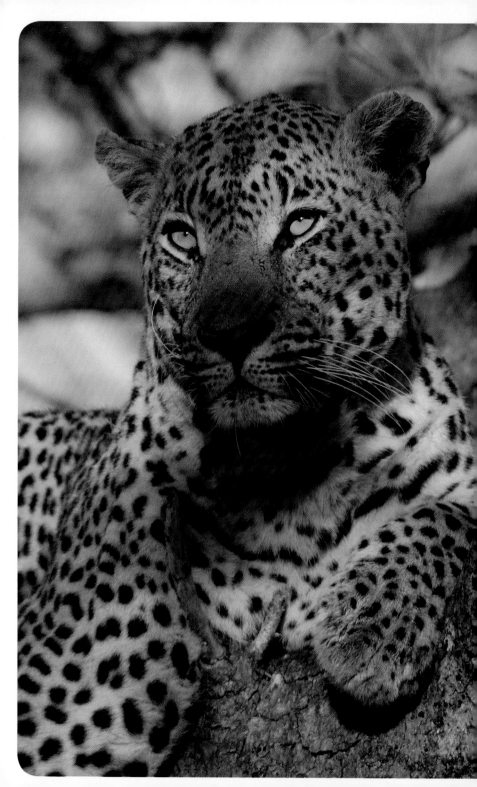

# How to use this book

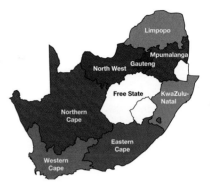

Each section in the book is labelled for your easy reference.

 At the top of each page is an icon representing in order from left to right: landscape, bird, mammal, predator and Big 5.

 The darkened icons for each chapter indicate what the specific area is best for and what you can expect to photograph.

 The coloured tabs on the side of each page indicate the particular province. By using the tabs and icons in conjunction you can, for example, quickly search for "birds in KwaZulu-Natal". You will then locate Giants Castle where you can read up about how best to photograph there.

At the end of each section, there is an "other information" table indicating accessibility, cost value and popularity. The cost value relates to accommodation if this is relevant in the area:

- Cheap: up to R500/night
- Affordable: R500–R1 000/night
- Mid-range: R1 000–R2 000/night
- Top-end: more than R2 000/night

◀ Golden sunlight in July is perfect to light up a subject, such as this leopard.

# Wildlife photography and the seasons

South Africa has two distinct seasons and, except for the Cape provinces, the rest of the country has a warm–hot rainy season that runs from October to April and a cool–cold dry season from May to September. Each season has its photographic advantages and disadvantages. It is up to you to use them accordingly for your own photographic benefit as these seasons affect animal viewing considerably.

| Month | Oct–Nov | Dec–Mar | Apr–May | June–July | Aug–Sept |
|---|---|---|---|---|---|
| Season | Hot and dry; first few rains starting; lots of 'dry storms'; migrant birds start arriving; vegetation turning green. | Hot with lots of rain and thunderstorms; birds in full breeding activity; vegetation starting to get very thick. | Rains abating; weather cooling; grass generally very tall; inter-season solstice. | Cool–cold weather with dry conditions; cold fronts bring cirrus clouds as well as snow to high-lying areas. | Cool–warm weather; the onset of summer; windy conditions. |
| Photography | Waterhole photography; green flush starting; impala fawns in November. | Birds, mammals in green surrounds; gannets are breeding in Lamberts Bay; harsh summer light. | Difficult season; arid areas are good; Betty's Bay landscapes. | Waterholes become more prominent; arid areas very cold; visibility through vegetation increases. | Waterhole viewing is excellent; dry conditions aid viewing and photography; dusty scenes; glowing red sunsets. |
| Place | KNP; Tswalu; KTP; Gauteng reserves; Mapungubwe; Sabi Sabi & Mala Mala; Pilanesberg; Addo; Table Mountain; Lamberts Bay. | KNP for birds; KTP; Tswalu; Mapungubwe; Lamberts Bay; Table Mountain. | KTP; Tswalu; Richtersveld; Betty's Bay. | KNP; KTP; Mapungubwe; Giants Castle; Mkhuze; Sabi Sabi & Mala Mala; Pilanesberg; Seal Island; Addo. | Betty's Bay; KNP; KTP; Richtersveld; Gauteng reserves; Giants Castle; Mkhuze; Mapungubwe; Sabi Sabi & Mala Mala; Pilanesberg; Seal Island; Addo. |

Rainy season thunderclouds provide striking interest to a landscape sky. ▶

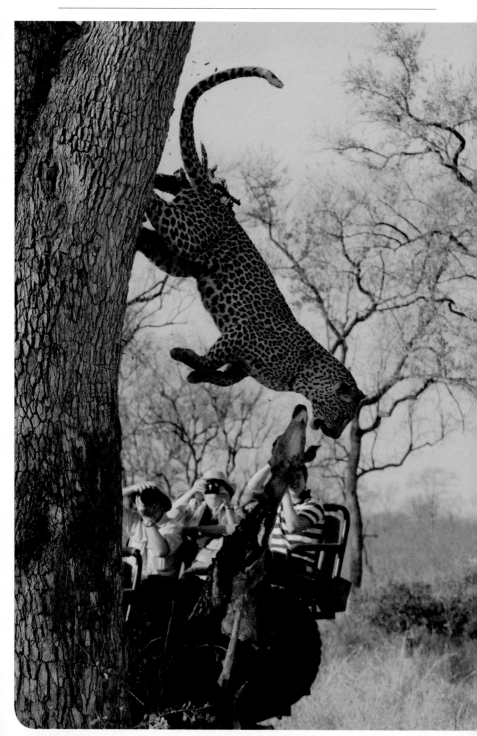

The Cape differs in that it has a cold, wet season from May to September and then a warm, dry season from October to April. However, for the most part, this weather pattern does not affect wildlife photography as much as in the north.

It's important to understand the differences in the quality of light during the different seasons. In the cold, dry months of May to September, the dust in the atmosphere accumulates on a daily basis. As the season wears on, this dust filters out the sunlight, which in turn creates a lovely golden glow at sunrise and sunset. Combined with the sun's lower angle during these months, we find the very soft golden hues that are perfect for photography. In the rainy season, October to April, the rains wash out the dust in the atmosphere leaving a very strong and brilliant light from the sun. Even at sunset in these months, the strength of the sun is very strong. However, this is also the season for large thunderstorms. If you have golden light shining on these storms, it makes for the most wonderful light show. If you have a subject in one of these lightshows, you will have some spectacular photographs.

A good wildlife photographer also needs to be a good climatologist. An understanding of weather patterns and knowledge of impending cloud formations or cold fronts will help you plan and take better photographs in the areas that you visit.

| Month | Nov–March | April–August | Sept–Oct |
|---|---|---|---|
| Weather pattern | Hot with thunderstorms and rain. | Cool with little clouds. | Warm to hot with cloud build-ups. |
| Clouds | Thunderstorms; cumulo-nimbus and stratus clouds. | Cold fronts bring cirrus and cirrus-stratus clouds. | Cloud build up on some days, but generally clear. |
| Angle of sun | Sun is directly overhead; makes for short golden hours, light becomes harsh early on. | 21 June sun is at its nadir; the low angle allows for longer photo hours. | Sun approaching zenith again but atmosphere is still dusty. |
| Photo opportunities | Excellent for white puffy clouds in mornings, large cumulo-nimbus clouds in afternoon; golden hour is very short due to clean atmosphere with no dust. | Cold fronts are perfect for landscape photography; dry dusty conditions towards August make excellent golden light at sunset. | Excellent golden sunsets with sun descending like a red orb; perfect for backlit images and classic African sunset scenes. |

◀ The private reserves in Sabi Sand and Mala Mala offer intimate and exhilarating predator viewing.

# Cameras and equipment

This book focuses on getting you to the best places in order to get the best photographs. It discusses camera techniques that will enable you to get great images. It does not cover information on how to use this camera. You will get the most value from this book if you understand your camera's functions and how aperture and shutter speeds work in order to get the best images.

One point to note is that lens length is referred to in the 35mm or "full-frame" format. If you are using a smaller format sensor, then you will have to make the conversion to equate your lens to that of a 35mm format.

In private nature reserves you will invariably ride in an open vehicle. Here there are various options to support your camera which are listed in each chapter according to the location. Remember that supporting your camera is very important and that this can be done using a tripod, monopod or beanbag depending on your preference and your vehicle.

## Defining different camera types

*Consumer camera:* Entry-level camera, plastic body and low frame rate

*Pro-sumer camera:* Mid-range model with alloy body and faster frame rates (4–6 fps)

*Professional camera:* Top-of-the-range model, full weather sealing, alloy body, high frames per second (8–10 fps)

## Getting the best out of your camera

Even if you have the best camera in the world and are acquainted with all the detail in the camera's manual, you will still need to know how light and composition combine to make great photographs. The following pages detail the fundamentals of both topics, which will help you take better photographs.

▲  Support is always crucial for long lenses. Here a heavy beanbag supports the lens.

▼  Proper camera technique using a beanbag and hand over the lens is essential to get sharp results.

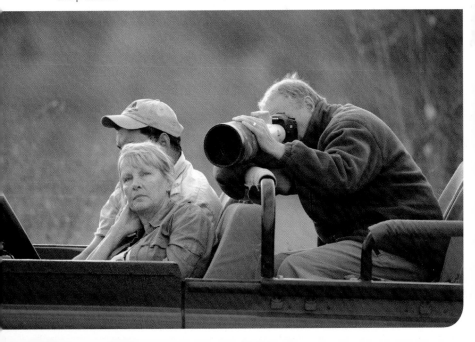

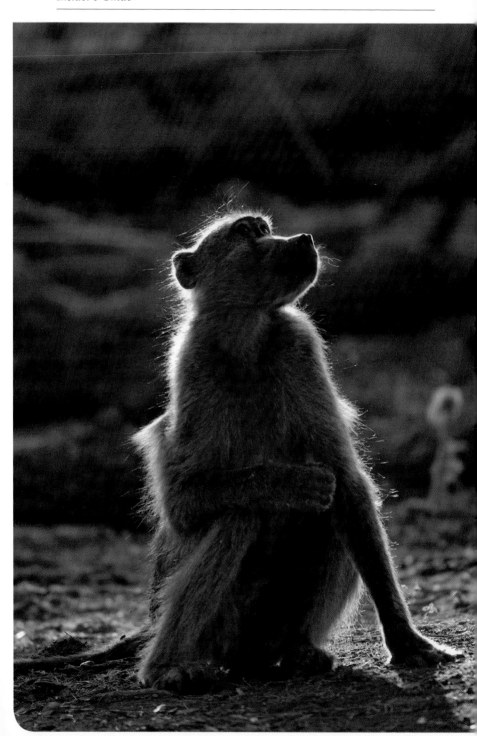

# Understanding light

As the sun rises each day, it follows a path from the horizon to overhead and then down onto the horizon again. This rising and setting affects the quality and colour of the light that reaches us. At dawn and dusk, the oblique angle of light produces very warm colours of red and gold. These hues result from the blue and green colours being filtered out by the band of atmospheric dust that lies just above the earth's surface. A side effect of pollution is that it has helped create warmer colours for photographers in the cities! Red and yellow rays are thus predominant during early mornings and late afternoons providing a lovely golden glow. These hours are termed the "golden hours" when the contrast is nice and low and shadows are very soft.

During midday hours when the sun shines directly down onto the earth's surface, there is little atmospheric dust to filter out the sun's rays. The colour of the light is more natural, but also harsher and with greater contrast. Of course, there are exceptions to the rule. Overcast days produce good, soft light in the middle of the day which also allows opportunities for good photography.

It is important to note that everyday subjects can change their appearance due to one factor – light.

The quality and colour of light are the primary indicators of how you set up your photography. They set the stage for you, your camera and the images that you create. By studying light you will notice how everyday subjects change their appearance in different light conditions.

## Types of light

*Front lighting* is described when you see a subject with the light shining from over your shoulder (you are between the sun and the subject). Front lighting shows very little shadow, and gives an excellent representation of your subject. This type of lighting provides very little depth, so the images are accurately representative but very two-dimensional.

◀ Backlighting is a striking effect that gives a lovely rim of light on your subject.

*Side lighting* is when the sun is shining at right angles to the subject. It shows great detail and texture in the subject as well as bringing out a third dimension in the image.

*Back lighting* is when the light is shining from behind the subject (the subject is between you and the sun). Almost always a silhouette, backlighting is very effective for subjects with a recognisable shape. Subjects with fur or hair often have a ring or halo of light around them, creating stunning effects. This is probably the most difficult of the three lighting techniques to master, but can be the most rewarding.

## Mood and atmosphere

Other climatic factors can contribute to create mood and atmosphere. Dust in golden light can create a very peaceful and ethereal scene. These elements can be very powerful in adding emotion, mood and atmosphere into an image.

## Diffused light

Cloudy skies are often a blessing in disguise for photographers. This is the one time when it's best to photograph during the midday hours. The clouds act as a filter and diffuse the light so that it falls very evenly, reducing shadows and saturating colours very nicely. This type of light is very good for taking portrait photos of all sorts of creatures.

## Sunray map

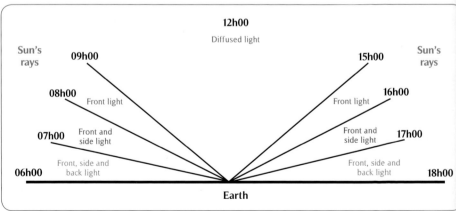

Side lighting gives both depth and texture to an image.  ▶

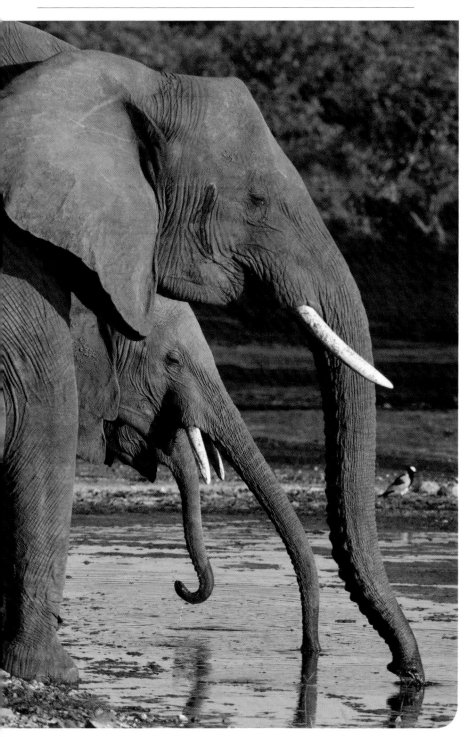

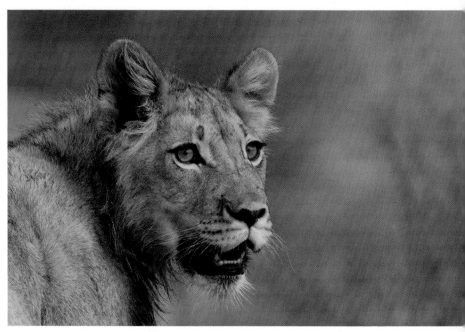

▲ Composing a subject looking into space helps balance a composition – such as with this young male lion, Kgalagadi Transfrontier Park.

▼ Overcast conditions create diffused light which can saturate colour.

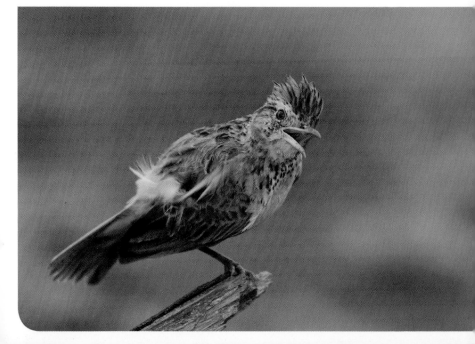

# Understanding composition

Composition is a matter of individual opinion and choice and has been the subject of much debate for years. There are, however, a number of compositional guidelines that give balance and impact to an image. These guidelines have been the basis in creating "harmony" in many historical artworks. Once you understand a bit about how light works, you can apply basic compositional techniques to work together with light.

## Rule of Thirds

Used by artists for hundreds of years, the "Rule of Thirds" are imaginary lines dividing the image into thirds both horizontally and vertically. The important elements of your composition are placed where these lines intersect. As well as using the imaginary intersecting points on the thirds, you can arrange your composition to occupy areas along the imaginary third lines themselves. This is often used to determine the horizon line, i.e. on the bottom horizontal third. Using the Rule of Thirds helps produce nicely balanced, easy-on-the-eye pictures. It is a rule that forms the basis for many images and can be used in landscape images as well as for portraits.

One thing about the Rule of Thirds, is that once you have got the hang of it, you will very quickly want to break it! This is fine. These "rules" are best used as guidelines, and if you can create a better image by bending or ignoring rules, then photograph away.

## Leading lines

A landscape image can be a pleasant enough looking picture, but without an object in the foreground to give depth, it will remain just that – a nice image. Great images tell stories, and a leading line is a way of taking the viewer into the image. Diagonal lines leading towards your subject are an excellent way to draw a viewer into the picture and can be used in conjunction with the Rule of Thirds.

## Subject placement

When taking portraits or head and shoulder photos of animals, it is a useful technique to frame the subject to the one side of the frame so that they look out of the image into the empty space. Likewise, for moving

subjects, such as birds in flight and running animals, situate the subject in the frame so that it moves towards the open space.

## Landscape and portrait mode

Photographers often forget that you can turn the camera sideways and photograph in another format. I find this an interesting mode to emphasise the scale and leading lines into photos.

## Changing angle

By changing the angle and the position from which you look at a subject, you can create a completely different image. Walking closer, kneeling down or moving sideways can alter the background, the angle and the shape of your subject. I often use this powerful compositional tool when approaching a new, non-threatening subject.

## Frame filling/impact

You have heard it before and you will hear it again – fill the frame. Used along with other compositional basics, it will give the image impact and keep the viewer's attention. For action and portrait shots, a subject that fills the frame makes a very arresting photograph.

# Animal behaviour

An understanding of animal behaviour is one of a wildlife photographer's greatest tools. Being able to interpret your subject's behaviour gives you the ability to anticipate what it will do next. This understanding is often the difference between an award-winning photograph and "just another photograph of a lion". Studying animal and bird behaviour will allow you to position yourself in the correct place at the right time to enable the perfect image. It will help you plan ahead. A sleeping leopard might look just like that – sleepy. But if it has been feeding and the sun is about to set, it could very soon get up to drink water. Very well worth the 45 minute wait for a wildlife photographer.

Understanding behaviour will also allow you to judge if an animal is stressed or not. Photographs very quickly show an agitated animal,

A relaxed subject will give you better photographs. Male lion drinking in Kgalagadi Transfrontier Park. ▶

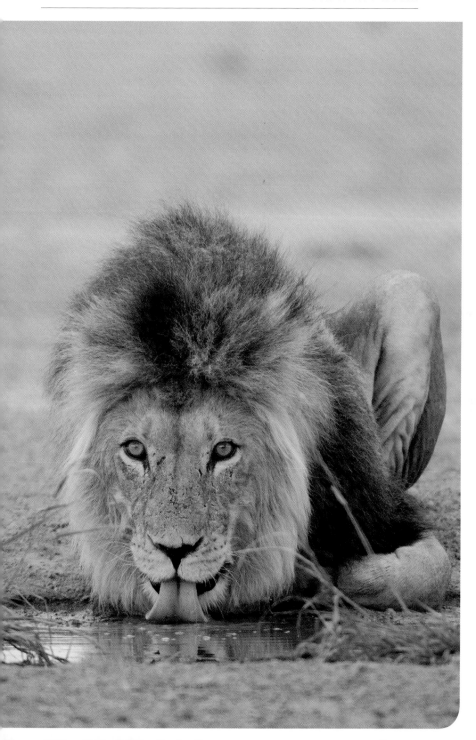

© Isak Pretorius

something you don't want in your images. By understanding the limits of your subject's range, you will keep the animal comfortable and end up with relaxed images. This also applies to larger mammals that may get stressed at your presence. Elephant, buffalo, rhino and hippo can all get aggressive if they feel threatened. This may be because of being cornered, being separated from the herd or young or just your direct proximity to them. By reading their behaviour, you can avoid any potential nasty situations, while still getting your photographs.

## Behaviour and ethics

South Africa's natural areas, wildlife reserves and stunning mountains are more than just nature reserves; they are a part of the heritage and culture. Some of the country's large expanses of land have been declared nature reserves and national parks, while others, mainly along the coast, are public land areas that are free for anyone to access. When visiting reserves, it is important to remember that you are the visitor and thus treat it accordingly. Follow park rules and always stay within the demarcated areas. When photographing in public spaces, please leave the area as you found it. This will ensure it remains as beautiful for the next generation.

When photographing animals and birds, it is very important to keep their wellbeing a priority. No photograph is worth causing any animal undue stress. It is easy to spot an anxious animal in a photograph and getting too close often results in a worse photograph. Keeping your distance from an animal will allow you to observe it in a relaxed state – which will make for better photographs and a much better chance of seeing some natural animal behaviours.

◄ Proper camera support is imperative to stabilise your lens – as is dress code!

# Seasonality and local movements

I have gathered together my experience with that of my photography friends and conservation colleagues who all have many years of combined knowledge of the areas covered in this book. I have chosen each area for its very specific attractions. However, as nature exists in a dynamic state, even subtle changes can affect the wildlife viewing of a specific area. The changes could be artificial, like pollution, or they could be natural, such as a change in seasonal animal movements: the only constant in nature is change.

The areas I have chosen in this book have all produced excellent and consistent photographic results over the years and I hope that even if changes occur, you will still enjoy the challenges of being out in the wild, taking photographs.

Namaqualand in the flower season is a magical
place for floral photography ▶

# Eastern Cape

Addo Elephant National Park

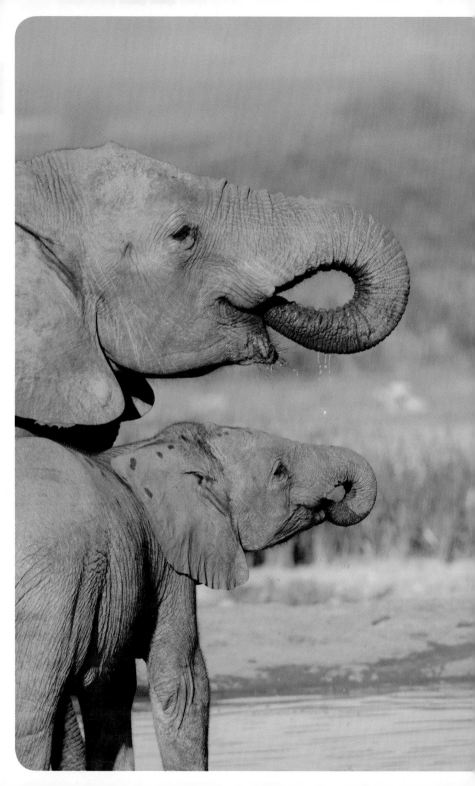

33° 26' 46" S
25° 44' 45" E

# Addo Elephant National Park, near Port Elizabeth

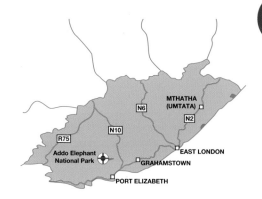

## Background

Photographing large mammals, land-based predators and mega herbivores in the Cape provinces is not easy, as there are just not many places that offer such animal viewing. Addo Elephant National Park is undoubtedly the best location in the southern, western and eastern Cape to consistently get good photographs of large mammals and has some interesting species that make a visit to this park quite worthwhile.

Addo had interesting beginnings. The park was originally established to protect the last remaining elephants in the area. Historically, large numbers of wild animals were found here and explorers and hunters alike told of the high densities in the various valleys. However, with the advent of colonisation and the subsequent farming activities, most of the wildlife was decimated. In 1931, the original park, 200ha in size, was proclaimed to protect the last remaining 11 elephants in the area. It has now grown to over 168 000ha and houses over 500 elephants. Other than elephants, the park is home to large numbers of greater kudu, warthog, red hartebeest and disease-free buffalo. Lion are frequently seen and are one of the main attractions to the park.

◀ Hapoor Waterhole is close enough to use a 400mm lens for full-frame portrait images of elephant drinking.

41

The park extends south to the coast and includes 5-biome communities, making it one of the most diverse conservation areas in the world. Most of the new sections of the park are designated wilderness areas with limited activities, and animal viewing in these sections is thus not very easy. The original "main" section is still the best way to access good wildlife and, of course, many photographic opportunities.

The main section of Addo is relatively small in size and you can cover almost all of it in one day. Photographically, you can easily see what parts of the park are productive, which will allow you to plan your time accordingly. With some of the waterholes being especially photogenic, Addo provides a great getaway to photographing wildlife in the Eastern Cape.

# The park

Being one of the South African National Parks, your time in the park is governed by sunrise and sunset gate times. Much of the park is covered in thick vegetation, which is not that productive for good wildlife sightings, so I suggest driving slowly through these parts towards the more open areas.

The woodlands drive up towards Carol's Rest Waterhole on Gorah Loop is an excellent example of one such open area. The short grasses cropped by the grazing animals make for easy viewing and photography. This is also a good morning drive, as Gorah Loop travels on the eastern side of an open valley, which gives you full access to the rising sun's rays. As you head towards the higher ground of Carol's Rest Waterhole, you get a beautiful view over the park. Being clear of vegetation, it keeps the background clean – perfect for portraits of animals as they come to drink. This is one of the most-favoured waterholes in Addo and spending time here is worthwhile, especially in the mornings. Keep an eye out for buffalo, which appear out of the densest vegetation to the south of the hole. Lions are also commonly seen in the area, often lying in the shade of the bushes on the outskirts of the open areas.

Kudu are very common in Addo and this is the place to try for a good portrait photo. There are lots of impressive males and many are very relaxed, allowing you to slowly idle up to them. Warthog are another

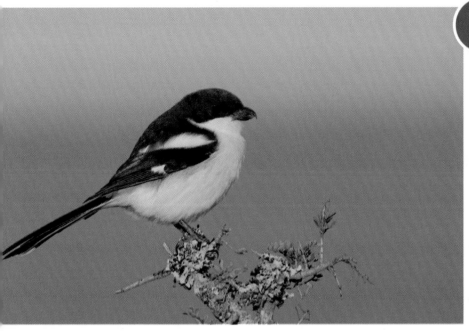

▲ Common fiscals are often seen and are easily photographed along the road sides.

▼ Kudu are plentiful in the reserve. With some patience you should get a top-class image of these graceful animals.

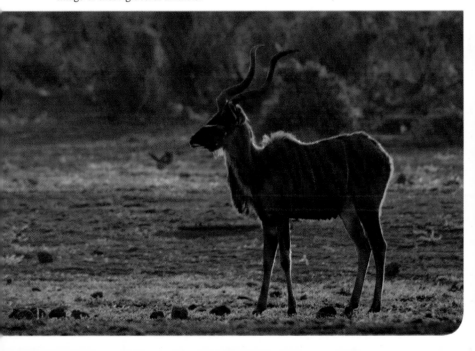

common herbivore. They are seen working their way through the grassy patches and are easy to photograph going about their business. Keep a look out for Cape fox in the sandy sections of the open areas. This is the most south-eastern distribution of their range. Keep your eyes open for recent diggings of fresh burrows. If you park your vehicle nearby, curiosity might get the better of them and they will sneak their heads out to have a look at you.

The Zuurkop road runs along the highest point in the park, giving you good views over the surrounding valleys and mountains. This is the best place to get scenic images in Addo.

The most famous elephant in Addo was called Hapoor, a legendary and large elephant that spent all of its life in the park. The waterhole now named after it is an excellent spot to find elephants coming to drink. Hapoor Waterhole is situated overlooking the valleys below. Although this is useful in providing a clean background, be aware that, as many of them are farmlands, your images may have man made lines in them, something you don't want to discover on return home. Hapoor is best in the mornings. The road lies to the east and south of it, and unless you want to photograph straight into the afternoon sun, it is strictly mornings only. As the park is quite small, you are able to be at Carol's Rest Waterhole for the dawn hour and then slowly move across to Hapoor where you will find the elephants coming to drink.

Birdlife in Addo is excellent and the many habituated birds allow for good avian photography. In the dry season of June and July, the flowering aloes attract a number of birds. There are plenty of aloes in the restcamp and here the birds are even more relaxed. You should also be able to get photos of dark-capped bulbuls, grey go-away-birds and greater double-collared sunbirds on the flowering aloes. A locally common bird in the park is the beautiful sounding and looking bokmakierie. Look out for its bright yellow and black breast as it sings from a prominent perch in the early morning. Often its call gives it away: the loud onomatopoeic call sounding just like its name, *"bok-makierie"*. The common fiscal is also often seen close to the roads hunting insects that are flushed out by the passing vehicles. You can easily get a photo of them perched on a branch if you approach carefully.

◄ The "call" of Addo is the beautiful song of the bokmakierie, also readily seen on top of perches in the mornings, singing of course.

Lions are seen throughout Addo, with some favouring the Carol's Rest area as well as the Woodlands Drive and Domkrag Dam area. A real treat in Addo is the frequency of caracal sightings. This rare and elusive predator is hardly ever seen in the wilds, yet here it is seen more often than anywhere else in the country. Perhaps the cooler, overcast conditions encourage their activity in the daytime, but either way, a sighting of one here will surely make any wildlife enthusiast's and photographer's day. If spotted, approach the caracal very slowly and quietly as any sudden movements or sounds will most likely scare these notoriously skittish cats away into the dense bush.

With Addo's proximity to the ocean, it often gets cloudy and it is common to have lightly overcast days. This makes photographing here possible throughout the day. In other areas, the sunlight is very harsh by 10:00. However, in Addo, on slightly overcast days, the best light is at 10:00 when the sun is softly diffused through the clouds. The animals stay active in the cool conditions, allowing you to continue photographing throughout the day.

The Cape is not necessarily known for its large mammal populations, but Addo Elephant National Park is the one place where you can confidently and consistently get good wildlife photographs of large mammals. Compared to many other reserves in South Africa, it "punches above its weight" in terms of sightings and photographic diversity.

## Photography and equipment

This is a self-drive park, so you will be photographing from a closed vehicle. The park is easily accessible to sedan vehicles. Photographing from a vehicle presents you with a few possibilities to work around. There are a variety of vehicle brackets and mounts that you can use. My opinion is to find the one that works best for you and then to stick with it. The one difficulty of working from a vehicle window is the lack of mobility. I find beanbags placed on top of a window rest the best option in terms of stability as well as flexibility.

Most of the animals in the park are fairly relaxed around vehicles, and a 400mm lens is normally enough for full-frame images. A shorter zoom is also handy for the larger species, like elephant and buffalo, which

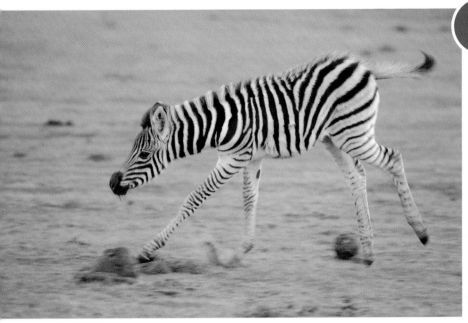

▲ The open plains around Carol's Rest Waterhole offer clean images with soft out-of-focus backgrounds.

▼ Elephants passing close to my vehicle allowed me to use the wide-angle lens to show a different perspective.

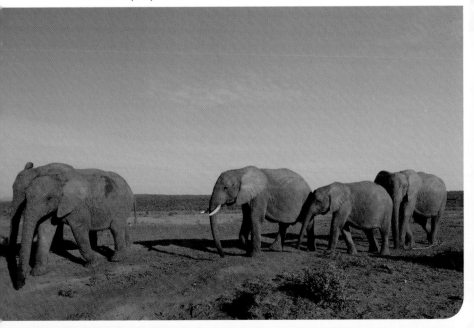

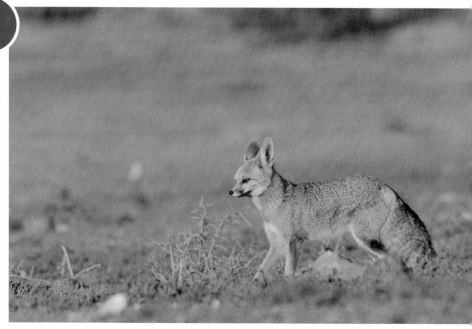

▲ Addo forms the south-eastern-most distribution of Cape fox, which is found on open plains with soft sand.

▼ Buffalo in the open offer good options for wide-angle images.

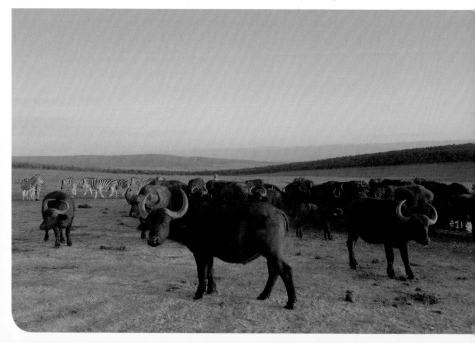

seem to completely ignore you and allow you to come quite close. Some elephant are so relaxed I have used a wide angle lens on them to good effect. A wide-angle lens is handy, but not a necessity due to the lack of real landscape scenes in the park. Of course a tripod won't be used as much while on drives, but will be of use at the rest stops and in camp, especially if you photograph the birds on the aloes. If you are working on the birds, a 500–600mm lens will be very handy.

## Getting there/accommodation

Driving from Port Elizabeth, take the N2 highway towards Grahamstown and carry straight on until the N2 splits off to the left from the N10. Carry straight on, following the N10 towards Cradock/Cookhouse. Take the R342 to the left when you get to the intersection with Paterson on your right. This will be sign posted "Addo Elephant National Park". Follow this road, looking out for the entrance to the park on your left.

Addo is managed by San Parks and bookings for accommodation can be made for their camps on the website: www.sanparks.org

## Highlights

- Close proximity to Port Elizabeth
- Easily accessible
- The best reserve in the southern part of South Africa for large mammal photography
- Good lion opportunities
- Open areas around certain waterholes make for clean backgrounds
- Relaxed large mammals – buffalo and elephant
- Often overcast in the daytime, meaning all-day photography
- Small park – you can scout the whole of it in one day to find the most productive areas
- Good birding of locally common species

# Shem's photography rating out of 10

| Photographic subject | Abundance | Viewing | Photography potential |
|---|---|---|---|
| Landscape | 2 | 2 | 2 |
| Birds | 6 | 6 | 7 |
| Mammals | 7 | 8 | 8 |
| Predators | 4 | 4 | 5 |
| Big 5 | 3 | 5 | 4 |
| Overall experience | 6/10 | | |

# Photographic equipment suggestions

| Photo skill level | Equipment |
|---|---|
| Intermediate to advanced | • 1–2 pro-sumer camera bodies<br>• Pro-body if you want to capture action and birds in flight<br>• 400mm lens for most wildlife<br>• 500–600mm lenses are beneficial for bird photography<br>• Medium lens for close-up work on mammals that come closer: 70–200mm |

# Other information

| Accessibility | Cost value | Popularity |
|---|---|---|
| Easy | Cheap to affordable | High |

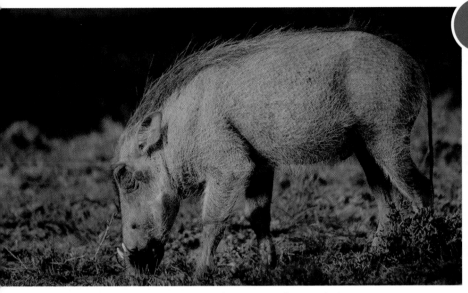

▲ Warthog proliferate in the reserve and are easy to photograph.

▼ Buffalo are very relaxed but you need to be in the open to get good photographs.

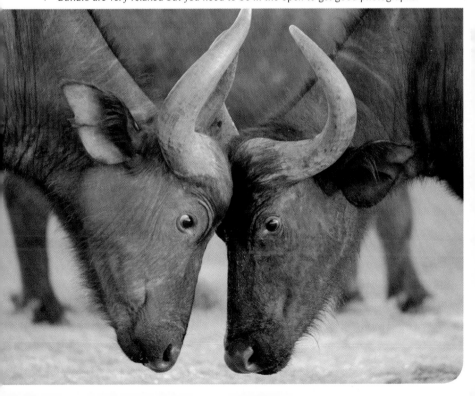

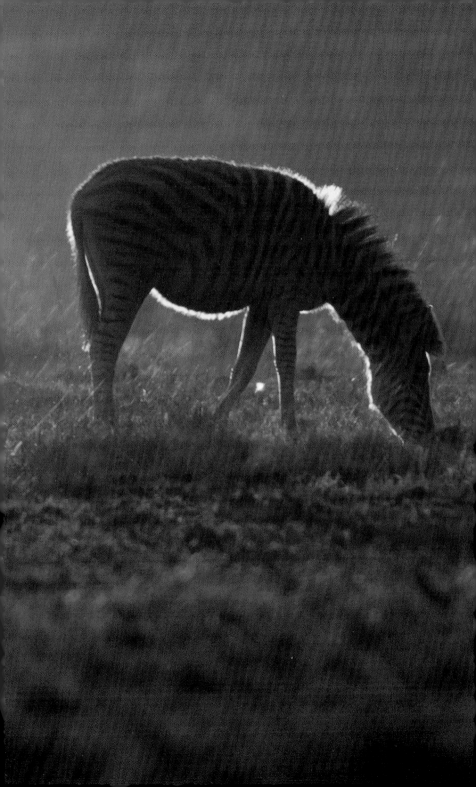

# Gauteng

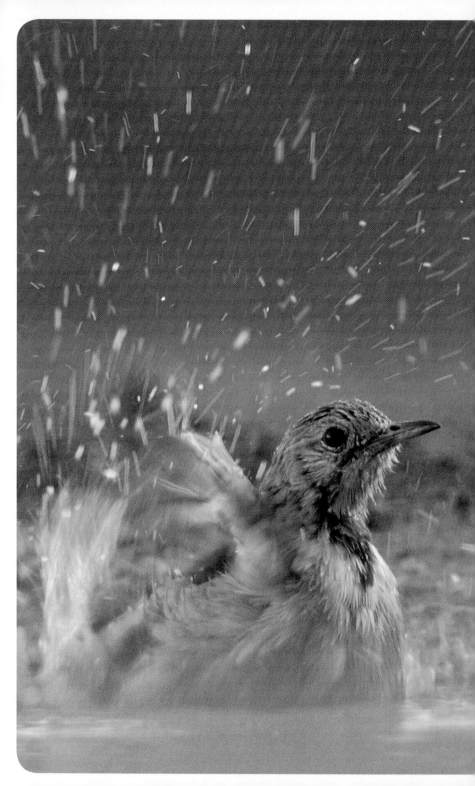

# Gauteng
# Introduction

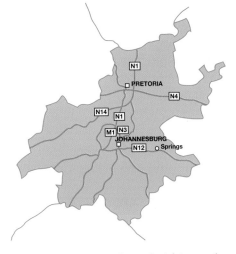

Gauteng is the most highly developed urban area of South Africa and thus doesn't make one think of good wildlife photography. Lying on a grassland plateau, Gauteng sits at an average altitude of 1 420m above sea level. Much of the landscape is defined as Bankenveld, which is an ecological transition zone between the mainly grassveld areas to the south and bushveld areas of the north. Before the advent of cities, this area was seasonally very rich in animal viewing, with reports of the grassland plains being filled with herds of thousands of animals.

Being situated at a similar altitude to the Masai Mara and with a very similar climate, this area should be very conducive to good game viewing. So if you head to the correct areas in the right season, you should at least witness what Gauteng looked like before gold was discovered and experience some very good wildlife photography too.

Unfortunately really good mammal photography is limited to only one reserve (Rietvlei Nature Reserve), but bird watching and photography is very good in the province and can at times be world class. With little effort, you can get some really good images of wildlife in Gauteng. It provides a great escape from the city environment and if you plan well, you can have an excellent morning's wildlife photography and still be at work by 09:00. If one is confined to the city, this will help to keep one's sanity.

◄ Cape longlaw is a common bird throughout grassland Gauteng, giving you the opportunity to get unique images of it.

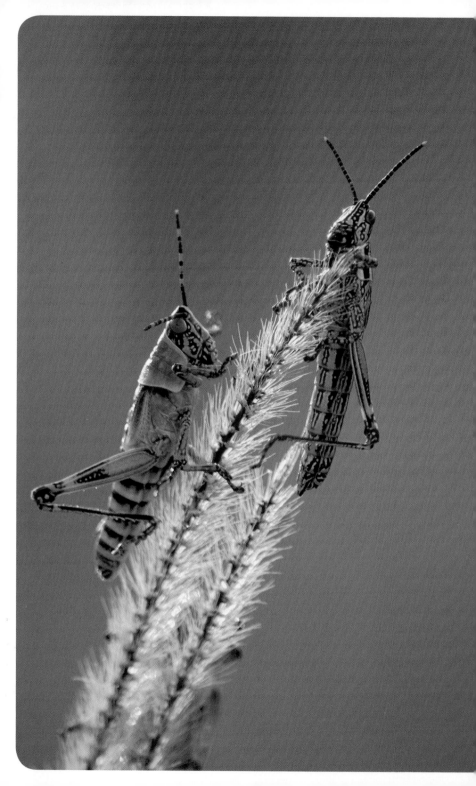

25° 46' 15" S
28° 13' 41" E

# Austin Roberts Bird Sanctuary, Near Pretoria/ Tshwane

## Background

Named after a famous ornithologist and mammalogist, this small sanctuary in the heart of Pretoria's old suburbs offers some very good bird watching and photography. The sanctuary is only 11ha large and birds are the primary attraction. It was opened in 1953 at the spot where two small rivers converged to create a small wetland, a natural attraction for many waterbirds. In the 1970s, the heronry was famous for the huge numbers of cattle egrets and pink-backed pelicans breeding on the island. Over the years, as urbanisation and traffic have increased, the massive flocks have long departed. However, Austin Roberts allows for some exceptional bird photography even though it may not be a great wilderness escape.

## The sanctuary

Much of the terrestrial area of the reserve is fenced off and so all your viewing is over the water of the main dams. For photographers, the main attraction is the entrance to the Hadeda Hide where many birds congregate, allowing you to easily get good images. Birds are common throughout the year, but it's in the dry, cold season from May to August that they congregate in numbers on the water when each morning, just

◀ It's not all about the birds and mammals. These elegant grasshoppers are about to mate.

before 09:00, birdseed is provided for them. This causes a huge flurry of activity, with many birds flying to and fro right in front of you. You will have close-up sightings of Egyptian geese, spur-winged geese, yellow-billed ducks, white-faced whistling ducks, fulvous ducks and red-knobbed coots. Goliath, purple and grey herons are commonly seen, as are sacred ibis and pied and giant kingfisher. White-breasted and reed cormorant are also commonly spotted and photographed.

A morning here filled with repeated activity and behaviour is an excellent way for you to hone your photography skills and techniques, and is most probably why it is so popular with nature photographers. If you are looking for repeated action to fine-tune a specific type of image, then this is the place to work on it.

# Photography and equipment

As you can park your vehicle right next to the hide, access and equipment is not a problem. The best option is to set up your tripod on the wooden platform access to the Hadeda Hide and photograph overlooking the water. The light is best in the months May to August, and once the sun is over the trees, it lights up the water to a beautiful blue. As you will stand and photograph from your tripod, moving and panning sideways is quite easy. Be aware that the hide can get very busy on weekends, so your space might be a bit limited on those days.

As the birds fly quite close to you, a 300mm lens will suffice for some of the bird photography. This is the one place where a shorter lens will enable you to get good bird images. A 400–600mm lens will allow you the full-frame images of Egyptian geese with wings spread wide open, yellow-billed ducks coming in to land and white-faced ducks in flight. The beauty of this place is that this can happen a few times in a morning, allowing you ample opportunity to make sure you get your shot. This is a spot for both beginners and advanced photographers to refine and learn about their equipment and technique. If there is one thing that improves your photography, it is repeated behaviour. Many top photographers visit the hide to "keep their eye in" or to work on a specific technique,

You will need at least a 500mm lens to get full-frame images of a red-billed teal preening from the Hadeda Hide at Austin Roberts.  ▶

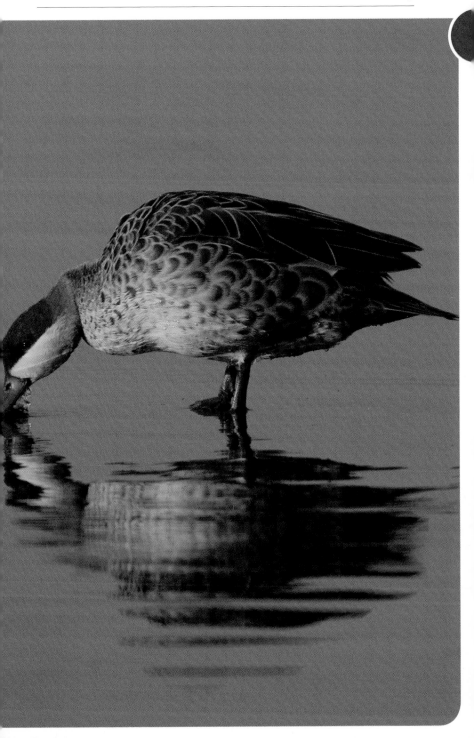

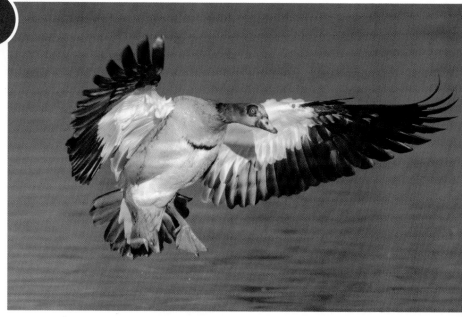

▲ An eqyptian goose landing at Austin Roberts will give your focusing skills a real test.

▼ The crisp, cold mornings in Gauteng during June and August leave their mark on the wildlife. Here an African wattled lapwing sits with some frost on its back.

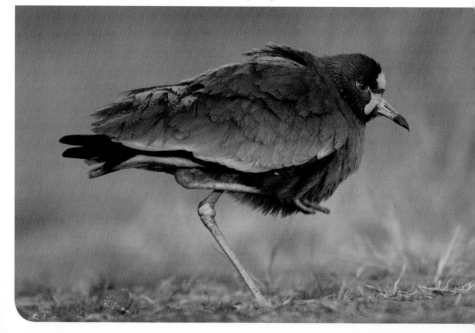

which may be slow sync flash or extremely slow shutter speeds – either way the repeated action allows them many chances to make sure they perfect their technique.

The main advantage of Austin Roberts is that it allows excellent and easily accessible bird photography within the city. It also has the added advantage of fresh hot coffee at the Blue Crane Restaurant on the other side of the dam! It certainly is worth a cold morning visit in the months of May to July.

## Getting there

The best access is from the R21/Fountains interchange. Turn into George Storrar Drive and follow it east. Cross over Queen Wilhelmina Avenue and turn left into Melk Street. Park in the bays on the corner of Boshoff Street.

In the summer months of September to April, the opening hours are 07:00 to 18:00; in Winter, from May to August they are from 07:00 to 17:00.

## Highlights

- Great chance to photograph Egyptian geese and white-faced ducks
- Bird-in-flight photography
- Grey, goliath and purple heron photographs
- Pied and giant kingfishers are commonly seen
- Beautiful quality of light in the dry season
- Repeated behaviour "fly-bys" allows you to work on your specific technique
- Very easily accessible

# Shem's photography rating out of 10

| Photographic subject | Abundance | Viewing | Photography potential |
|---|---|---|---|
| Landscape | - | - | - |
| Birds | 8 | 8 | 8 |
| Mammals | - | - | - |
| Predators | - | - | - |
| Big 5 | - | - | - |
| Overall experience | 6/10 | | |

# Photographic equipment suggestions

| Photo skill level | Equipment |
|---|---|
| Beginner to intermediate to advanced | • Beginner/pro-sumer/pro-camera bodies<br>• Pro-body if you want to capture action and birds in flight<br>• A 300mm lens will give you full-frame images of some birds<br>• Long lenses 500–600mm are required for birds landing in the water<br>• Converters for extra length for tight bird images |

# Other information

| Accessibility | Cost value | Popularity |
|---|---|---|
| Very easy | Free | High from May to August; very high on weekends |

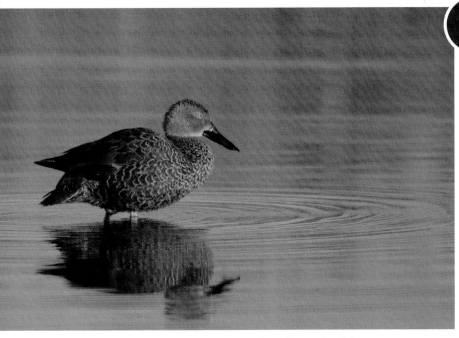

▲  A Cape shoveler waddles through the water in the early-morning light.

▼  White-faced duck are the most common birds at Austin Roberts. The repeated "fly-bys" are perfect practice for action photography.

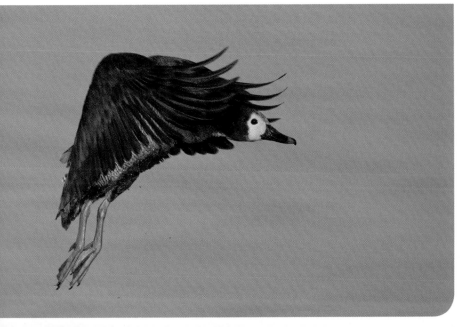

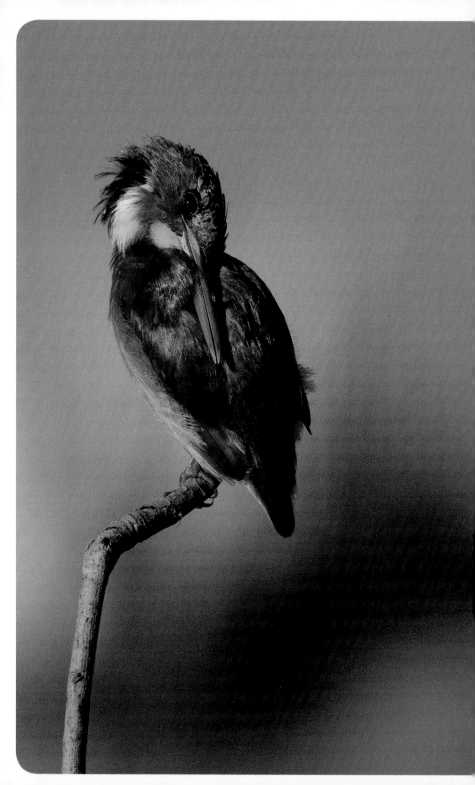

26° 21' 24.61" S
28° 30' 54.34" E

# Marievale
# Bird Sanctuary,
# Near Nigel,
# East Rand

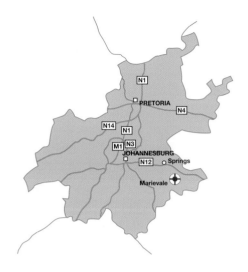

## Background

As the name suggests, this is primarily a bird sanctuary. So if you are searching for mammals, you can skip this section. If however, you are looking for top-class bird photography, Marievale offers some fantastic sightings and opportunities for the keen photographer. Located east of Johannesburg on the outskirts of Nigel, the sanctuary lies within the larger Blesbokspruit catchment area. Marievale is one of the largest open-water areas of the entire catchment. Birdlife is excellent all year round and the importance of the wetland has been recognised by it being declared a Ramsar convention site. Ramsar sites are wetlands of international importance.

## The sanctuary

Entrance to the wetland is free – the only requirement is that you close the gates behind you. The wetland is composed of a single-track road linking various hides together. It completes a large circle through the various causeways, reedbeds and open waterways. Although birdlife is good throughout the year, in the wetter months the reeds grow quite high, making visibility difficult and not conducive to good bird photography.

◀ A perch close to the Hadeda Hide at Marievale allows you to get up close and personal with malachite kingfishers.

65

The greater availability of water in the wet season also sees many of the waterfowl disperse widely, so in fact you see less of them.

It's the dry, cold months that make this a photography haven: the reeds die down, visibility increases, mist hangs over the water and birdlife is prolific. Marievale then becomes the best roosting and feeding sanctuary for waterfowl in the whole eastern part of Gauteng, and this increase in bird numbers also provides many more photographic opportunities. There are a number of hides to photograph from, but the one that really stands out is the Hadeda Hide.

This well-built wooden hide has the normal open viewing ports and a wooden bench. It faces directly west into open water with reeds on both sides of the hide. At first glance, it appears a normal bird-viewing hide. However, with patience all manner of birdlife comes flying past and towards the hide. The added beauty of the scene is in the stillness of the water which creates a mirror-like effect. Often mist hangs over the water in the dawn which adds to the mood. The sun rises directly behind you and the water turns a golden colour as it reflects off the reeds, creating a wonderful backdrop. Birds come and go on their daily business in this wonderfully calm and serene place.

The quality of the light is especially good in the dry season, for two reasons. Firstly, the sun remains lower on the horizon, and secondly, the water reflects the light upwards, shining on the underside of what would normally be a dark wing in shadow. With such good photography conditions, it hardly feels as though you are only 30 minutes from the largest city in South Africa.

Sitting at the hide, red-billed teal will most likely be the first visitors you see. They fly in fast and low and normally land out in the open water. Cape shovelers and southern pochard dabble in among the shallows, and yellow-billed ducks will be in and out in a flash, their typical duck call giving them away. Little grebes (dabchicks) and red-knobbed coot busily swim by. Keep an eye open for the male coots aggressively chasing other smaller birds and coots away. Moorhens and various warblers will be in and out of the reeds around the water's edge, right next to the hide. African marsh-harriers often flap by overhead, their heads pointing downwards looking for prey. African purple swamphen and African rail

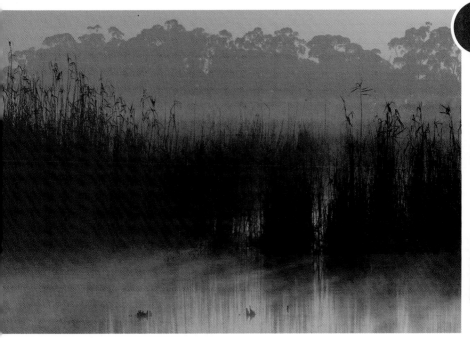

▲ Mist over the water is a characteristic of early-morning Marievale.

▼ A white-faced duck launching out of the water will test your reaction time!

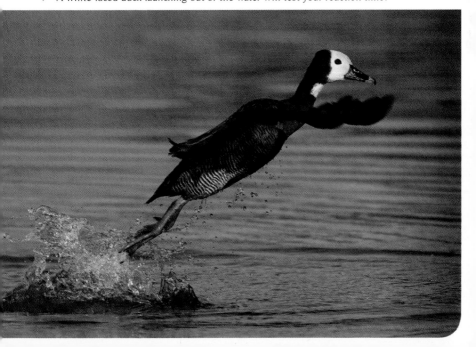

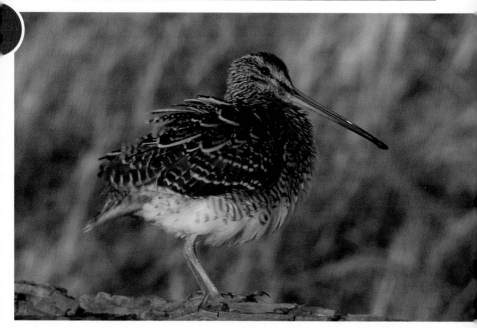

▲ The relatively uncommon African snipe is frequently seen and photographed at both Marievale and Rietvlei.

▼ African marsh harriers are commonly seen searching for prey in the reeds at Marievale.

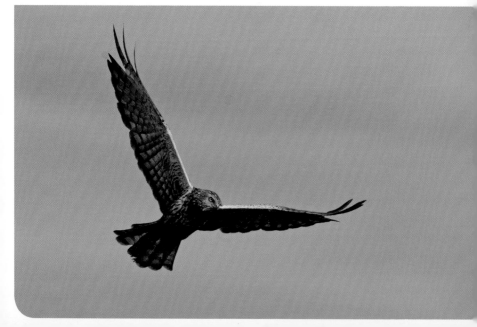

sometime stick their heads out of the far reedbeds and walk along the water's edge – both are relatively secretive birds so photographing them is a real bonus.

The real highlight is the malachite kingfishers that often come to perch on a specific stick in front of the hide. The stick is nicely curved, which makes a lovely composition. The smooth blue watery background compliments the colours of the kingfisher beautifully and if you have the pleasure of being treated to a visit by these birds, you will understand exactly the type of photograph that is possible.

Marievale is not only about the Hadeda Hide. You can take a slow drive along the road onto the causeway, which is particularly good for red-knobbed coots and purple, black-headed and goliath herons. Pied kingfishers are also common along here, perched in the reeds and trees alongside the water.

## Photography and equipment

This is the sit-and-wait type of photography: the type not frequently encountered in South Africa. Select a spot in the hide, set up your equipment, make yourself comfortable and wait. The hide has a large port, so your lens should fit through it. You have the option of using a beanbag, ergo rest or tripod for your lens. Either way, make sure you can pan from side to side with ease and comfort as that is how the birds will fly across you. You will need at least a 500mm lens to get full-frame images of the birds. A 600mm and 1.4 converters are comfortably used here too. With birds you never have enough glass. If you want to capture birds in flight, then have a pro-sumer or a professional camera body attached to your lens. This will ensure you have the most accurate focusing as well as fast enough frame rates to capture the wing beats and the splash when the birds land in the water.

When visiting the wetland in the cold, dry season, make sure you are prepared for the cold conditions. Mornings are regularly at -2°C with a thick frost on the ground. Sitting on a cold wooden bench inside a hide can get uncomfortable, so take gloves, beanies, jackets, hot drinks and something to cushion the cold on the rear end. Sometimes the activity gets very busy and you don't want to be frozen stiff and missing out on

good bird activity in excellent light. The hide gets very busy on weekends, so make sure you get your spot on the wooden bench early.

If Marievale were in a stunning wildlife reserve, it would be a world-class birding destination. The fact that it is so close to Johannesburg makes it extremely appealing as a destination. If you can handle the cold frosty mornings in a hide, you are bound to be rewarded with excellent bird photos. The combination of good waterbird species, the brilliant quality of light and unique visitors, like the malachite kingfisher, make the effort and cold well worth it.

## Getting there

Marievale is on the East Rand near the town of Nigel. You get to Nigel from Pretoria via the R50 Delmas road. If you are coming from Johannesburg, take the N3 (south of Johannesburg). As you get out of the main suburban area, you take the R550 offramp and turn left (south). After about 20km you will reach a T-junction. Turn right and go through Nigel. A few kilometres outside the town, you will see a large sign saying "Marievale Bird Sanctuary". Take this turn and follow the road till you get to the sanctuary.

The sanctuary is open daily – 05:30 to 19:30 from October to March and 06:30 to 18:00 from April to September. There is no entrance fee. Contact: 011 364 1101.

## Highlights

- Excellent waterbird photography
- Bird-in-flight photography
- Beautiful quality of light in the dry season
- Mist over the water adds a certain mood to the scene
- Calm, glass-like water creates stunning reflections
- Good diversity of birds to photograph
- One of the best places to photograph malachite kingfisher

# Shem's photography rating out of 10

| Photographic subject | Abundance | Viewing | Photography potential |
|---|---|---|---|
| Landscape | 1 | 1 | 1 |
| Birds | 8 | 8 | 8 |
| Mammals | 1 | 1 | 1 |
| Predators | - | - | - |
| Big 5 | - | - | - |
| Overall experience | 7/10 | | |

# Photographic equipment suggestions

| Photo skill level | Equipment |
|---|---|
| Intermediate to advanced | • Pro-sumer/pro-camera bodies<br>• Pro-body if you want to capture action and birds in flight<br>• Long lenses 500–600mm are required for birds<br>• Converters for extra length for tight bird images |

# Other information

| Accessibility | Cost value | Popularity |
|---|---|---|
| Easy | Free | High from May to August; very high on weekends |

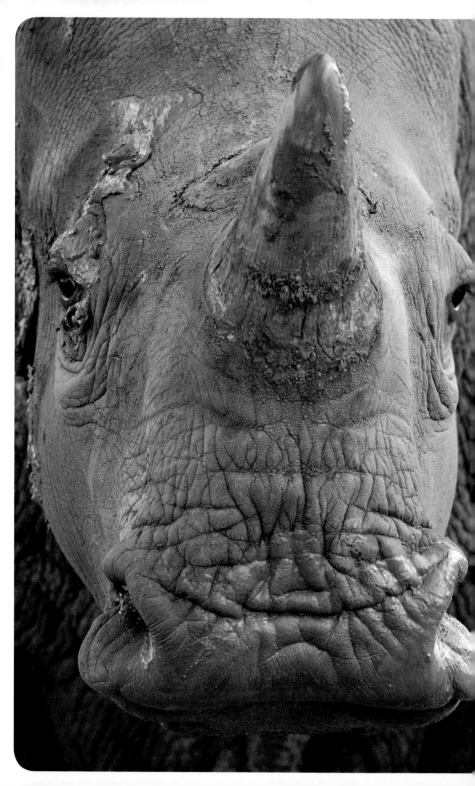

25° 52' 59" S
28° 15' 48" E

# Rietvlei
# Nature Reserve,
# South of Pretoria/
# Tshwane

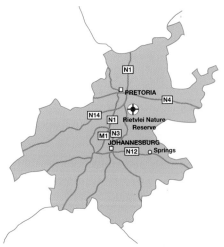

## Background

Rietvlei Nature Reserve, on the southern outskirts of the Pretoria/ Tshwane metropolitan area, is one of the few unknown reserves that is a top spot for photography in Gauteng. The 3 000ha reserve is easily accessible from both Johannesburg and Pretoria and has all the facilities for a good day of photographing. For its size, the reserve hosts a remarkable diversity of species. Of the general antelope, black wildebeest, eland, blesbok, springbok, zebra and red hartebeest are all easily seen. The reserve also holds white rhino, cheetah and buffalo; and more recently, in a separate enclosure, lion. Some unusual mammals like brown hyena, suricat and bushpig have been seen in the reserve. With such a high diversity of subjects in a small reserve, you are bound to have good sightings of at least one species. Birding is very good too, especially in summer when the migrants are back and the grassland birds are all displaying.

## The reserve

The best way to get good results is to slowly drive along higher roads, scouting for animal herds in the valleys. The herds tend to concentrate in specific valleys, and once located, you can make your way towards them.

◄ The water puddles on the road are perfect wallows for white rhino at Rietvlei. If you notice some rhino near a wallow, sit and wait – you could be rewarded.

Due to the volume of vehicle traffic, most animals are very relaxed and will allow you to get close enough for portrait images. Black wildebeest are very difficult to see in the wild and this is the one place where you can get good photographs of them. The herds tend to congregate in the valleys and open grassland. Similarly, it is an excellent place for eland photographs. These large antelope are usually very skittish, but at Rietvlei are relaxed enough for portrait images and with luck you will spot cattle egrets on their backs which makes for some special shots. Zebra are perhaps the easiest species to photograph; and with the ubiquitous cattle egrets in tow, they allow for some interesting images.

Being near a highly urbanised area, power lines, buildings and fences litter the skyline, so you need to be aware of your background when composing your images. Luckily, the reserve is relatively hilly and so this eases your choice of background.

During the rainy season, the grass tends to get very high, especially in the months of March to May, which can hinder mammal photography. However, it's in this season that the birding here is very good. The high abundance of insect life attracts many migrant birds, and flocks of Amur falcons are regularly seen here in these months. European bee-eaters are also common in summer, as are banded martins, barn swallows and Diderick cuckoos. A summer characteristic of Rietvlei is the numerous long-tailed widowbirds displaying with their long, black tails flapping behind them. Notice how they display, flying into the wind, and try to position yourself in their flight path where you should be able to get some photos of them displaying, with a beautiful green backdrop to complement the image.

Ant-eating chats are resident in the reserve and use old aardvark burrows to nest in. They hover characteristically just above the burrows when returning to the nest, which offers some interesting in-flight images. One of the sounds of summer in the reserve is the rufous-naped lark, whose characteristic "rusty gate opening" whistling call is made from the top of a termite mound or on top of a branch. Every so often, they hop skywards and hover in midair, which provides some good action photo opportunities.

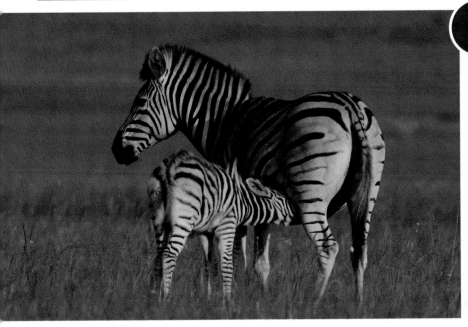

▲ The short green grass of September makes a perfect backdrop for photographing plains (Burchell's) zebra.

▼ A typical December scene in Rietvlei: green grass, white rhino grazing and white clouds in the sky.

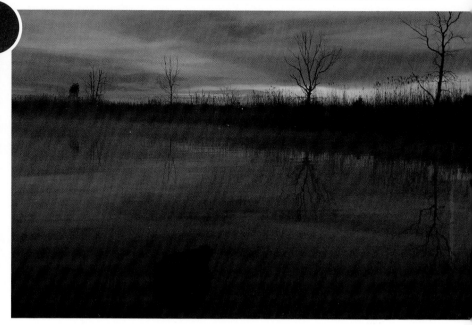

▲  A stunning sunrise lights up fog on Rietvlei Dam on a May morning.

▼  Cattle egret are very common in Rietvlei, making for lots of opportunities with the camera. Note the perch.

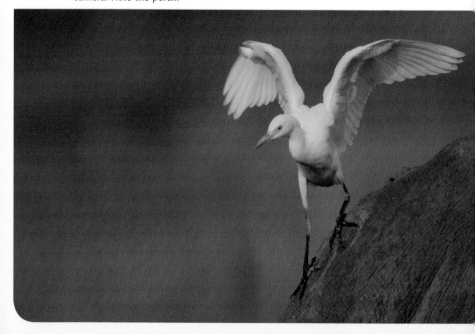

Birds of prey that are seen are black-shouldered kite, black-chested snake-eagle and secretarybird. At the Hippo Hide and picnic spot, the red bishops and southern masked-weaver are easily photographed in the reeds at the water's edge. Pin-tailed whydahs are also commonly seen at the picnic area, making it a worthwhile stopover for some bird photography. There are two hippos in the dam, but they are usually very shy, showing only their noses above the water.

Suricats occasionally frequent the reserve, especially along the eastern boundary. Look out for the sentinels on top of the termite mounds trying to get a vantage point over the long grass. Yellow mongoose are very common but they are elusive and camera shy. The start of the wet season is the best time to photograph the large mammals, the grass is still short and the typical thunderclouds in the background make for some excellent summer scenes.

As the dry season approaches from June to September, the grass changes from green to a gold-red and the herbivores start eating away much of the thick growth, making viewing and photography much easier. Controlled management fires also open up parts of the reserve, and with a green flush of grass these burnt blocks make photographing a trouble-free undertaking. The dry season here is very harsh and early-morning temperatures often fall to below -3°C with thick frost covering the ground. Dense mist hanging in the valleys in the mornings makes for some very atmospheric images and is a great way to start a day's photography. Frost also provides opportunities for different images and I've photographed African wattled lapwing (wattled plover) and African snipe both covered in frost. The snipe breed in the colder months and are easily seen displaying over the marshy grassland areas.

Many birds use the dams as roosts. If you position yourself in their flight path, you should find black-headed herons, yellow-billed ducks, red-billed teals and little egrets flying past you. Marsh owls are often seen circling the marsh area in the north of the reserve just before dusk. Cape longclaws are common all over the reserve and are often found on the road verges in the short grass, with their bright orange throats standing out against the grass. With the grass such a brown colour, the early evening hours of the day provide beautiful photographic light and the reserve seems to turn gold in colour.

One of Rietvlei's specials is white rhino. In the dry season, they frequently visit the watery patches next to the roads to wallow. This allows for great close-up images of these behemoths. Cattle egrets are almost always with them which makes for a refreshing change to the more usual portrait. It is one of the best places in South Arica to view and photograph these creatures. September brings a flush of green to the burnt areas in the reserve and is the best time to see the buffalo, which for most of the year hide in the wattle stands, but are now attracted by the fresh grazing. Look out for jackal dens in old aardvark burrows next to the road. Some of these have provided for excellent opportunities to photograph the pups.

It may have power lines running through it and be surrounded by an urban skyline, but the joy of Rietvlei is that it is found in such close proximity to the cities. You can photograph birds in great light for an hour in the morning, see rhino and buffalo grazing in the open, listen to jackals howling and hear the African fish-eagle call and be in the office at 09:00. A better start to the day would be hard for a city-bound wildlife photographer to find.

# Photography and equipment

As you will be driving your vehicle, photography will be from your window. Photographing from a vehicle presents you with a few options to choose from. There are a variety of vehicle brackets and mounts that you can use. My opinion is to find the one that works the best for you and then to stick with it. One problem of working from a vehicle window is the lack of mobility it allows you and I find beanbags resting on top of a window frame as the best option in terms of stability as well as flexibility. You can photograph from the hides, where a tripod and/ or a beanbag would be helpful, but the hides aren't very productive for good photography. A tripod is very useful at the Hippo Hide picnic spot when photographing the bishop birds and weavers in the reeds.

400–600mm lenses are needed for mammal portrait shots and the bird photography with a 300mm can easily be used on rhino. The long lenses compress the scenes nicely and help you exclude any artificial structures in the background. A wide-angle lens is recommended for those wet season thundercloud scenes.

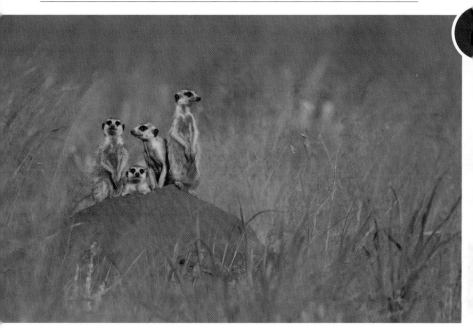

▲ Suricats sometimes frequent Rietvlei. If you are lucky, you may have a chance
of photographing them.

▼ There are few reserves that hold black wildebeest anymore. Rietvlei is one of the best
places to photograph them.

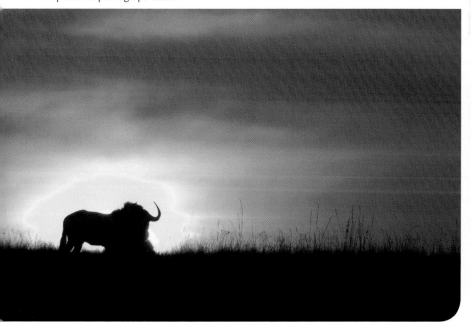

# Getting there/accommodation

Rietvlei is just off the R21 highway. Take the Nellmapius/Irene offramp and turn east. At the first traffic lights, turn right into Boeing Road – 2km along, just across the Sesmylspruit River, a signboard will direct you to Rietvlei. From there it is 2km till the entrance of the reserve, which is well signposted.

There is accommodation in the reserve in the form of chalets. All enquiries and bookings can be made at the main reception area 012 358 1810/1/2.

Rietvlei is open daily from 08:00 to 18:00 on weekdays and from 06:00 to 18:00 on Saturdays, Sundays and public holidays. Entrance to the reserve closes at 16:00. An entrance fee is charged. Gate times are based on sunrise and sunset times, according to the season.

## Highlights

- Good nature photography close to urban centres
- Very good sightings and photography of white rhino
- Great diversity of birds with lots of photo opportunities
- Good place to photograph grassveld species like black wildebeest, blesbok and eland
- Golden grass in dry season provides excellent backdrops in good light
- Very good photography of bishop birds, weavers and whydahs at the Hippo Hide picnic spot in summer
- Early morning mist in the dry season
- Relaxed animals make portrait photography relatively easy
- Unusual species pop up on a regular basis – bushpig, brown hyena (at dusk) and suricats

# Shem's photography rating out of 10

| Photographic subject | Abundance | Viewing | Photography potential |
|---|---|---|---|
| Landscape | 4 | 3 | 3 |
| Birds | 7 | 8 | 7 |
| Mammals | 5 | 8 | 6 |
| Predators | 2 | 2 | 2 |
| Big 5 | - | - | - |
| Overall experience | 6/10 | | |

# Photographic equipment suggestions

| Photo skill level | Equipment |
|---|---|
| Beginner to intermediate to advanced | • 1 entry level – pro-sumer camera bodies<br>• Pro-body if you want to capture action and birds in flight<br>• Long lenses 400–600mm are required for birds and mammal portraits<br>• 400mm lens will be good for most mammal photography<br>• Wide-angle lens are needed for landscapes: 14–70mm<br>• Medium lens for larger mammals |

# Other information

| Accessibility | Cost value | Popularity |
|---|---|---|
| Very easy | Cheap | Very high |

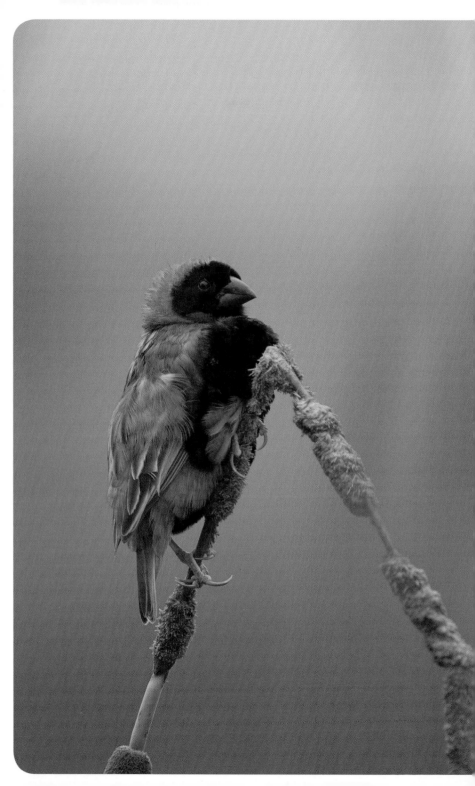

# Other Reserves in Gauteng

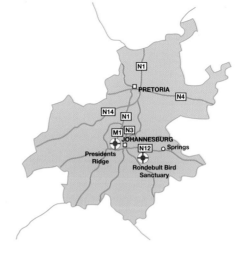

With lots of semi-urban sanctuaries and a number of wetlands, Gauteng offers a lot of good photography opportunities. Below are two places that are worth a visit.

## Rondebult Bird Sanctuary

26° 10' 40.38" S   28° 14' 38.65" E

This 95ha sanctuary is situated to the south-east of Johannesburg. It is a mix of grass and wetland and has eight hides interspersed among the various pools and marsh areas. It is these hides at the wetland pans that are the main attraction for photographers. Birding here is first class and you should see an assortment of ducks, geese, ibis, teals and herons. You can also reliably see avocet, black-winged stilt, black heron and hamerkop. The water levels do fluctuate quite a bit between the dry and wet seasons, so it is best to enquire about this beforehand if possible.

In the wet season, flamingos are often seen in the pans, which is the only place in Gauteng where they can reliably be seen and is a wonderful place to photograph them. Green algae covers the water periodically, which is not pleasing for most photography, but it does not seem to bother the birds. As with most bird photography, this is a spot for longer

◀ Southern red bishops are easy to photograph in the various reedbeds of wetlands.

lenses (500–600mm) and pro-sumer/pro-cameras to enable fast focusing and high frame rates.

## Getting there

The sanctuary is found by heading south-east from Johannesburg on the N3 highway towards Durban. It is well sign-posted. Turn left at the R103/R554 (Heidelberg/Alberton road) offramp and the sanctuary is on the right-hand-side of the road after 9km. There is a gate guard to open the gate, but it is possible to drive straight in if he is not there.

The sanctuary is open daily throughout the year from 07:00 to 17:00.

# Presidents Ridge Bird Sanctuary

27° 59' 30" S   26° 06' 26" E

Situated in the heart of one of Johannesburg's major centres, the Presidents Ridge Bird Sanctuary is excellent for bird photography, primarily at the very active heronry. Cattle egrets breeding in the heronry are the main attraction here, especially as they fly back and forth during the breeding season. Black-headed herons, Egyptian geese, grey herons, little egrets, reed cormorants and darters all breed on the island and are regularly seen. At 2.7ha in size, you can easily walk around the whole sanctuary. There is a hide overlooking the dam, but you can set yourself up anywhere to photograph. 500-600mm lenses are needed for most of the birds in flight images. A smaller lens can be used for birds along the water's edge.

## Getting there

Presidents Ridge Bird Sanctuary is situated in Randburg, Johannesburg. Take Malibongwe Drive going east from the N1. At Cross Street turn left; then turn right into Malcolm Road; travel about 500m until you see an open park on your left – this is the sanctuary. Entrance is via a pedestrian gate. Contact number: 011 787 1557.

It is open only on Saturdays, Sundays and public holidays.

Late afternoon is the best time to find marsh owl, which if approached carefully, will allow you a photograph.   ▶

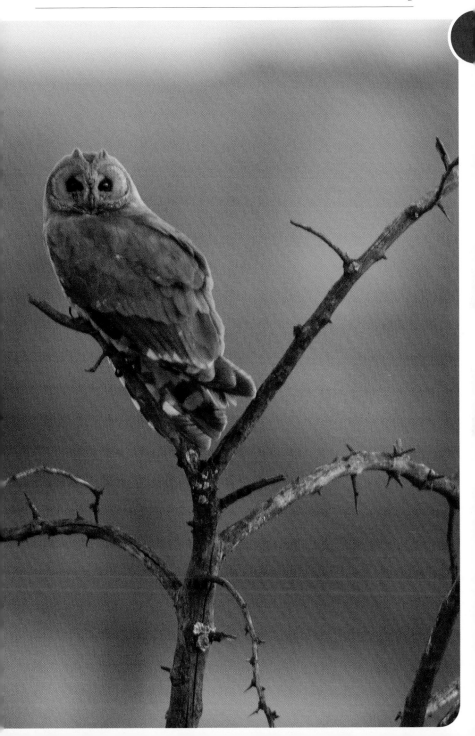

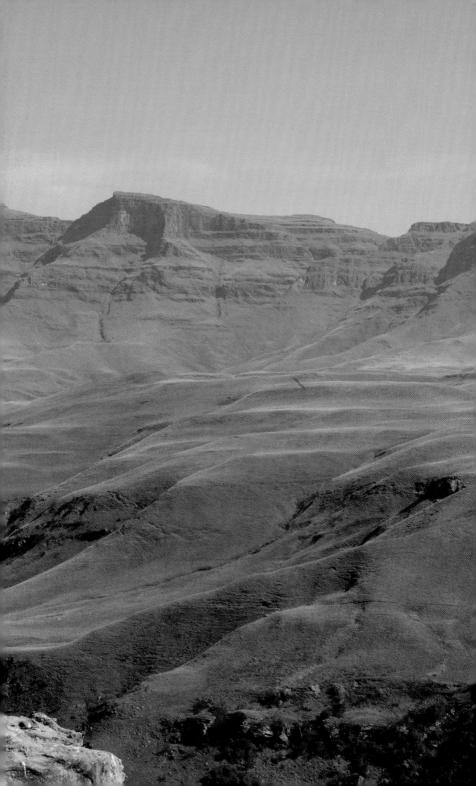

# KwaZulu-Natal

Giants Castle Vulture Hide
Mkhuze Game Reserve

29° 15' 23" S
29° 31' 42" E

# Giants Castle Vulture Hide, Ukhahlamba-Drakensberg Park

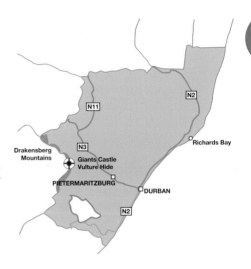

Drakensberg Mountains

N11

N3

N2

Richards Bay

Giants Castle Vulture Hide

PIETERMARITZBURG

DURBAN

N2

## Background

One of the greatest thrills of nature photography is having large birds of prey slowly swoop past you, filling your camera frame with their beaded eyes which are only metres away. Photographing large raptors at close quarters is a very exciting experience and the vulture hide at Giants Castle is one of the finest places in the world where one can consistently get high-quality images of the endangered bearded vulture (lammergeier), as well as the many other magnificent raptors that frequent the feeding ledge.

Set up in the 1960s, the feeding restaurant was initiated to conserve bearded vultures, whose numbers had declined dramatically in South Africa. Africa holds only three populations of these vulture: 4 000 pairs in Ethiopia; 50 pairs in Kenya/Tanzania; and approximately 200 pairs in the southern African stronghold of the Lesotho and Drakensberg mountains. This legendary mountain bird's name contributed to its decline in numbers throughout the last century. The name lammergeier or "lamb catcher" was exactly what farmers thought the vultures were doing and hence they set about eradicating them until no more than 100 pairs of birds remained.

The then "Natal Parks Board", in a proactive conservation drive set up the "restaurant" to provide a safe feeding place for the birds in the

◄ The hide overlooks a contoured ledge on which the raptors come to feed.

dry, cold months of May to August, when food sources are scarce. The construction of the hide came later, and over the years has become a favourite place for keen bird photographers to obtain high-impact images of bearded vultures, Cape vultures (Cape griffons), Verreauxs' eagles and other magnificent birds of prey.

# The hide

The Drakensberg is South Africa's largest mountain range that extends from the Cape to the Limpopo Province. However, the central regions are by far the most spectacular and Giants Castle sits in the heart of these most impressive rock buttresses and basalt massifs. The view from the hide is often described as spectacular. Situated on a contoured ledge above the valley below, the hide is well camouflaged within the surrounding scenery and allows a 180° view of the mountains in front of you through large mirrored glass windows.

The hide can comfortably accommodate three photographers, each with a large lens. There are three camera ports through which to photograph, and photographers can support their camera set ups with beanbags, super clamps or ergo rest tripods. No one support system is 100% effective, but for the longer lenses like 500–600mm, an upside-down ball head hung from a super clamp is very effective.

The hide faces south-west, with decent light on the birds for most of the day. Morning light is of course the best, but the afternoon can also provide some interesting side and back lighting on the birds.

There is no toilet facility at the hide and most people go for a walk over the hill when nature calls. Make sure you take enough food and drinks for a day in the hide.

The months June to September can get very cold, so warm drinks are highly recommended. In the morning, after offloading your equipment at the hide, it is suggested you park your vehicle a distance down the road so as to keep disturbance to a minimum.

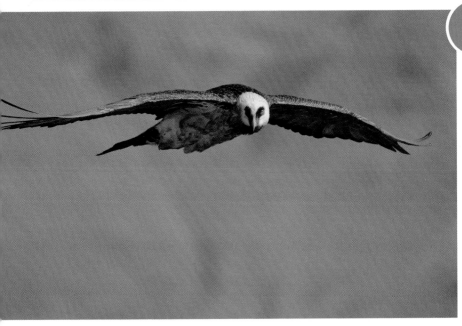

▲  The experience of an adult bearded vulture at close quarters is quite thrilling.

▼  Jackal buzzards are masters of flight, testing your reaction time. But the rewards are worth the effort.

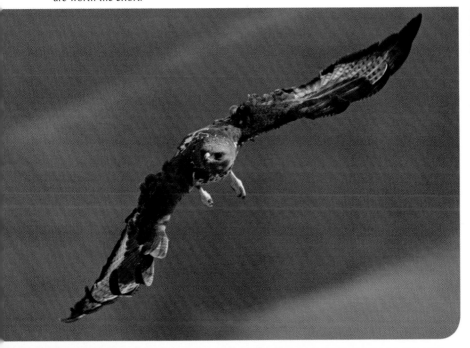

# Photography and equipment

Although a bucket of bones to lay out for the birds is supplied by the restcamp each morning, I suggest also taking some of your own meat to the hide. Old shinbones, off cuts and joints seem to work well in attracting the raptors. You can place the meat anywhere along the ledge where you think it will attract the birds. The Cape and bearded vultures prefer the well-known rock on the protruding ledge furthest from the hide. Closer to the hide a number of other birds stop to feed on the meat provided. You will see where the birds have whitewashed the rocks, indicating their most-favoured perches, where it is sensible to place some bones. Generally, the larger birds like the large bones, especially the bearded vultures. The Cape vultures will not fly away with bones and tend to stay longer when they come to feed. The jackal buzzard and lanner falcons enjoy the smaller pieces of meat and bones – the size of golf balls will be perfect for these smaller raptors.

Equipment-wise, this is the place for longer lenses (500–600mm), good auto focus, precise cameras and fast-frame rates. To capture the Cape and bearded vultures landing on the furthest ledge, you need to have a 500mm lens for a full-frame image with wings widespread. The jackal buzzards often land closer to the hide, but due to their smaller size, you will still need a large lens to capture them full frame. The action can come in thick and fast, making for high-action photography with lots of frames released in a short space of time. Pro-sumer/pro-camera bodies with their fast-frame rates, large memory buffers and excellent autofocus are needed to capitalise on the action.

Having a bearded vulture majestically glide slowly along the rock ledge right past you is a startling experience and makes photographing at this hide an adrenaline-filled affair. If you manage to obtain a close-up headshot, it is one you won't forget in a hurry! The highlight though must be an adult bearded vulture coming in to land. This is truly a magnificent sight that will test your determination as a photographer as well as delighting the senses.

Dawn light over the 'Berg – a good reason to get to the hide early in the morning. ▶

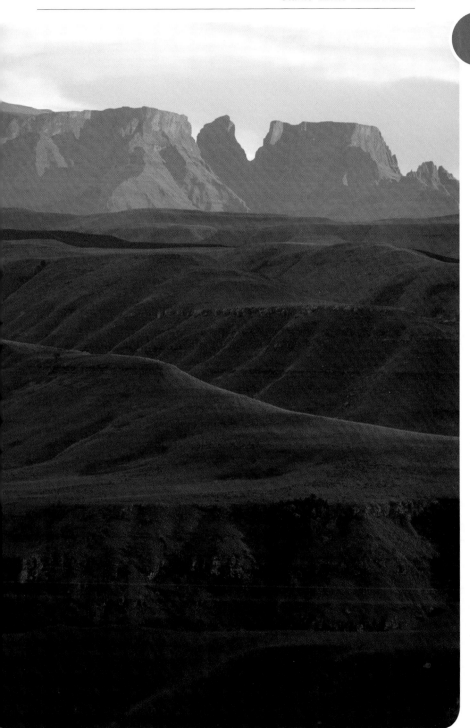

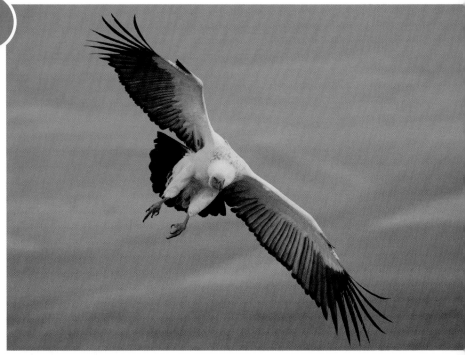

▲ Cape vultures are massive birds and easily fill your frame when coming in to land.

▼ Fighting between black-backed jackals and vultures offers some exciting interaction.

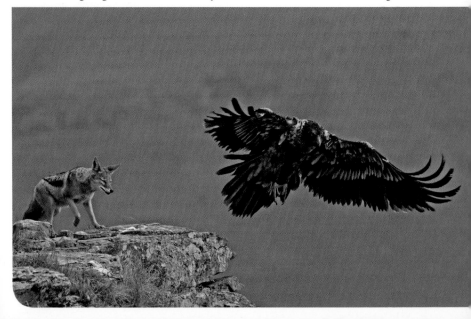

The action is not only limited to the birds described earlier. The masters of flight, white-necked ravens, are in abundance, often harassing other species. There is often inter- and intra-species action as the birds fly by, presenting even more action photo opportunities. A black-backed jackal sometimes frequents the hide to steal the meat and if some of the large raptors are present, this can result in some great interaction between the two species.

Closer to the hide there are many smaller birds to photograph. Malachite sunbird, buff-streaked chat, familiar chat, Drakensberg prinia, red-winged starling, greater double-collared sunbird and Cape rock-thrush provide good opportunities for portraits while you wait for the large birds to appear.

The birds can land at the ledge anytime through the day. The most frequent visits tend to happen between 09:00 and 13:00, although I've always enjoyed staying longer. The activity is erratic with some days very quiet, and then the next morning action packed. There is no assured way of attracting the birds and luck seems to play a part in the amount of activity that may occur.

Giants Castle is one of the most beautiful places in South Africa and offers some spectacular landscape images, especially with the greater 'Berg massif as your backdrop. A walk around the hide is well worth the leg stretch and an early start before sunrise is worthwhile to catch the golden rays of light. Note the protea trees that provide good foreground subjects.

The contoured rock-strata leading, covered with various coloured lichen, provide some interesting and strong lines in composing landscape images as well as adding colour to the scene. Giants Castle hide is arguably one of the finest spots in the world to photograph the bearded vulture. It offers comfort, warmth, protection from the elements, excellent proximity to the birds and some unparalleled action photography: all in all an unsurpassed situation. You couldn't ask for more – it really is a world-class spot for raptor photography.

# Getting there

Giants Castle is easily accessible by a normal sedan car, but you will need a 4x4 or a vehicle with a diff-lock to access the hide. It is approximately 6 hour's drive from Johannesburg or a 3-hour drive from Durban. Ezemvelo KZN Wildlife runs the restcamp and reservations can be made through their central reservations office http://www.kznwildlife.com/site/contact/. You book the actual hide by phoning the restcamp for your required dates: 036 353 377.

The hide is open all year round, with May to August being the most popular times to visit.

## Highlights

- Close-up encounters with Cape and bearded vultures, jackal buzzards, Verreauxs' eagles and white-necked ravens
- Excellent bird in flight photography
- Lots of action images of birds taking off and landing
- Many smaller bird species to photograph
- Good landscape possibilities
- Stunning location
- Wilderness experience

▲ The inside of the hide accommodates three photographers quite easily.

▼ An adult bearded vulture landing is a sight to behold; and it tests your photographic nerves too.

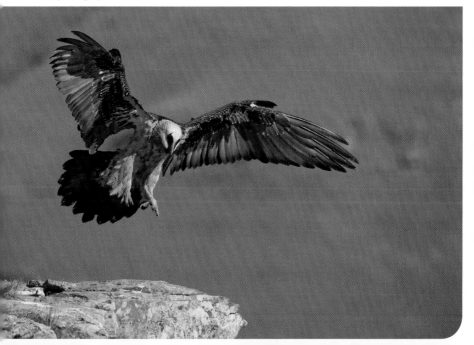

# Shem's photography rating out of 10

| Photographic subject | Abundance | Viewing | Photography potential |
|---|---|---|---|
| Landscape | 8 | 8 | 7 |
| Birds | 7 | 9 | 9 |
| Mammals | 3 | 7 | 6 |
| Predators | 2 | 2 | 4 |
| Big 5 | - | - | - |
| Overall experience | 7/10 | | |

# Photographic equipment suggestions

| Photo skill level | Equipment |
|---|---|
| Intermediate to advanced | • Pro-sumer/pro-level camera body for accurate focusing and fast-frame rates<br>• Fast-focusing, prime lenses advised 500–600 f4mm<br>• Wide-angle lens for landscapes 18–70mm<br>• Medium lens for environmental images 70–200mm |

# Other information

| Accessibility | Cost value | Popularity |
|---|---|---|
| Easy (4x4) | Mid-range | Very high |

Good landscapes are easily accessible within easy
walking distance from the hide. ▶

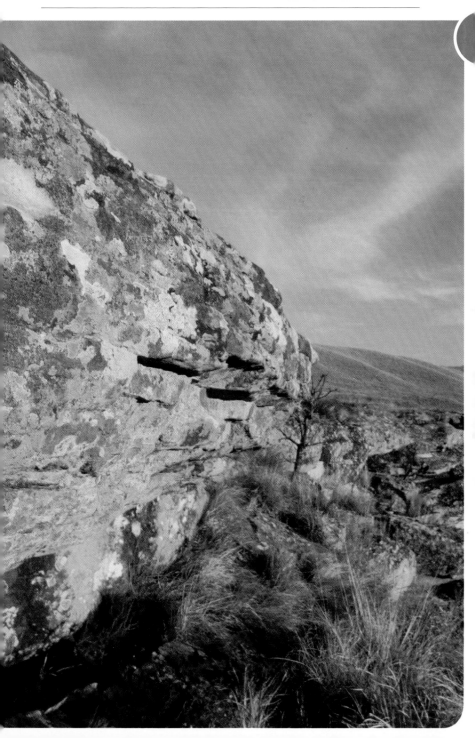

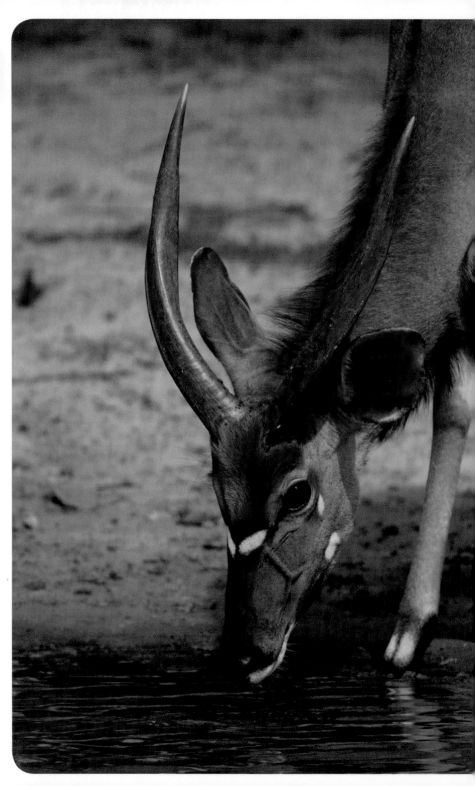

29° 15' 23" S
29° 31' 42" E

# Mkhuze Game Reserve, Near St Lucia

# Background

Situated between the Lebombo mountains and the coast, this 40 000ha reserve, proclaimed in 1912, lies in an area better known for its excellent birding than for its wildlife photography. The clayey soils are very fertile and the lush vegetation results in high densities of animals, such as impala, kudu, wildebeest, nyala, giraffe and zebra. These high animal populations were exploited in the 19th century and the animals were nearly wiped out by hunters greedy for the high prices that game hides fetched. It has varied vegetation types with hill savannah in the Lebombos, acacia savannah on the plains, sand forest on the ancient dune ridges, fever-tree-lined pans, and sycomore fig forests along the Mkuze River. The great variety of habitats in the reserve contributes to the high bird numbers, and a stroll along the "Fig-tree Walk" sees some of the best birding in South Africa, with many of the species found here at the southern-most limit of their distribution. Indeed, the area has recorded 420 bird species, almost half the total number found in southern Africa.

Much of the reserve is dense acacia thickets, which wouldn't seem to provide much in the way of good photography. Yet in among these thickets, lies a gem of a viewing hide, the Kumasinga Bird Hide, which is one of the best hides for wildlife photography in South Africa.

◄ 400mm will give you a head tight portrait from the hide.

101

Within the reserve there are well-established populations of black and white rhino, and elephant, leopard and hyena can also be seen. The Nsumu Pan is a veritable paradise for birds, such as pelicans, ducks, stilts, egrets, storks, herons and African fish-eagles, while hippo and crocodile also abound. Kumasinga offers the best animal viewing from a hide anywhere in southern Africa particularly during the dry season. Many famous "wildlife drinking at the waterhole scenes" have been captured over the years in Mkhuze's hides, especially Kumasinga.

# The reserve

The main camp in the reserve is called Mantuma and is the perfect place to base yourself as the birding in the camp is exceptional, with some "Mkhuze specials" found flitting around the flowering plants in camp. Many campsite birds are habituated and allow you close enough to photograph. Purple-crested turacos are commonly seen in the high canopy, as well as Neergaard's sunbirds. This birdlife will provide lots of photographing opportunities while not out on a game drive.

The road network covers approximately 100km in the reserve. However, there are a few main locations that are highly productive for photography. It is important to note that the optimum animal viewing season in Mkhuze is August to October, during the driest months of the year. This is in direct contrast to the best birding season, which runs from November to March when all the migrant birds are present. During this time, Mkhuze really comes alive with bird song and life. However, many of the iconic species of birds, such as the African fish-eagle, pelicans and turacos, are present through the dry season as well.

## Kumasinga Bird Hide

Only a few kilometres south of Mantuma Camp lies this hide, situated in some dense sand forest. At first glance, the walkway does seem unusual, but as you follow it down towards the hide, you notice that this is not a normal animal viewing hide. The pathway leads for about 70m before you get to the hide door. Opening it, the first thing you see is that the hide is built in the middle of the waterhole. The walkway leads over the water and the hide is a rectangle with open window ports on all sides.

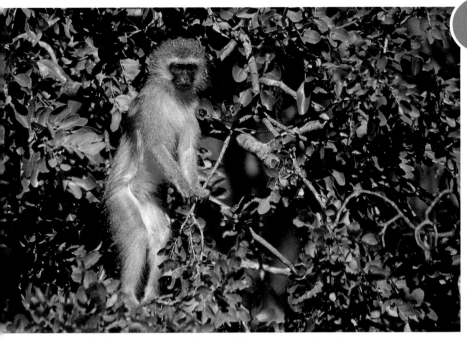

▲ Vervet monkeys are common, if not suspicious, visitors to the hide.

▼ Up close and personal – white rhino are rewarding sightings in Mkhuze.

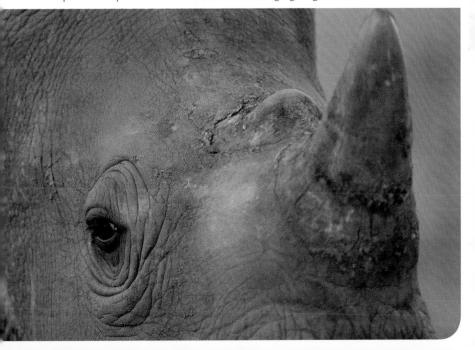

The banks of the waterhole lie between 5 and 10m from the windows. Proximity to animals is very, very close.

During the dry months this waterhole is one of the most popular for mammals. It is west facing and thus best for a morning photo session. Your strategy should be to get in early, set yourself up and wait. The procession of animals coming to and fro is quite remarkable. It is a privilege to be so close to secretive animals, such as nyala, as they stalk so quietly down to the water. You can expect to see zebra, impala, wildebeest, kudu, nyala, white rhino, chacma baboon, vervet monkey and bushbuck coming to drink, while warthogs are regulars too, wallowing in the thick mud.

The hide is most productive mid-morning, just before the sunlight gets too harsh. However, you might want to stay longer just to watch each species of animal take their turn to drink. The action does not stop in the late afternoon either, but at this time the light is against you. However, white rhino enjoy coming to the hide in the late afternoon, especially just before dusk, so staying on in the hide could be worthwhile, especially if you have the chance to see them wallowing.

Sitting in the hide also allows for excellent bird photography. You should see purple-crested turaco, black-collared barbet, crested guineafowl and barn swallows that sometimes perch on the branches right above the water. Gorgeous bush-shrikes and pink-throated twinspots, and if you are lucky, eastern nicators can be found around the car park area.

Keep an eye open for the terrapins in the water below the hide. As the day warms up, they surface and sun themselves on the various stones and stumps in the water.

## Kubhubhe

Situated in similar sand forest vegetation as Kumasinga, Kubhubhe is the smaller sister of the more famous Kumasinga. The position of the hide is more conventional, situated next to a waterhole. I've found the hide to be a bit erratic in terms of productivity. It is definitely less active than Kumasinga, but at times it can get really busy and your angle of view and close proximity to the animals makes for excellent photography.

◄ Often the unexpected greets you while walking to a hide –
this tree monitor lizard eyes me from a hole in a tree.

## Nsumo Pan

In the southern central part of the reserve lies the meandering Nsumo Pan, fed by the Mkhuze River. The drive along the shores of the lake is quite spectacular, with large fever-trees dominating the water's edge. There are a couple of viewing platforms and a small hide, as well as a picnic spot, where you can stop and get out of your vehicle. The viewing platforms don't offer much in terms of photography, as they are quite far from the water. However, if you walk from the picnic spot to the water's edge and set up in a concealed spot, you should find a number of waterbirds such as yellow-billed and woolly-necked storks, African openbill, great egrets, black-winged stilts and glossy ibis flying past within photographic range. This is one of the best places to get good images of pink-backed pelicans flying over water. Flying so close to the water, you have the opportunity for some lovely reflections.

## Fig-tree Walk

You have to book this walk with the KZN Wildlife, who will escort you through this amazing forest. Photographically, it is very difficult to get any good wildlife images here, as you will be walking, but the prospect of being in such a unique and beautiful forest is something you have to experience when at Mkhuze. The birding is also quite spectacular, with unusual species such as southern banded snake-eagle, broad-billed roller in summer, and white-eared barbet, scaly-throated honeyguide, blue-mantled crested-flycatcher and green twinspot. There are also opportunities for some landscape photography in and among the giant fig trees.

# Photography and equipment

Being a self-drive reserve, you will be photographing from your vehicle while you drive around. As photography from the vehicle is not as productive as at the hides and picnic spots, most photographers tend to head to the hides and sit patiently there. Both Kumasinga and Kubhubhe hides cater well for photographers in that the lenses fit nicely through the viewing ports. At Kumasinga, make sure you open all the ports right

The reflections in the water offer some interesting images. ▶

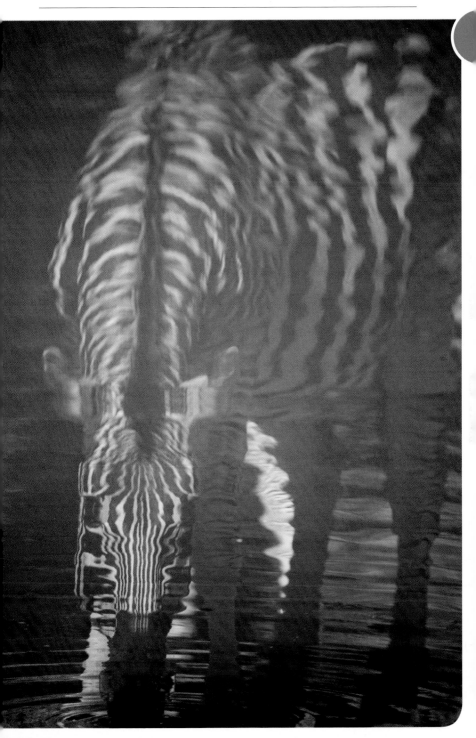

around the hide when you arrive. You don't want to be noisily opening the flaps when a skittish herd of kudu come to drink.

A tripod can be used in the hides to support your long lens. Beanbags are very handy here and fit well onto the window sills, providing excellent support for long lenses. Anything from a 300–500mm lens is more than enough reach here. In some cases you will be too close for a 500mm lens to focus! A 70–200/300 is a good lens for getting full animal and group images. A 300–600mm range will give you some nice tight portraits of the animals when they are right at the water's edge. Either way, if there is good activity at the hide, you will be using all your lenses. It is likely you will spend the whole morning in the hide, especially if there is lots of action. Take some drinks and food along to sustain you as walking out of the hide to fetch food from the vehicle is noisy and will scare animals away. The hide can also get quite cold, so make sure to take some warm clothes along.

For bird photography at Nsumo Pan, it is the territory of the 500–600mm lenses attached to fast-frame rate cameras. Make sure you set up your camera with lots of space to pan sideways. Waterbirds tend to fly quite fast and direct, so you will have to be very quick to catch them in flight as they fly parallel to the shoreline. A sturdy tripod and fluid panning head will make this easier.

# Getting there/accommodation

Coming from Durban, drive north on the N2. About 50km north of Hluhluwe town, a sign indicates Mkhuze town to the right. Follow the road through the town till a T-junction where you turn right. Follow this road, which becomes gravel, for 10km, after which you will see the entrance of the reserve on the left. If you are coming from the north on the N2, the turnoff to Mkhuze town is 60km from Pongola.

Ezemvelo KZN Wildlife manages the reserve's accommodation. You can contact them via www.kznwildlife.com to make a booking in the various types of accommodation. These range from camping, to safari tents and chalets.

## Highlights

- The unique fig-tree walk with excellent birding
- Kumasinga Bird Hide – one of the best animal-viewing hides in the country
- Excellent close-up photography of kudu, nyala, impala, zebra, blue wildebeest, warthog and white rhino
- Dry-season game viewing at the hides is second to none
- Smaller subjects like terrapins, vervet monkeys and chacma baboons
- Good waterbirds in flight at Nsumo Pan
- Best place in South Africa to photograph pink-backed pelicans in flight
- Excellent birdlife with lots of bird photography potential in camps and at picnic sites

# Shem's photography rating out of 10

| Photographic subject | Abundance | Viewing | Photography potential |
|---|---|---|---|
| Landscape | 2 | 3 | 2 |
| Birds | 8 | 7 | 7 |
| Mammals | 7 | 8 | 8 |
| Predators | 1 | 1 | 1 |
| Big 5 | - | - | - |
| Overall experience | 6/10 | | |

# Photographic equipment suggestions

| Photo skill level | Equipment |
|---|---|
| Beginner to intermediate to advanced | • 1 pro-sumer camera bodies<br>• Pro-body if you want to capture action and birds in flight<br>• In hides 70–200/300mm for animal scenes<br>• 300–600mm for extra close-up portraits of mammals<br>• 500–600mm for birds in flight over the pan<br>• Beanbags for hides<br>• Tripod<br>• Fluid tripod head |

# Other information

| Accessibility | Cost value | Popularity |
|---|---|---|
| Easy; sedan vehicle | Affordable | High |

Full-frame images of animals drinking is a highlight of Kumasinga Hide. ▶

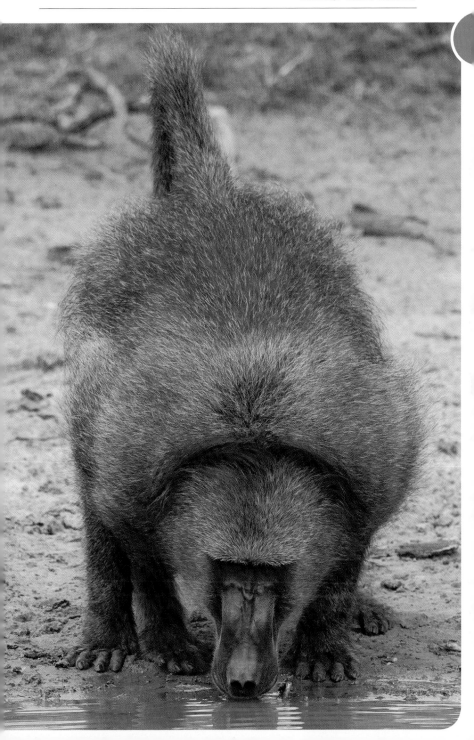

# Limpopo

Kruger National Park

Mapungubwe National Park

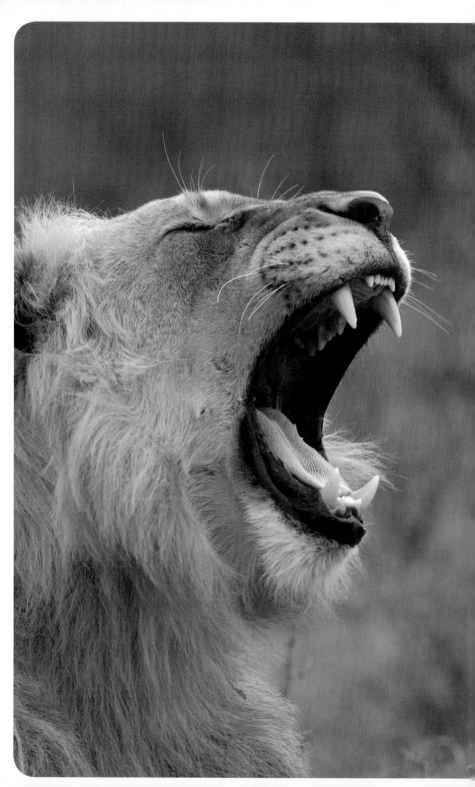

Phalaborwa Gate:
23° 56' 43.63" S
31° 9' 54.15" E

# Kruger
# National Park,
# Limpopo
# (and Mpumalanga)

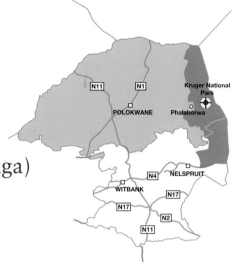

# Background

If ever there was a jewel in the crown of the national parks in South Africa, then Kruger is that sparkling gem. With over 2 million hectares of conserved land, it offers the nature lover and photographer unrivalled access to such a diversity of habitats and photographic opportunities that some photographers spend most of their lives just getting to know this vast reserve. Affectionately named "The Park" or just "Kruger", this national park forms a large part of South Africa's cultural heritage – with a holiday in the park part of most family's plans on at least one occasion. It is understandable that the Park is such a firm favourite with locals, for it offers some excellent, as well as diverse, wildlife viewing, which means some very, very good wildlife photography. The sheer diversity of subjects, as well as the high incidence of large predators, are sure to keep the cameras constantly clicking away.

The Park is named after a former president, Paul Kruger, who was involved in proclaiming the initial Sabi Game Reserve in 1898. Initially a "Government wildlife park", the reserve was first set up to protect the severely diminished wildlife numbers that had been decimated by years of hunting. The initial size was only one third of the current park, but in 1926, it was linked up with other parks in the north and west to become the official Kruger National Park. Interestingly, the first tourists to visit

◀ Lion are common throughout the Park and are seen fairly regularly.

115

the Park came in by train, where they would alight and go on a walk into the bush with armed guards. As this became more popular, calls were made for tourists to have greater access to the Park. The first self-drive tourist vehicles entered the Park in 1927. Today, one of Kruger's main attractions is its ease and accessibility to the everyday tourist in a sedan vehicle. There are few other parks of this scale in Africa that cater so well for the public, and this is one of the main reasons for its high popularity and why it remains a favourite with locals and visitors from around the world.

Kruger is known for its large and healthy lion prides, its exceptionally large bull elephants whose natures are extremely calm, and the very relaxed wildlife in general. While some people complain about being restricted to driving on the roads, it has been documented that the road network follows some of the most productive areas in the reserve, resulting in excellent game viewing. With over 60 years of becoming familiar with vehicles, the animals are very relaxed which results in brilliant photo opportunities of even the most common species.

# The park

The multitude of animals living in the Park would seem to indicate some great wildlife viewing. However, the sheer magnitude of the park means it can be quite intimidating and daunting to the visitor. The reserve crosses many vegetation and ecotypes, many of which are locally seasonal, and this produces better wildlife sightings at certain times of the year. If you move to the correct areas at the right times, your experience will be greatly enhanced with better wildlife viewing and better photographs.

This section on Kruger is divided into the following headings:

- Vegetation and geology
- Where and how to look for specific large mammals and predators
- General wildlife photography: south, central and north
- Photography in restcamps
- Bird photography

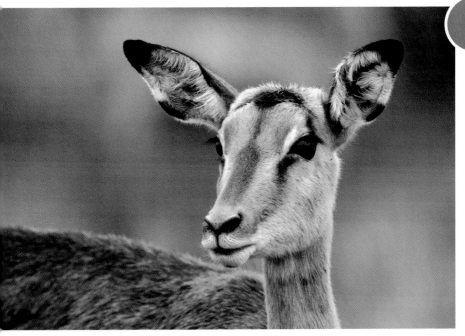

▲ Kruger has some of the most relaxed impala on earth.

▼ A leopard sharpens its claws on a tree near Berg-en-Dal Camp – a good place for leopard viewing.

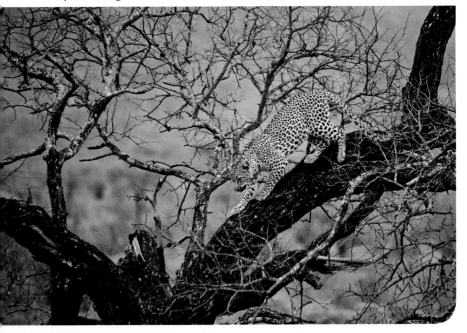

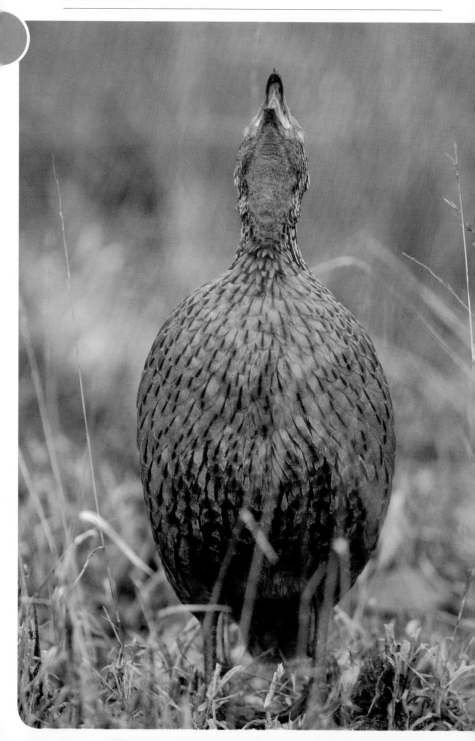

## Vegetation and geology

While this is not the usual introduction to a photographic guide, it is important to recognise that basic geography and vegetation of the Park determine why certain animals are in specific places. At 380km in length and averaging 60km in width, the Park forms a long finger that runs in a north-south direction. The main road (H1-2/3/4) that runs from north to south through the centre of the Park divides it into two distinct geological areas. West of the H1 road are the granite-based soils, while to the east lie the basalt plains. This may not mean much to the casual visitor, but it has an influence on the wildlife. Both hold an assortment of animals, but the eastern side generally comprises undulating broad-leafed woodland with shallow drainage lines, and the east is made up of stunted thornveld and open plains. These differences affect wildlife distribution. Lion and leopard are common across both areas but leopard favour the drainage lines in the east, and cheetah prefer the eastern open plains. Side-striped jackal favour the western granite section, black-backed jackal are generally found in the east, with white rhino mostly enjoying the eastern plains.

From Olifants Camp northwards, one finds large swathes of mopane trees. These cover almost the entire width of the Park up to the northern boundary. This is elephant country and in among the mopane you will find numerous herds as well as large bull elephants that roam widely.

In the south, the terrain around Pretoriuskop and Berg-en-Dal is much hillier, with rocky outcrops dotting the landscape. These are general guidelines which will help you plan your search for animals. If you are searching for cheetah, you should keep on the eastern side of the Park looking on the open plains. However, nothing is absolute in the wild. The maxim that the animals failed to read the guidebook often seems very true when looking for a particular species.

As most geology and vegetation generally runs in a north-south direction, the roads that traverse an east-west direction cover the most changes in vegetation types. This increases your chances of seeing a greater diversity of animals and birds, a consideration when planning your drives.

◀ A Swainson's spurfowl ignores my presence as it goes about its morning calls.

## Where and how to look for large mammals and predators

Each restcamp has a sightings board which lists the current and previous day's sightings. Check this for updates and movements of animals as it is a very valuable tool in gleaning information about animal and predator movements. Chatting to fellow visitors is a part of Park culture and a friendly hello can result in a surprising amount of information and knowledge.

*Lion (last census: 1 500)*

The lion population is very healthy and if you search you are likely to encounter them in any part of the Park. They are generally more frequently seen in the southern-central regions and along riverine vegetation in the northern mopane woodland. During the dry season, they are inclined to frequent waterholes as a means of catching prey. Indeed, lion home ranges tend to centre around waterholes, so scour these areas thoroughly. The best lion areas are on the basalt plains – the S100 east of Satara is legendary for its lion sightings. The whole area around Satara is good for lion, as is Lower Sabie and Crocodile Bridge. The H4-2 north of Crocodile Bridge is also renowned for lion sightings.

Most of the lions are very relaxed and thus offer excellent photo opportunities, more especially if you find them doing something. In the north, lions tend to move along the large meandering rivers that cut through the mopane thickets. Early morning drives along these rivers – Letaba, Shingwedzi, Mphongolo – offer your best chance of seeing them in this part of the Park. Near Skukuza, the Maroela Loop is a very productive road for lions.

*Leopard (last census: 1 000)*

The most elusive and nocturnal of the large predatory cats, leopard are notoriously difficult to find, never mind photograph. Luckily parts of Kruger have some of the highest leopard densities in Africa, making your chance of seeing them much higher than in other parts. A study conducted in the 1970s showed that leopard density could occur in a ratio of one adult leopard per 6 sq km along the Sabie River, or at least one leopard in a radius of 1.3 km from Skukuza itself. Of course, leopards prefer dense, riparian vegetation, so planning your routes through these areas will increase your chances of seeing them. In viewing data taken over 8

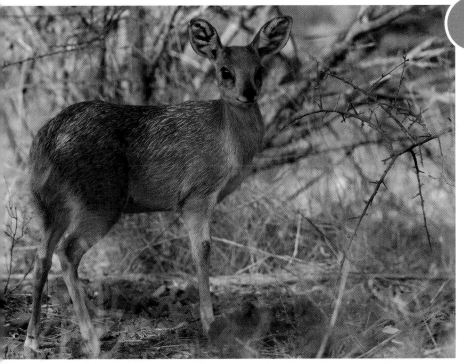

▲ Mahonie loop, around Punda Maria is excellent for Sharp's greysbuck where you will have to drive slowly to photograph them.

▼ Marabou storks roost at Sunset Dam, just outside Lower Sabie Camp.

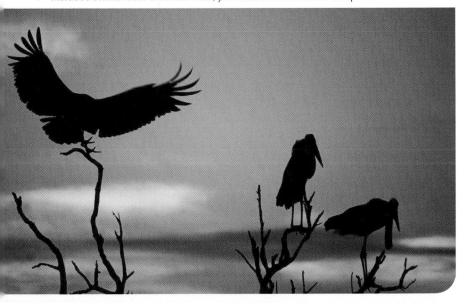

years, 55% of leopard sightings were in riparian vegetation and along large and non-perennial rivers. There is a notable increase in diurnal leopard activity in the dry months compared with those in the rainy season. During November to April, the best time to see active leopards was recorded as early morning. This changed significantly to late afternoon in the cooler months of May to August. It is also significant that leopards don't spend as much time in trees as we think. In the same viewing data, leopards were seen in trees only 8% of the time. If you are looking in trees, don't bother to look in the sycomore fig. Even though their branches are beautifully large and open, leopards don't like the white powdery residue and tend to avoid them. Instead scan the jackal-berries, marula, leadwood, apple-leaf and weeping boer-bean trees.

There are some particularly good roads for viewing leopard. The Lower Sabie Road (H4-1) is possibly the best public road to view leopard in Africa. Due to the high volume of visitors and the perfect habitat, sightings are frequent along this stretch of road from Skukuza down to Lower Sabie. The H1-2 link road and the Maroela Loop are good leopard territory too. When driving in the south-central regions between Pretoriuskop, Berg-en-Dal and Malelane, scan the rocky outcrops as these cats love to rest on exposed rocky areas, especially in cool winter mornings and afternoons. The S139 is an excellent road too, but only those staying at Biyamiti Camp have access to it. Further north, try the S125 and S126 along the N'waswitsontsa and the Sweni rivers. Any further north, good leopard territory becomes scarcer. The road from Letaba to Engelhard Dam is a favourite to find leopard, and the Mahonie Loop around Punda Maria is also good habitat for them.

*Buffalo (last census: 36 000)*

There is an excellent population of buffalo in the Park and this is one of the few places where you can find herds of over 400 animals grazing away – a classic scene of old Africa. The large old bulls or "dagga boys" that live on their own can be found anywhere with some water and dense cover. The breeding herds tend to enjoy the central grassland plains near Satara and north of Lower Sabie. Buffalo need good grass cover, so

◄ Pearl-spotted owlets are common in restcamps and, if approached carefully, are easily photographed.

expect them where grazing is good. Large herds tend to congregate up north among the mopane trees. This can make them difficult to spot, but it is quite a sight when they come down to the rivers to drink. In the wet season, you can expect to find them grazing in the lusher drainage lines where the sweeter grass grows.

*Elephant (last census: 12 900)*

With that huge number of elephants roaming the Park, you are almost certain to spot them. They can occur anywhere, so it is helpful to check the sightings boards. In the northern regions, they enjoy feeding along the river courses. Here you can also spot some of the large "tuskers", elephant bulls with enormous tusks. This is one of the last remaining strongholds for large tuskers in Africa and seeing one is quite a privilege, especially if you get a good photograph. These bulls roam across very wide territories so it's difficult to predict their movements. Spending a mid-morning break at a waterhole is a good idea as elephant usually come to drink between the hours of 9:30–12:00. Watching them drink and play in the water is a special experience.

*White rhino (last census: 9 000)*

You are most likely to find these animals in the south of the Park. Berg-en-Dal, Malelane and Pretoriuskop region are very good areas to search for them. Also the areas north of Lower Sabie are excellent – the H10, S29 and S128 and loop roads in particular are good.

*Black rhino (last census: 300)*

They are very difficult to see, never mind photograph. They tend to spend most of their time in the eastern thickets against the Lebombo mountains. The Gomondwane Road (H4-2) and S28 are good for sightings of them. The Tinga concession north of Skukuza has regular sightings of black rhino but you will have to stay in their lodge to have access to the area.

*Wild dog (last census: 350)*

With such a small population, they are rarely seen. However, they sometimes move to a particular area and tend to spend some time there. If you do find them, they usually completely ignore you and can often come right up close, enabling some great photos. Watch the sightings boards for reports on them. If they have been spotted close to your area,

▲ Kruger is full of surprises, with this genet found posing right next to a restcamp.

▼ Two young elephant crossing a riverbed in northern Kruger, where there are large herds.

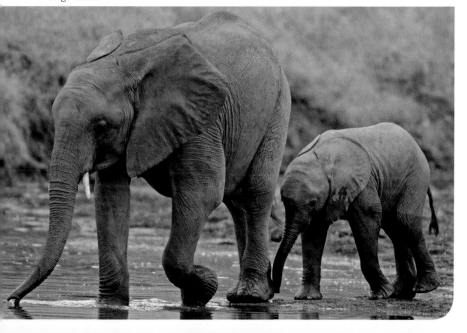

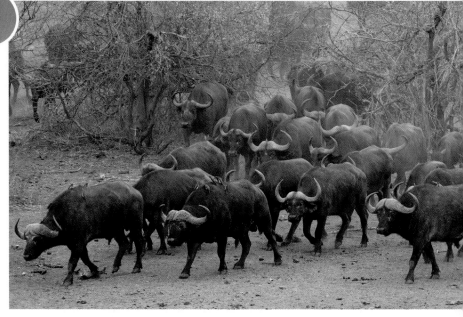

▲ Nsemani Dam is excellent for buffalo and elephant, the high-viewing angle showing the herds well.

▼ Relaxed animals mean relaxed birds. In this case a red-billed oxpecker, taken with a 600mm lens.

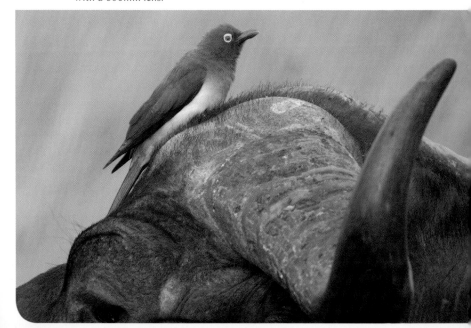

it is worthwhile having a look for them. The S1, which leads onto the H11, is an excellent road for wild dog, and further south the S114 is very good.

*Cheetah (last census: 200)*

The numbers have dropped over the past years but they are still seen more frequently than wild dogs. They are also very relaxed and provide great photo opportunities. Orpen Road (H7) is the best area for seeing them, as well as the roads south of Lower Sabie towards Crocodile Bridge (S28 and S137). The areas north of Lower Sabie on the H10 and associated loops are good cheetah country too.

*General wildlife viewing*

The basalt plains on the east provide lovely vistas of "African plains" with herds of buffalo, wildebeest and zebra. On the western side, where granites are found, one can find some of the more unusual species such as sable. A good road is S36 towards Manzimhlope Dam. Towards the north, roan antelope are more commonly seen, especially just south of Babalala.

# General wildlife photography: south, central and north

## The southern region – south of Tshokwane

Being closest to the main urban centres, this is the most easily accessible part of the Park and thus the most popular. The high density of animals and great game viewing make this a favoured area for visitors. Pretoriuskop region allows you the opportunity to photograph side-striped jackal, the rarer cousin of the black-backed jackal. White rhino also are commonly seen near Pretoriuskop as are giraffe and tsessebe, and if you're lucky, sable. The hilly and rocky areas around Berg-en-Dal have less density of animals but the scenery is quite beautiful. Keep an eye open for leopards walking on the granite domes in the late afternoon and early morning. This is excellent leopard country, especially on the S110 Matjulu Loop, which is also good for spotting white rhino. An afternoon at the Matjulu Waterhole should give you an opportunity to see them drinking, and if you are lucky, also wallowing.

If you are staying at Biyamiti Camp, this road, only accessible to residents of the camp, is one of the best for leopard in the south. Towards Crocodile Bridge you can expect to see large buffalo herds, especially along the Crocodile River on the S25. If you stop off at Crocodile Bridge Camp, take a drive onto the low water bridge. Waterbirds such as African jacanas, black crakes and yellow-billed storks all feed in the shallows very close to the bridge, giving you excellent opportunities for photos. The S28 leading north from Crocodile Bridge to Lower Sabie is excellent for cheetah, especially on the northern part of the road.

The Lower Sabie Road to Skukuza (H4-1) is one of the roads around which myths and stories have grown in the Park. Starting at Lower Sabie Camp, it follows the Sabie River to the confluence of the Sand River and then onwards to Skukuza. You can easily have good sightings of lion, leopard, buffalo and elephant, along with a great many other animals all in one morning along this road. Watch out for the baboons as they are likely to cause a traffic jam by lazing on the road. This is where you will find the most relaxed impala in the Park. Sit quietly next to them and you could get a photo of a red-billed oxpecker as well. These charming birds are quite skittish, so patience and stealth are necessary to get close enough to get a good image.

The low-water bridge north of Skukuza is very productive for hamerkops, and yellow-billed and marabou storks in the river. You will find it difficult to stay on the bridge for long though, as there is a large amount of traffic all wanting a turn to stop. The low-water bridge just north of Lower Sabie is also very good for waterbirds. If the water is flowing over the causeway, there could be crocodiles waiting for fish coming over the edge right next to the bridge.

The high-water bridge at the confluence of the Sand and Sabie rivers provides a beautiful scene of African riparian bush. It's a stunning view in both afternoon and morning light and well worth the drive. Hippos should be visible lazing in the warm sand. Check carefully in among the rocks for lions. They often frequent the warm rocks of the dry sections of the river.

As the Lower Sabie Road moves south-east it crosses the Lubyelubye River. On the rocky outcrops klipspringer are frequently seen and are

easily photographed as they are found at eye level. The H1-2 bridge north onto Maroela Loop and back via the H1-2 is very productive for wildlife viewing and makes a good morning's drive. The areas directly north of Lower Sabie Camp are good for general wildlife as well as white rhino. Sunset Dam, just outside Lower Sabie, is excellent for general wildlife and waterbirds. As it's close to the camp, there is a lot of traffic passing by.

## The central region – Tshokwane to Olifants

North of Tshokwane, the S125 turns off to the left. This road follows the very scenic N'waswitsontso River to the S36. Along here keep an eye out for leopard as they frequent the river's edge. Further north on the H7, look out for cheetah in the open areas on both sides of the road. This is one of the best places to see them in the Park. The Sweni Road S126 is also very productive for both leopard and lion. However, it is the S100 near Satara that is the real highlight of the area. This road follows the N'wanetsi River east and is another fabled "Kruger drive", with great sightings of lion prides, leopard, elephant and buffalo along it. Keep an eye out for ground hornbills walking next to the vehicle. Their unique looks make for excellent photographs, but you will have to be fast, as they don't stand still for long. Further east is the Sweni Hide, just south of the N'wanetsi Picnic Spot. There are a lot of hippos here that come close to the hide and it's one of the best places in the Park to get photos of them. General wildlife viewing is very good here too and you should be able to get images of kudu and impala, as well as giraffe browsing on the knob-thorns, their favourite nourishment. There are some very good waterholes close to the road on the H7 that allow for close-up photography. Nsemani Waterhole is popular with both buffalo and elephant and the proximity makes it an excellent photographic stake out. The S39 follows the Timbavati River and is very good for lion and buffalo. Girivana Waterhole is always very active, attracting giraffe and predators. You are very close to the water and can view the waterhole from 270°, which makes it ideal to position yourself for photography.

Towards Olifants Camp, the high bridge over the Olifants River offers some spectacular views. There are often elephant and other animals grazing in the vegetation below. It is well worth a stop here to photograph a variety of species. Keep an eye open for yellow-billed kites swooping past the bridge in search of scraps of food. They are masters of flight but

also can provide hours of fun as you try to catch a photo of them in full flight. The low-water bridge below Olifants Camp is another highlight. Waders and storks patrol the waterways and kingfishers are found in the reeds. You can see pied kingfishers hovering next to the bridge, often coming close enough for a full-frame action photo. The S91 below Olifants is very productive for general wildlife. Look for klipspringers on the rocky side of the road. They perch prominently on the tops of rocks, providing a chance for some great compositions in your photographs.

## The northern region – Olifants to Pafuri

Mopane bushveld becomes a prominent feature in the northern parts of the Park. Although this can at times become monotonous, it is interspersed with some beautiful areas, most notably the rivers Letaba and Shingwedzi. Along these river courses, wildlife concentrates in greater numbers than in the mopane. The roads around Letaba along the river courses are all very good for general wildlife viewing, as well as lion. The road that follows the Letaba River south to Olifants is a beautiful drive with lovely scenery. Tsendze Loop (S48) is another road that is great for lion spotting. Keep an eye out for elephant as large bulls roam these areas. It is a similar scenario further north at Shingwedzi, with most of the animals proliferating along the river courses. Just north of camp, the S135 crosses the Shingwedzi River. If the water is flowing, it will attract many storks, herons and hamerkops that feed right in the road. Excellent for photography! The S56 along the Mphongolo River is also very good for general wildlife and is one of the most scenic roads in the Park with large jackal-berries, apple-leaf and fig trees along the riverbanks.

Further north at Punda Maria, the Mahonie Loop is the most productive drive. It crosses a few different habitats and offers great diversity. It is excellent for unusual species, such as Sharpe's grysbok and nyala. From there it is a long drive to Pafuri through the mopane. Situated right at the northern tip of Kruger, Pafuri offers some of the most beautiful riverine landscape in the whole Park. Large fever-trees and sycamore figs line the beautiful Luvuvhu and Limpopo rivers. Lots of elephants and buffalo are found in the area and baobabs dot the horizon. Photographically, the scenes along the river are stunning and encourage landscape photography. This is also the place for photographing nyala – they are the most commonly found animals along the river's edge.

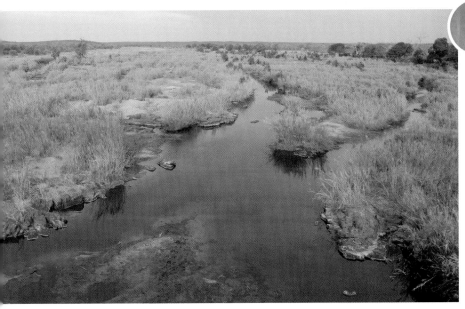

▲ The view of the Olifants River from the high-water bridge at sunset is perfect for landscape photos.

▼ A testament to relaxed animals in Kruger is this full-frame portrait of a young male waterbuck.

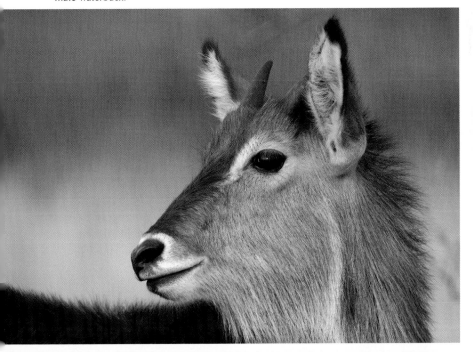

# Photography in restcamps

Most of the restcamps in Kruger are large and spread out with extensive indigenous gardens. The flowering plants attract many birds and this provides great photo opportunities. During June to July, the aloes flower, attracting many birds as well as monkeys. You can set up your camera next to a stand of flowers and get full-frame images of collared, amethyst and scarlet-chested sunbirds, various starlings and dark-capped bulbuls. Vervet monkeys also enjoy feeding on the aloe flowers, and this is one time you will be able to get close enough to them for a photo. Besides the attraction of the flowering plants, the camps have a host of colourful birds that are relaxed enough to photograph. Black-headed orioles, black-collared barbets and green wood-hoopoes are common in the camps, as are brown-hooded kingfishers, golden-tailed woodpeckers, Natal spurfowl and grey-headed bush-shrikes. With some determination, patience and stalking, you should be able to get images of a large number of these birds. Fruiting sycomore figs are a magnet for barbets and other fruit-eating birds and a perfect place to stake out.

A number of camps, such as Letaba, Shingwedzi, Lower Sabie, Crocodile Bridge and Skukuza, are based on the banks of large rivers and command beautiful scenes over the rivers. Often there are elephants drinking and playing in the waters of the rivers below the camps. At Satara, the African scops-owl is resident. It is often seen in the daytime and with a quiet approach you can get some great photographs. Pearl-spotted owlets also favour certain perches and are common in many of the camps. If they are active in the day, other birds mob them, giving their presence away and making finding them much easier. The tree cover in the restcamps is perfect for smaller raptors to hawk birds from. African goshawk, lizard buzzard and little sparrowhawk are commonly seen hunting in the day. If you watch carefully, you can see where they perch and can approach for a photograph.

Olifants camp, higher than the surrounding areas, attracts very different species of birds. Red-winged starlings, crested barbets, white-bellied sunbirds and yellow-billed kites are all very easily photographed in this camp. The view over the river is not too bad either! Olifants and Satara seem to have the most habituated birds of all the restcamps, and you should be able to get good images of a number of species very easily.

In the evenings watch out for the smaller creatures. Genets visit the camps looking for scraps of food, and thick-tailed galago (or thick-tailed bushbaby) can be seen sleeping in the trees in Skukuza, when they are easier to photograph than at night when they are active. Tree agamas are common at Skukuza and Lower Sabie. The males have beautiful blue heads that make them very attractive, but they tend to move to the opposite side of a tree from you, ask a friend to help you flush them around!

Letaba has a number of bushbuck that allow you to come really close. Other camps such as Berg-en-Dal and Skukuza have bushbuck that come near the camp allowing for photographs. Chacma baboons aren't allowed into the camps, as they cause problems. However, they are often found nearby. When spotted on the roads around camp, they provide excellent subjects for a variety of photos. Their cute babies and the never-ending activity of the youngsters is an excellent excuse to sit and photograph their antics.

If you are staying a while in the Park, it is well worth spending at least a morning photographing in the camp. The results can be very rewarding.

# Bird photography

Kruger is a veritable birders' paradise; especially in the hot rainy season from October to April, when the migrant and breeding birds are around. The camps come alive with birdcalls and their overall number increases dramatically. You can feel the activity levels increase with all the courting, breeding and nesting taking place. Driving along the roads in the Park provides some great opportunities for images of lilac-breasted roller, purple roller, magpie shrike, southern yellow-billed hornbill, greater blue-eared starling, Cape glossy starling and grey go-away-birds. Stopping at one of the dedicated picnic sites, you can expect to see the starlings and hornbills at very close quarters as they try to steal some food.

The Park is well known for its large population of birds of prey, whose numbers increase in the rainy season with the arrival of the migrants. Images of African fish-eagle, tawny eagle, and black-chested and brown snake-eagles are all possible, and with luck you could also photograph

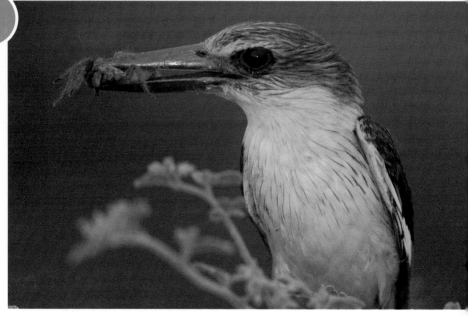

▲ A gravel road away from the traffic was quiet enough for this brown-hooded kingfisher to perch right next to me.

▼ Restcamp bird photography is very productive, with many species easily approached, in this case an olive thrush.

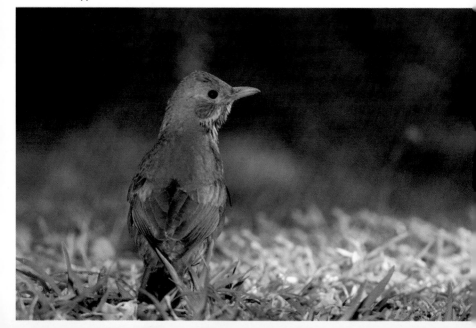

the magnificent martial eagle. During the rainy season the arrival of migrant raptors adds Whalberg's, steppe and lesser spotted eagles to the list of raptors. There are many vultures in the Park and if you find yourself close to a kill, you should see and photograph white-backed, lappet-faced and hooded vultures. If photographing birds of prey is your particular interest, it is best to head out in the mornings. The prevailing winds are from the east and as the birds alight, they take off into the wind, and more importantly, into the sunshine, lighting them beautifully from the front. In the afternoon, with the sun in the west, the birds will continue to take off into the east but now the sun is behind them – not ideal for great images.

If you are a serious bird photographer, then a stay at Letaba and Shingwedzi is a must. The diversity of birds around the camps is higher here than in the south, especially during the rainy season.

One of the highlights in the Park is waterbird photography. It is possible to get really close to a wide variety of waterbirds along the many streams, waterholes and low-water bridges that cross the rivers. Most of them are commonly found and you should be able to get really good images of yellow-billed stork, African openbill, black-winged stilt, African jacana, three-banded plover, hamerkop, various herons and lapwings. Patience is the key to great photographic results and sitting quietly on one of the many causeways will yield some wonderful images of these birds.

Lake Panic Bird Hide near Skukuza is a wonderful spot to visit. Sit patiently and soon you'll find pied and malachite kingfishers perching next to you. A white-breasted cormorant is resident and grey and goliath herons are common visitors. A green-backed heron also stalks around the edges of the lake, providing some good photographic opportunities. Other varieties of birds come and go and you could see as many as six different species of birds in one morning's photography. The afternoons are the best for photographs, as you have the sunlight behind you. However, if it is misty in the mornings, the sun shining through the mist creates a surrealistic lighting effect over the water, which adds to the photographic experience.

# Photography and equipment

In terms of equipment, the best advice for a visit to Kruger is: bring everything! The variety of subjects to photograph within the Park is amazingly diverse and you will find a use for every piece of equipment you may have. Whether is it a landscape image of a wide, meandering river flowing off into the sunset, a lion portrait five metres from you or a white-browed robin-chat in the restcamp gardens, you will have the opportunity to use all your lenses while in the Park.

Kruger is very popular and visitors often complain about the high volume of traffic. There are lots of visitors, but I find that even in a full camp if you leave at dawn for your drive, you will be one of only a handful that are out during the wonderful golden hours of the morning. Many visitors are on holiday and prefer to sleep in, leaving the roads with little traffic and providing an advantage for the photographer.

Another tip is to take the gravel roads. As many people don't like getting their vehicles dusty, you'll find fewer cars on these roads and even fewer on the smaller back roads where you'll have less vehicle disturbance at sightings, allowing you to sit patiently waiting for your special moment. I've parked near a brown-hooded kingfisher nest-hole on a causeway on the S140 for a whole afternoon without seeing one vehicle, providing a wonderful opportunity to view and photograph some excellent bird behaviour.

When out on game drives, you will be photographing from your vehicle. This means you will have to use a beanbag or a window mount to support your camera. Choose one method and perfect it, as that is the best way to make your system work for you. The less you fiddle with your set up, the more time you will have to get your photographs. A tripod is a must for working around the restcamps, as is a good tripod head for your long lenses. You will need at least a 500mm for your bird photography. A strong torch for finding and lighting up owls at night is advisable if you want to photograph them.

# Getting there/accommodation

There are nine official entrance gates to the Park. Kruger lies on the north-eastern boundary of South Africa in the provinces of Mpumalanga and Limpopo. It is easily accessible by sedan vehicle from many different urban centres. It is 4–5 hours from Johannesburg, 30 minutes from Nelspruit and 3 hours from Polokwane. Air connections to the Park are through Kruger Mpumalanga International Airport.

The restcamps cater for a variety of accommodation types, from campsites through to beautiful guesthouses. Private lodges operate on various private concessions within the Park. All the information on the bookings, accommodation and reservations can be found at www.sanparks.org

## Highlights

- One of the largest conservation areas in Africa
- Excellent for Big 5 sightings
- Scenically beautiful rivers and riverine areas
- The best public roads in Africa on which to see leopard
- Very easy access
- Close-up encounters with most animal species due to their relaxed nature
- Very large elephant bulls – "tuskers"
- Brilliant bird photography, especially in the restcamps
- Many hides and viewing sites to sit at patiently
- Large road network that gives you many options

# Shem's photography rating out of 10

| Photographic subject | Abundance | Viewing | Photography potential |
|---|---|---|---|
| Landscape | 5 | 5 | 5 |
| Birds | 7 | 8 | 8 |
| Mammals | 8 | 8 | 8 |
| Predators | 7 | 7 | 7 |
| Big 5 | 8 | 7 | 6 |
| Overall experience | 8/10 | | |

## Photographic equipment suggestions

| Photo skill level | Equipment |
|---|---|
| Beginner to intermediate to advanced | • 1 pro-sumer camera body<br>• 1 pro-body if you want to capture action and birds in flight<br>• 400mm lens for most wildlife<br>• 500–600mm for bird photography<br>• Medium lens for close-up work on mammals that come closer: 70–200mm<br>• Wide-angle lens 17–35mm for landscapes over the rivers |

## Other information

| Accessibility | Cost value | Popularity |
|---|---|---|
| Easy; sedan vehicle | Cheap to affordable to high | Very high |

Last light glances across a lilac-breasted roller, one of the most beautiful birds in Kruger. ▶

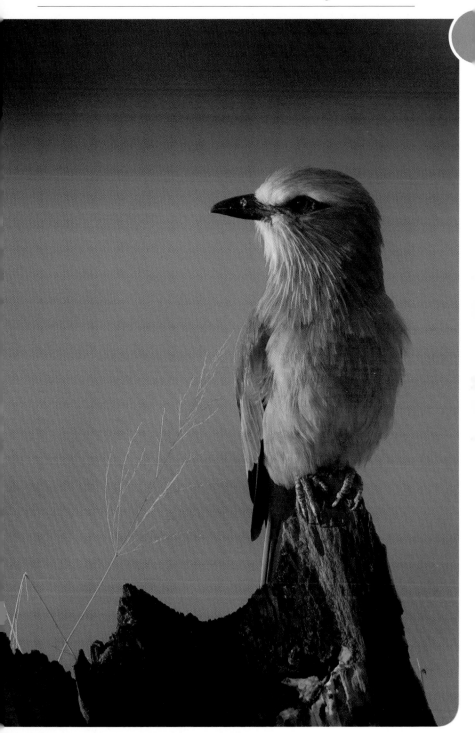

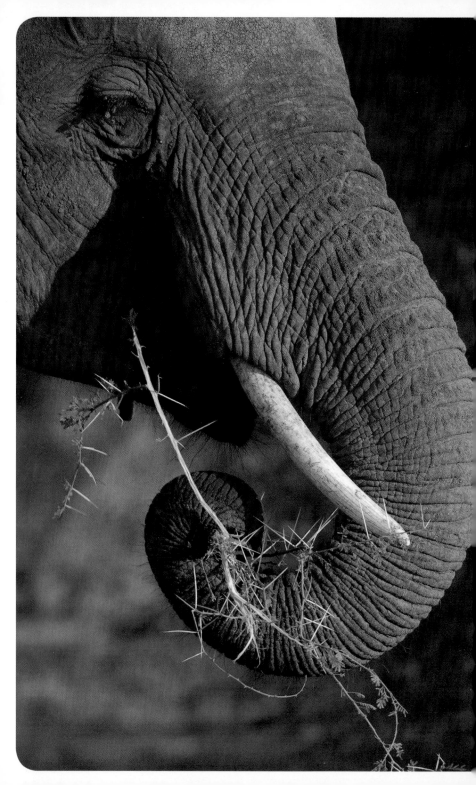

22° 14' 36.0" S
29° 24' 1.5" E

# Mapungubwe National Park, (border of South Africa, Botswana and Zimbabwe)

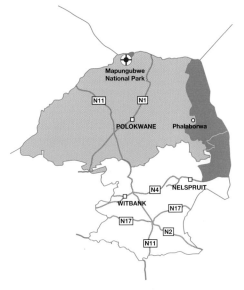

## Background

Although Mapungubwe was only declared a national park in 2004, with visitor facilities opening soon afterwards, it is fast making a name for itself as a great wildlife and nature photography destination. Situated five easy hours drive from Johannesburg, Mapungubwe offers excellent wildlife, culture and landscapes to photograph.

Situated at the southern confluence of the Shashe and Limpopo rivers, there is a lot more to Mapungubwe than just wildlife and nature. The archaeological remains of a large and organised society that once lived here in the 13th Century are found throughout the area, particularly around Mapungubwe Hill and K2. The hills and living areas where this society made its home are strewn with artefacts and bones, the most famous one being the golden rhino that was discovered here in 1932.

The significance of the site is indicated by the history of the artefacts found here. They indicate that the Mapungubwe people were a cattle and crop society that traded extensively with other countries as far away as India, Egypt and China. No one knows why the society disbanded and there is no record of what happened. Mapungubwe was declared a World Heritage Site in 2003 because of the archaeological value of the site.

◀ Elephants love the acacia thickets in the west section –
and are easily approached.

The history of the park is intriguing. The natural and historical significance of the park was recognised in 1922. In 1944, it was established as the Dongola Wildlife Sanctuary. The National Party of the time objected to this as they were reluctant to protect the cultural heritage at the expense of agricultural land. After they won the elections in 1949, the land was returned to farmland. Things changed again after the 1994 elections and the area was formally protected in 1998 as the Vhembe/Dongola National Park. It changed its name to Mapungubwe National Park in 2004.

In terms of wildlife, you can expect to see a variety of animals. Elephant and leopard are becoming more numerous. Animal viewing is best along the Limpopo River where you can see bushbuck, impala, nyala, warthog, giraffe and waterbuck. On the higher-lying areas, expect to find eland and klipspringer.

This recently proclaimed park is proving very popular with visitors and offers a variety of activities in very beautiful surrounds. Once all the farms are removed from the reserve, it will be one of the highlights of SANParks. Even as it stands now, it already has a great deal to offer the nature lover and photographer.

# The park

The farmlands, which are still in the process of being reclaimed, split the reserve into two sections with the farming section in the centre. This can be a bit awkward from a wilderness concept perspective, but both the east and west sections have a lot to offer.

## The east section

The main entrance to the reserve lies in the eastern section and this is also where Mapungubwe Hill and K2 are situated. As you drive into the park, you are greeted by a series of undulating sandstone hills and buttresses, and it does not take long to spot Mapungubwe Hill, whose breadloaf shape is quite unmistakable. The scenery is stunning: large baobabs; steep-sided hills with fierce valleys; and colourful sandstone rock formations offer all manner of photography possibilities. It is worth scouting for landscape compositions to photograph in the

▲ Maloutswa Hide is one of the best places to photograph bush pig in South Africa.

▼ Mapungubwe is situated on the banks of the beautifully tree-lined "great grey-green greasy Limpopo".

'AT LAST HE CAME TO THE BANKS OF THE GREAT GREY - GREEN GREASY LIMPOPO RIVER, ALL SET ABOUT WITH FEVER TREES'

(RUDYARD KIPLING: THE ELEPHANTS CHILD: JUST SO STORIES: 1902)

▲  The landscape of sandstone offers excellent photo opportunities.

▼  Baobab trees are characteristic of the area, as are beautiful sunsets.

good light hours. These are sandstone formations and the late afternoon light really makes the rock glow. It is the perfect situation for the landscape photographer.

The road eventually leads down towards the confluence viewpoint. The views from the various platforms are spectacular. You look out over the Shashe River as it flows into the Limpopo, both rivers fringed by tall and dense riverine trees. Botswana is on your left and Zimbabwe on the right with the Shashe River creating the boundary. This is also an excellent place to reconnoitre for an early morning or late afternoon landscape shoot. All the elements are in place for some excellent landscape images, especially if there is water flowing in the rivers.

A 10-metre high raised tree canopy walk leads you through some beautiful fever-trees to a viewing hide, which overlooks the Limpopo. The main highlight on this walk is strolling through the canopy at such a height. It is not ideal for photography but does offer a host of opportunities for new ways of seeing and photographing the fever trees.

The rest of the roads in the park lead through some very scenic areas, providing lots of potential for landscape images. The road leading past Schroda Dam is known for good leopard sightings. You may not find them close to the vehicle, but it does offer you the chance to see them in their natural environment. Look out for them on the rocky sections.

There are daily organised guided tours up to Mapungubwe Hill. This will not be a photographic opportunity, but you will get fascinating glimpses of the archaeological highlights.

## The west section

Much of this section comprises farmlands that used to be commercially active, and evidence of this activity still remains in some parts of the reserve. Don't let this distract you from the very good animal viewing that this section has to offer. This part of the park, filled with acacia and marula trees, has become a favourite for elephants. Small breeding herds are seen all year round feeding in the acacia thickets. There is a beautiful drive along the Limpopo River through a stand of ana trees. If you visit in the early morning or late afternoon, the shafts of light shining through the trees onto groups of animals grazing below is one of those classic wildlife scenes.

A real high point of wildlife viewing in the park is Maloutswa Hide, situated in amongst a grove of acacia trees overlooking a muddy waterhole. Particularly in the dry season, from May to September, this is an excellent place to spend some time. The procession and diversity of animals coming to drink is quite remarkable. Kudu, impala, elephant, bushbuck, warthog, zebra, wildebeest, eland, nyala, giraffe, vervet monkeys and chacma baboons all come down to drink in front of the hide. Photographing them is relatively easy, with some of the animals walking within a few metres of the hide. Possibly the greatest highlight here is the frequent sightings of bush pig. Not commonly seen in nature, they often come to drink at this waterhole in the daytime. The distance between the hide and the water's edge allows perfect framing of a bush pig sounder with a 500mm lens. Elephant love the waterhole and if you're lucky, you may see them wallowing in the muddy sections. This is a spectacular sight to photograph.

Birdlife around the waterhole is excellent, with many birds using it to drink from and bathe in. You can expect to see helmeted guineafowl, brown-hooded kingfishers, lots of Cape turtle-doves and Meves's starlings as the common visitors.

Both camps in the west section of the park have very active birdlife. Meyer's parrots nest on the dead trees in the forest tented camp, and francolins scuttle and call in the pathways. At night the woodland comes alive with the calls of owls, and on occasion no fewer than four species have been heard together.

It is best to get to the hide early and sit quietly through the morning. If the wildlife is active, it's the most wonderful experience watching and photographing the animals and birds as they come and go.

A zebra reflected in the water at Maloutswa Hide.  ▶

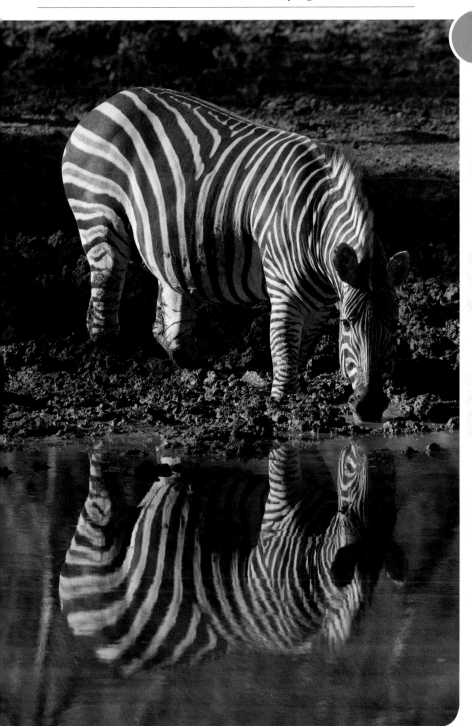

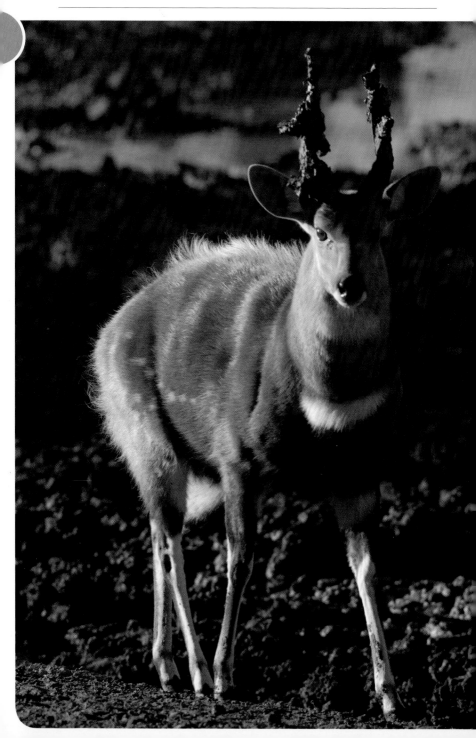

# Photography and equipment

Being a self-drive national park, you will be photographing from your vehicle while out on drives. This means you will either have to use a beanbag or window mount to support your camera.

Make sure you have your camera readily accessible, for as common as the leopards are, they are also skittish. Elephant herds are far more relaxed and you should have ample opportunity to photograph them properly. Remember to use all your lenses with the elephants – the 500mm to go in close on the details and then the wider lenses to show the herd in the environment.

You'll need a good wide-angle lens for the lookout point. If you are serious about capturing it in all its beauty, then graduated filters will be necessary to even out the exposure in the twilight hours. A tripod and cable release are a necessity. When photographing from the hide, beanbags are the best to rest your lens on. They provide excellent support and allow you to move about the hide with greater ease than a tripod.

A 500mm lens is required to get good portrait images of most animals. A zoom lens with a range of 100–400mm is excellent for capturing the elephant herds as they come to drink and wallow in the mud. Being a very good birding destination, a 500–600mm lens will assist you greatly in getting the required magnification for full-frame images.

If you are staying in the camps, listen out for the owl calls at night. Using a spotlight or strong torch, look for them perched out in the open. They often sit very still and will allow you a chance at getting a good photograph.

◀  A bushbuck walks close enough to the Maloutswa Hide to be photographed with a 300mm lens.

# Getting there/accommodation

From Johannesburg, Mapungubwe is 5 hours drive north on the N1 to Musina. Here you take the R572 for 68km, where you will see the main reserve entrance on your right. You need to book into the park through this entrance, even if you are staying in another section.

Accommodation varies from campsites, tented camps, chalets and guesthouses. Make all your reservations and enquiries at http://www.sanparks.org.

## Highlights

- The viewpoint over the Shashe and Limpopo river confluence can only be described as spectacular
- Fever-tree forest walk on the boardwalk offers some creative photo opportunities
- Maloutswa Hide offers some exceptional animal and bird viewing in the dry season (May to September)
- Maloutswa Hide is probably the best place in South Africa to view and photograph the elusive bush pig
- Very good elephant herd viewing in the western section
- Restcamp birding is very good
- Landscape potential is very high
- Beautiful sandstone rock formations

Morning light filters through the forests backlighting a chacma baboon. ▶

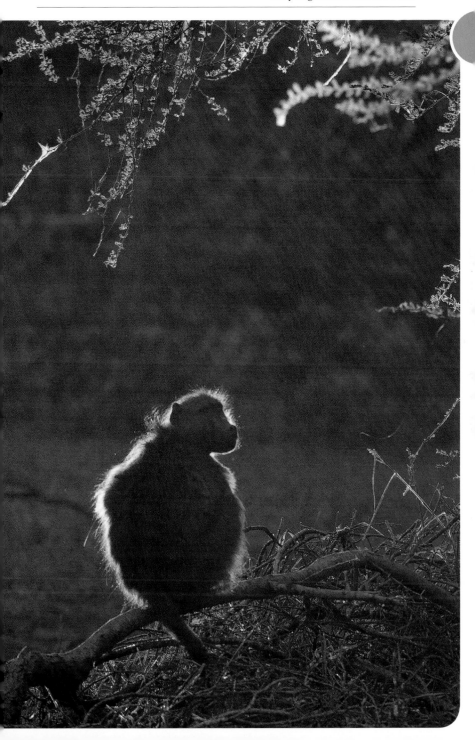

# Shem's photography rating out of 10

| Photographic subject | Abundance | Viewing | Photography potential |
|---|---|---|---|
| Landscape | 7 | 8 | 7 |
| Birds | 6 | 7 | 6 |
| Mammals | 7 | 8 | 8 |
| Predators | 4 | 3 | 4 |
| Big 5 | - | - | - |
| Overall experience | 7/10 | | |

# Photographic equipment suggestions

| Photo skill level | Equipment |
|---|---|
| Beginner to intermediate to advanced | • 1 pro-sumer camera body<br>• 1 pro-body if you want to capture action and birds in flight<br>• 400mm lens for most wildlife<br>• 500–600mm is beneficial for bird photography<br>• 500mm for full-frame portraits in hide<br>• Medium lens for close-up work on mammals that come closer: 70–200mm |

# Other information

| Accessibility | Cost value | Popularity |
|---|---|---|
| Easy; sedan car | Cheap to affordable | High |

It's not all about big animals. Mapungubwe offers excellent macro and insect photography. ▶

# Mpumulanga

Kruger National Park

Sabi Sand Private Game
Reserve and Mala Mala
Game Reserve

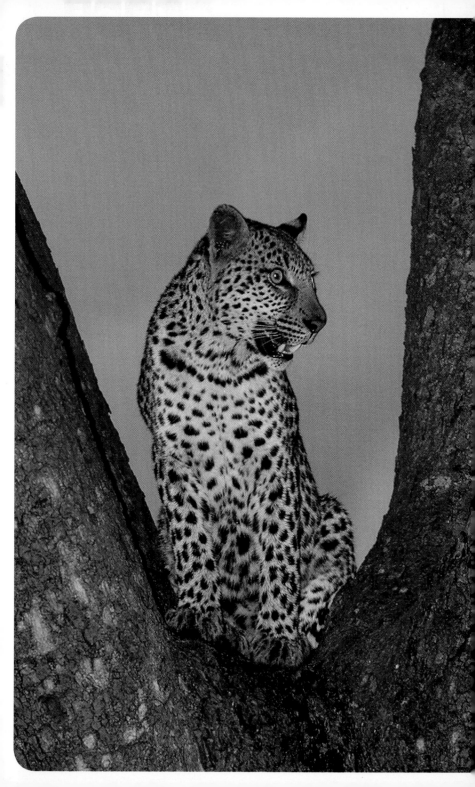

Kruger Gate: 24° 58' 52.70" S   31° 29' 6.92" E
Skukuza:     24° 59' 45" S   31° 35' 31" E

# Kruger National Park, Mpumalanga (and Limpopo)

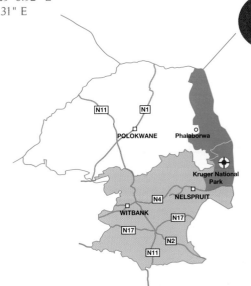

The southern part of Kruger is situated in Mpumalanga, but I have included all the information for the Park in the Limpopo chapter – see page 111.

◄ A perfectly framed leopard just waiting to be captured.

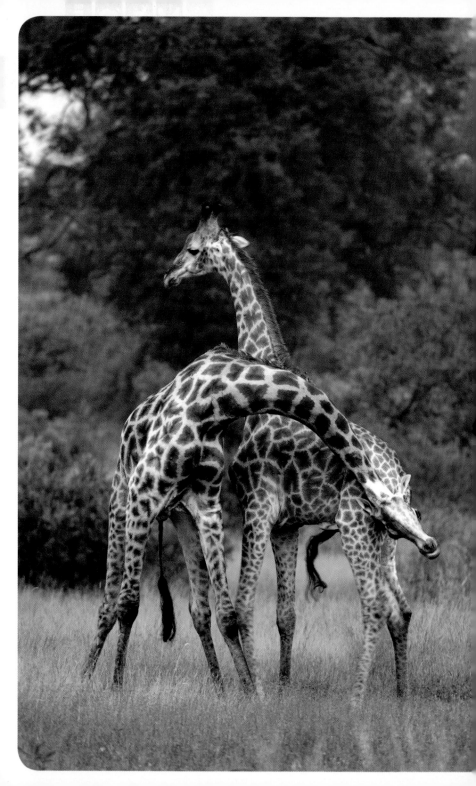

24° 22' 24" S
31° 42' 23" E

# Sabi Sand Private Game Reserve and Mala Mala Game Reserve

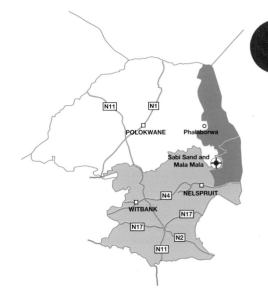

## Background

The Lowveld of South Africa has always been a haven for wildlife, and if photographing the fabled Big 5 is what you're after, then this is the place for you. The reserves of Sabi Sand and Mala Mala offer some of the best Big 5 viewing in Africa. As if that were not enough, the leopards here are so relaxed around the presence of vehicles that it is the best place in Africa to get photographs of these beautiful predators.

In 1898, when the South African government proclaimed the original Sabi Reserve, the land incorporated much of the present-day Kruger National Park. In 1926, the whole area was proclaimed a national park and many farmers were moved off the Sabi Reserve. These farmers formed the Sabi Private Reserve which later became the Sabi Sand Game Reserve. Many of the current landowners are third and fourth generation families whose forefathers pioneered conservation efforts by dropping the internal fences between their farms. It is a credit to them and the younger generation that conservation management has remained at the forefront of the reserve's policies. Eventually the fences between Kruger and Sabi Sand were dropped as well. This opened up the 50km common border to make the Sabi Sand part of one of the largest continuous ecosystems in the world.

◀ These necking giraffe were too absorbed in their battle to worry about me photographing them.

These various landowners and lodges make up the entire complex that is known as the Sabi Sand Game Reserve. Some of the properties are 840ha in size, while others, like Mala Mala, are 13 300ha. Mala Mala is not contractually part of the Sabi Sand Game Reserve, but as it falls between the reserve and the Kruger, it is thus integrated.

Sabi Sand and Mala Mala have become synonymous with high-quality lodge accommodation, excellent Big 5 and wildlife viewing, professional guides and rangers and, of course, top-class photography. The relaxed manner with which the animals move around vehicles is astonishing at first. But this is natural in this area as the wildlife has grown so accustomed to vehicles and has become so habituated that game viewing is a very intimate and close-up affair.

# The reserves

Situated at only 400m above sea level, the term Lowveld is self-explanatory. The lie of the land is 1 200m lower than the escarpment to the west and is made up of a series of gently rolling drainage lines clustered with thornveld and mixed broad-leafed savannah woodland.

There are a number of lodges that operate in the area. Understanding their operations will make a difference to your experience as a visitor. Lodges with the smaller land area, located mainly in the north and west, have agreed to shared access to their land to enable a greater wildlife viewing area. They share traversing rights between properties. On any particular drive, you might see vehicles from other lodges driving around and bump into them at your wildlife sightings. If it is an exciting sighting, there could be a queue of vehicles waiting to see the action. However, the lodges manage this process very carefully, allowing you plenty of time at the sightings.

You will invariably be on a vehicle with other tourists staying at your lodge. Booking a private vehicle is not easy and is expensive. Vehicle seat numbers tend to match the bed numbers at each lodge. A good tip if you are a photographer travelling on your own, is to sit in the passenger seat next to the ranger. This will allow you your own space to photograph from and you will also be out of the way of the other clients on the back of the vehicle.

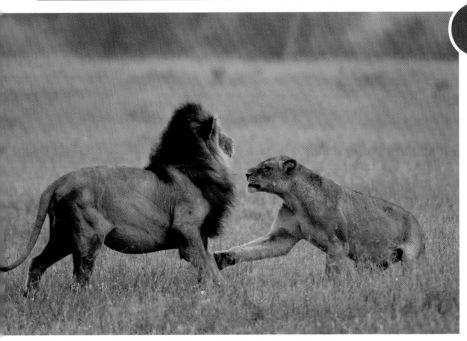

▲  Lions are common in this predator haven, giving you a very high "hit rate".

▼  Relaxed wildlife makes portraits a simple affair.

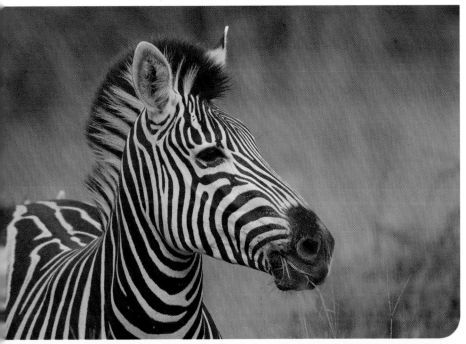

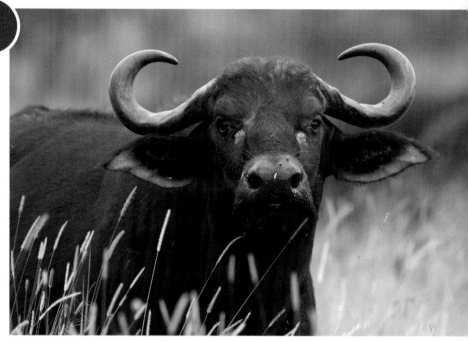

▲   There are a number of large buffalo herds in the Sabi Sand Reserve.

▼   The Sabi Sand/Mala Mala area offers some of the best predator viewing in Africa.

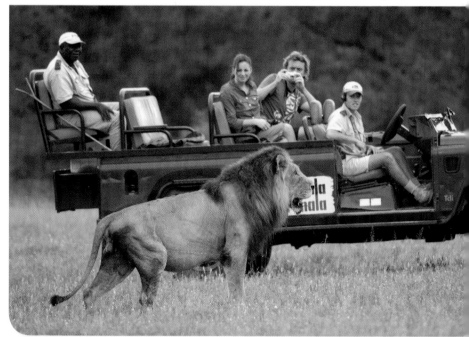

Only three lodges, Mala Mala, Londolozi and Sabi Sabi, operate solely on their own land. These lodges offer a lot more leeway in respect of your sightings as well as how long you can stay out in the reserve. It is also much easier to organise private vehicles for photographers at these lodges. Such an arrangement will allow you full access to the animals on the properties all day long – something that most photographers only dream of!

Nature viewing in the reserves is truly superb. Many visitors expect to find the density of the animal population of the Masai Mara or Serengeti. It is nothing like that, although you can expect to see the usual numbers of animals. However, it is the predators and other large mammals that really make this a spectacular place to view and photograph them. All the predators, lion, leopard, spotted hyena, wild dog and cheetah are present, and all are very relaxed around vehicles. If you are able to stay a few days, you will really get to understand and read their behaviour. This will help predict their behaviour and enable you to plan what and how you want to photograph. It takes away much of the guesswork and gives you the advantage of being prepared for your afternoon's photography.

Of course the real stars of the show are the leopards. It is almost like viewing TV documentaries. These cats are exceptionally relaxed and allow for all manner of close-up photographs. They are so beautiful they are worth photographing even when their eyes are closed! Behaviourally, they are often up and about during the day in the cooler, dry months of May to September, especially in the late afternoons. This offers excellent opportunities for capturing them doing something other than sleeping. In the dry season, much of the grass dies off and the leaves fall off the trees which makes spotting and viewing much easier than in the wet season when it is lush and green. With the browns and golds of winter, you get a lovely glow on your subjects, particularly lions or leopards in the late afternoon light.

The wet season brings the rain and lush green growth. This thickens up the vegetation, but it also provides a beautiful green backdrop for your subjects. If you travel in the early rainy season during November and December, the vegetation will still be short, yet green. It is one of my favourite times for photographing in the area. This time of year is also very productive for bird photography as most start to breed and

the migrant birds return busily calling out their courtship songs. The last week of November usually heralds the birth of impala fawns. Photographically this provides an excellent opportunity as with baby impala running about the predators can easily catch food.

April to May is a difficult time for photography as the grass stands very tall. The rains increase the vegetative growth and viewing is more difficult. From June until September, the ease of viewing improves and the temperature drops enough for the predators to become more active in the early mornings and afternoons. This is the real predator viewing season with daily sightings of lion and leopard, often on every single drive.

Bird photography of the common species is relatively easy. You will need a longer lens such as a 500mm to get good full-frame images of birds. Restcamp bird photography is also good, especially in the summer. You should be able to see black-backed puffback, brown-hooded kingfisher, dark-capped bulbul, grey go-away-birds, Burchell's coucal and a variety of sunbirds on the flowering aloes during June to July. While out on a drive, look out for various raptors, such as brown and black-chested snake-eagles, and martial and tawny eagles. Lilac-breasted rollers, magpie shrikes and crested francolins are commonly seen while out in the vehicle and offer good chances of getting photos of them. In the wet season, the birdlife increases by a third, and you should see (and hear) the striking woodland kingfisher, grey-headed kingfisher and European roller while out on a drive.

# Photography and equipment

Photography in these reserves is all about close up encounters with large mammals and predators. In most cases, you will be within 10–15m of your subject, sometimes even closer. It makes sense then to have the appropriate lens. Anything from a 200–400mm lens will suffice in getting full-frame portraits, as well as full-body images. As many of the animals are well habituated to vehicle presence, they may walk very close to your vehicle. A zoom lens is almost a necessity here in order to be able to zoom out and keep your subject in the frame. I've found a 70–200mm

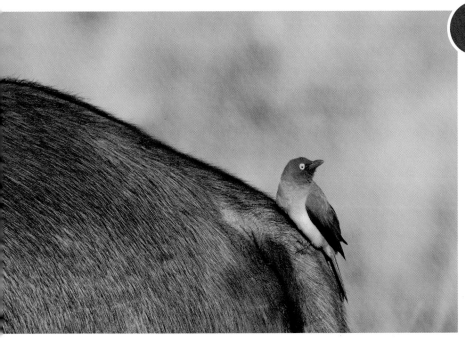

▲  A red-billed oxpecker is relaxed enough to be photographed on top of a buffalo rump.

▼  Hyena feeding on a hippo carcass.

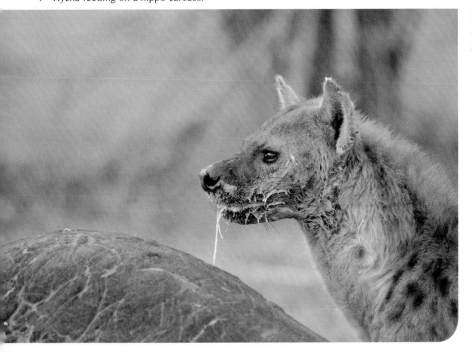

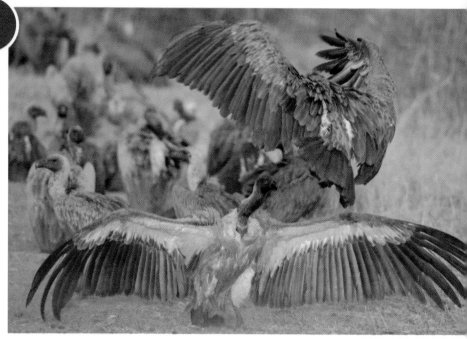

▲ Fighting white-backed vultures provides excellent interaction photography.

▼ A common and approachable summer visitor, the European roller.

and a 200–400mm lens to be a very good combination when working in this environment. A 70–300 range will also work well.

As you will be on an open game drive vehicle, support is a serious consideration. Each vehicle is very different and there is no single answer to how best to support your lenses. Beanbags are the most versatile option but you could find yourself in some very awkward positions when using them, especially if there is no support at shoulder height and you may have to use the seat to support your lens. If you manage to sit in the front passenger seat, then beanbags become very useful, as the support of the open dashboard and side window are at the perfect height to comfortably take photos. If the vehicle you are using has a bar above the seat, you can attach a clamp to it with a tripod head attached to that. However, this does limit you to one fixed position from which to work, and the rule of the bush states that as soon as you are perfectly set up, the animal will walk to another position!

If you are used to using a gimbal head or a good quality ball head, an option is to attach it to a monopod. This set up can work very well for this type of photography. The monopod allows you some flexibility in moving around, and once you brace it against the side of the vehicle, it provides excellent stability. The gimbal head is an excellent way to manoeuvre a large lens and is probably the best solution for photographing from open vehicles. It is also the least intrusive way of photographing should you sit next to other non-photographing tourists.

As you will be exposed to the elements, be aware that dust and rain could affect your cameras in the various seasons. The lodges do supply raincoats and ponchos, but make sure you have at least some protection for your equipment. Rain and the subsequent damp are the most dangerous elements that can affect your cameras.

# Getting there/accommodation

Most people fly to specific airstrips inside the Sabi Sand Reserve and are then conveyed to the various lodges. There are scheduled flights from Johannesburg's Oliver Tambo International Airport as well as from Nelspruit's Kruger Mpumalanga International Airport.

If you are driving, the lodge will give you exact directions to the entrance gate. There are various gates in the south, east and northern parts of the reserve that service specific lodges. The R40 that runs from north to south (to the west of the Sabi Sand) has all the access roads that lead to it running off it. Access towns are: Hazyview on the R536 for the southern lodges to the Sabi Sand Gate; and Acornhoek on the R531 for the northern lodges at Gowrie Gate.

All the accommodation is in lodges, from where you are escorted out on drives with a ranger. These lodges vary in style, luxury and service. An indication of the level of service is the high regard in which they are held by the international safari travellers.

## Highlights

- Excellent viewing of large mammals
- Probably the best Big 5 – leopard, lion, elephant, buffalo, rhino – game viewing in Africa
- Good to excellent accommodation with very experienced rangers
- Close-up encounters with the large predators
- Intimate viewing of leopard – probably the best in Africa
- Decent sightings of other predators, such a wild dog and spotted hyena

With excellent leopard viewing almost a certainty,
you can witness some brilliant behaviour.  ▶

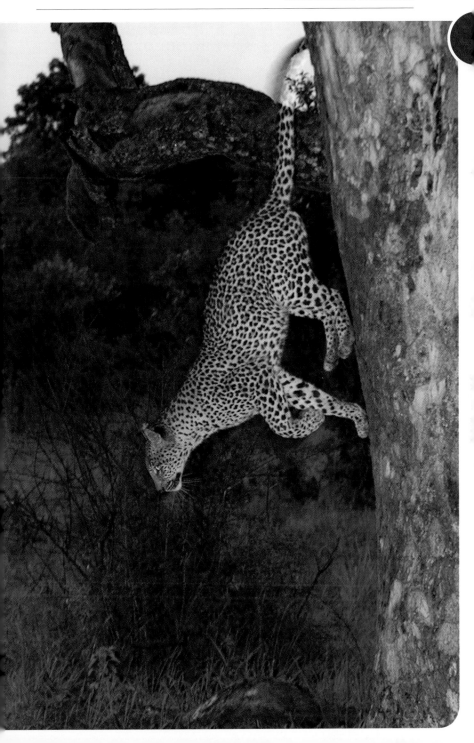

# Shem's photography rating out of 10

| Photographic subject | Abundance | Viewing | Photography potential |
|---|---|---|---|
| Landscape | 2 | 2 | 2 |
| Birds | 6 | 7 | 6 |
| Mammals | 7 | 8 | 8 |
| Predators | 7 | 8 | 8 |
| Big 5 | 7 | 8 | 8 |
| Overall experience | 8/10 | | |

# Photographic equipment suggestions

| Photo skill level | Equipment |
|---|---|
| Beginner to intermediate to advanced | • 1 pro-sumer camera body<br>• 1 pro-body if you want to capture action and birds in flight<br>• 400mm lens for most wildlife<br>• 500–600mm is beneficial for bird photography<br>• Medium lens for close-up work on mammals that come closer: 70–200mm |

# Other information

| Accessibility | Cost value | Popularity |
|---|---|---|
| Easy | Mid range to top end | Very high |

Close enough to be photographed with a 400mm lens, this
saddle-billed stork completely ignored my vehicle.  ▶

# North West

## Pilanesberg National Park

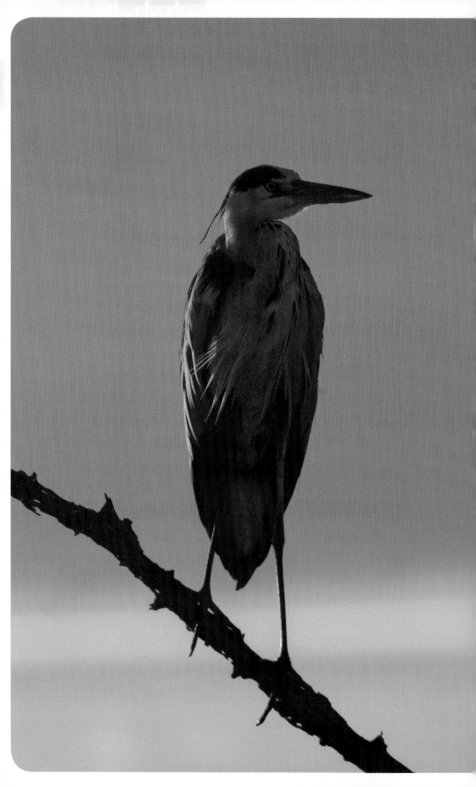

25° 15' 40" S
27° 6' 3" E

# Pilanesberg National Park, Near Rustenburg

## Background

150km and 2 hours north of Johannesburg, this 55 000ha reserve lies in the bed of an ancient volcano. Located at the transition between wet and dry ecosystems, Pilanesberg offers game viewing of species not normally seen together, such as impala and springbok.

The reserve was proclaimed in 1979 and has since become the focus of the largest game translocation in the world, aptly named "Operation Genesis". This involved reintroducing over 6 000 animals into the park, the Big 5 being among them.

Before it was declared a reserve the area was a collection of old cattle farms and villages. It was in 1979 that "Operation Genesis" began and the reserve was named after one of the most powerful chiefs in the area, Chief Pilane. All the villages except for the Pilanesberg Centre were destroyed. This centre used to be the old magistrate's offices and today functions as the information centre of the park as well as a restaurant.

◄ Soft morning glow and mist over the lake provides a beautiful light in which to photograph a grey heron.

# The park

Pilanesberg is one of the most scenic reserves in South Africa. Lying in the bed of an ancient, eroded volcano, the reserve consists of a series of concentric circular hills of which the caldera is now Mankwe Lake. Ecologically, it lies on the transition between the arid west and the lusher east. This means that there is excellent diversity, with both dry and wet species living side by side. No other reserve in South Africa offers this type of habitat. You drive through beautiful grassland areas in the east and then enter woodland mountain areas to the west. The variation in habitat is scenically wonderful and offers many opportunities for the photographer and animal viewer. This is the closest park to the Gauteng cities with large and viable populations of wild animals. It is malaria free and the predominant activities are guided game drives. Photographically it provides scope for beautiful landscape scenes of the old volcano and frequent opportunities for large game photography, as well as some of the more colourful bushveld birds that frequent this area.

General plains animals are easily seen in the park. Mankwe Dam is at the centre of the park and many of the roads lead around it. You can reliably see waterbuck, giraffe, warthog, hippo, impala, springbok and zebra in the vicinity of the dam. The hippos keep the grass around the dam well cropped, which allows for good viewing and of course, great photography of the mammals along the water's edge. This is one of the best places to see hippo in the north of the country, but they are difficult to photograph.

White rhino are the most commonly found large animals, and lion and elephant can be viewed on most days. Rhino can be seen in almost all areas and are relaxed around vehicles. Cheetah were relatively common and easily spotted in the park, however the lion population has now increased to a point where they outnumber cheetah which are now rarely seen. The best place to find black rhino is in the northern areas on the road to Bakgatla Camp.

Birding and bird photography in Pilanesberg is very good. You can reliably photograph the common birds like lilac-breasted roller and

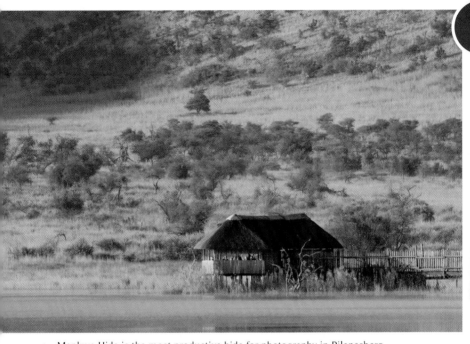

▲ Mankwe Hide is the most productive hide for photography in Pilanesberg.

▼ The hide is an excellent place to photograph pied kingfishers.

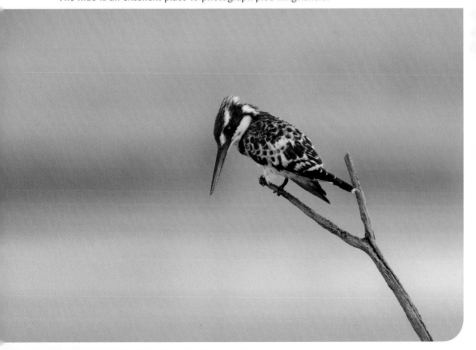

magpie shrikes alongside the road. The public camps (especially Manyane) have excellent birding, with breeding colonies of southern masked-weavers, as well as many yellow-billed hornbills, southern pied babblers, violet-eared waxbills and crimson-breasted shrikes. All of these are approachable, and Manyane Camp is most probably the best place to photograph the elusive crimson-breasted shrike as it hops around camp. The camp also has a large aviary in which birds live and breed. It is a good place to test your bird photography skills, as the birds are relatively tame.

At the waterholes you should see storks, herons and egrets. Most of the hides are well set up for photography, although only Mankwe Hide offers consistent photo opportunities. Timing and luck play a part in what you can see at these hides, and as a result I never spend much time at any one of them. Mankwe Hide is an excellent place for reed cormorant, spur-winged goose, grey heron, pied and giant kingfisher and, if you are lucky, African fish-eagle. If you patrol the walkway along the Mankwe Hide in early mornings, you should get close to pied kingfishers perched on the dead trees. With patience, you can get images of them in flight as well as catching a fish for their breakfast. A walk around the Mankwe Hide parking lot is also productive as Natal spurfowl and crested guineafowl scratch around in the sand. It is worth your while to spend a morning in the hide and along its walkway. A lot of bird activity takes place here and with luck, you may see hippos close by and out of the water.

Pilanesberg is a very popular park, especially on weekends when many visitors come to get away from the cities. There are a number of lodges that also run game drives into the park, and there are bus tours from Sun City. This makes the roads very busy and it is advisable to get in as early as possible to avoid the traffic. By taking the smaller gravel roads, which many buses avoid, you will maximise your photography opportunities.

At the end of the wet season, from March to May, the grass will have grown very tall which makes it difficult to get good photographs, especially of the smaller animals. During the rest of the year, when the grass is quite short, photography is easier. Each year different sections

◀ Crested guineafowl are common birds that are easy to photograph in the reserve.

of the reserve are burnt. This takes place between July and August. In September, these burnt areas become fresh green lawns as the new grass shoots push through. This attracts the herbivores and also allows for clear views and some excellent photography. It is not uncommon to see white rhino grazing on these open patches among the other animals. These months are some of the best times to get great images of plains animals in this park.

Pilanesberg has a very high incidence of brown hyena. These scavengers are very hard to see, never mind photograph, yet some good photographs have come from this park. Keep an eye open for them in the very late afternoon or early mornings. Giraffe are easily seen and very relaxed, allowing you to get wonderful close-up images. If you spot them walking alongside the open areas at Mankwe Dam, it offers a lovely natural environmental scene. Buffalo are very difficult to see as they spend most of their time in the wilderness area to the north-west of the reserve. If, however, you are intent on seeing them, a drive along the full length of Baile Road provides the best opportunity. There are wild dogs in the park, but as they roam widely sightings of them are quite infrequent.

# Photography and equipment

For most game viewing, a 300–500mm zoom range will suffice. A 600mm lens will be handy if you are keen on bird photography, which is well provided for in Pilanesberg. There are options for game drives in open vehicles. These are mainly for nature tourists and don't offer the best opportunities for photographers. The best way to get good photos is to drive yourself slowly through the park, in which case a beanbag or window mount on which to support your camera will be necessary.

The larger animal species will allow you to use the 200–300mm focal length, while the wide-angle lenses can be used at the scenic areas, such as Mankwe Hide and from the top of the lookouts at Fish Eagle Picnic Spot and Pilanesberg Lookout. Driving east along Nare Drive in the late afternoon makes for great scenic photography, the sun behind you giving a golden glow to the grass and the valleys in the distance providing good depth in the scene. The most productive roads and loops for game viewing are Tilodi Loop all the way till it joins Tshwene Road. The

▲ White rhino are extremely common and relaxed, allowing for some great close-up photography.

▼ Red-billed oxpeckers love the relaxed white rhino, so you can get two subjects in one.

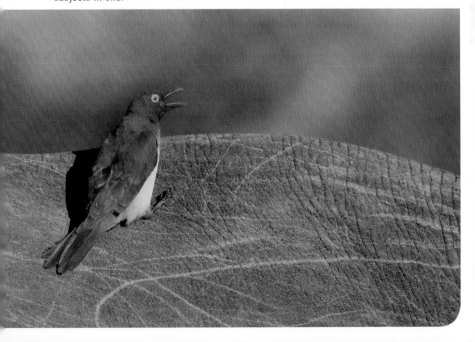

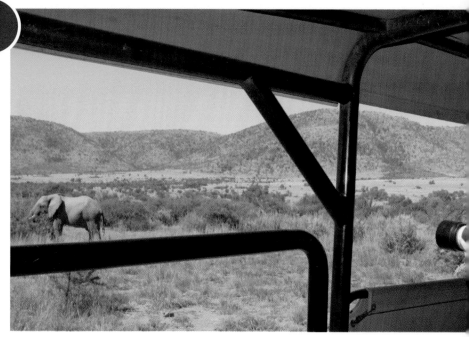

▲ Elephant are common and are now very relaxed – allowing for good photographs.

▼ Mist and reeds on Mankwe Lake provide great compositions in the early mornings.

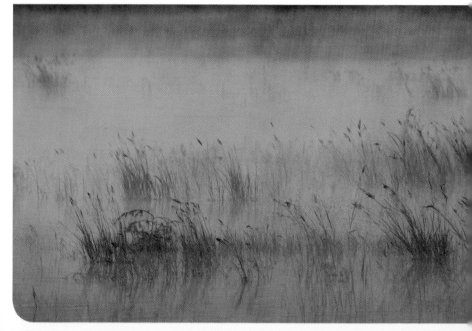

various roads and loops around Mankwe offer excellent game viewing potential. Many animals cross the Tshepe and Mankwe roads heading towards the dam, so the incidence of animals is very high. To the west, Tlou, Nare and Ntshwe drives join together and offer great viewing over savannah plains, often with giraffe or white rhino in the scene. Kgabo Drive in the north is the best place to see black rhino, especially in the late evening or early morning. These animals are often in thick bush, so try to photograph them in their environment if you cannot get a clear photograph of them on their own.

In the cold, dry season which stretches from April to August, thick mist is often found hanging over Mankwe Lake in the early mornings. It's worth getting to the hide early as the mist creates a wonderful mood and allows for some really creative images with the sun rising over the hills in the east. A really remarkable experience, especially as you are likely to find yourself on your own.

Viewing data taken from 2002–2006 shows the following viewing percentage of large animals:

| Specie | Percentage | Photography out of 10 |
| --- | --- | --- |
| Black rhino | 26.7 | 3 |
| Brown hyena | 66.7 | 4 |
| Buffalo | 13.3 | 1 |
| Cheetah | 20 | 2 |
| Elephant | 80 | 8 |
| Giraffe | 100 | 10 |
| Hippopotamus | 100 | 7 |
| Leopard | 6.7 | 1 |
| Lion | 60 | 5 |
| White rhino | 100 | 10 |
| Wild dog | 13.3 | 1 |

# Getting there/accommodation

Pilanesberg's major attraction is its proximity to the large cities of Gauteng. It is an easy 2-hour drive from Johannesburg, which makes a day trip to the reserve a possibility, however you will miss most of the good photography light if you get there late. Close to Sun City, Pilanesberg is well marked on the road network. From Pretoria, you take the N4 west and follow the signs. From Johannesburg, you can either take the N1 to Pretoria and then the N4 west, or the R511 through Hartbeespoort Dam from where you follow the signs. There are many gate entrances: the most popular is Bakubung, right next to Sun City; and Manyane on the eastern side.

There are various types of accommodation from 5-star luxury lodges to camping on the peripheral family resorts, as well as staying at Sun City itself.

## Highlights

- Large animal and predator viewing within a 2-hour drive of the large cities
- Excellent bushveld bird photography
- Good photography of kingfishers, herons and cormorants at Mankwe Hide
- Decent landscape photography in the hilly outcrops
- Excellent close-up photography of white rhino
- Good potential for elephant photography, especially old bulls
- Giraffe are easily photographed
- High diversity of animal species

# Shem's photography rating out of 10

| Photographic subject | Abundance | Viewing | Photography potential |
|---|---|---|---|
| Landscape | 7 | 7 | 7 |
| Birds | 7 | 8 | 8 |
| Mammals | 7 | 6 | 6 |
| Predators | 3 | 3 | 3 |
| Big 5 | 5 | 4 | 5 |
| Overall experience | 6/10 | | |

# Photographic equipment suggestions

| Photo skill level | Equipment |
|---|---|
| Beginner to intermediate | • 1 pro-sumer camera body<br>• Pro-body if you want to capture action and birds in flight<br>• Long lenses 400–600mm<br>• Wide-angle lens is needed for landscapes 14–70mm<br>• Medium lens for close-up work on mammals that come closer: 70–200mm |

# Other information

| Accessibility | Cost value | Popularity |
|---|---|---|
| Very easy; sedan vehicles allowed; 2 hours from Johannesburg | Cheap to top end | Very high |

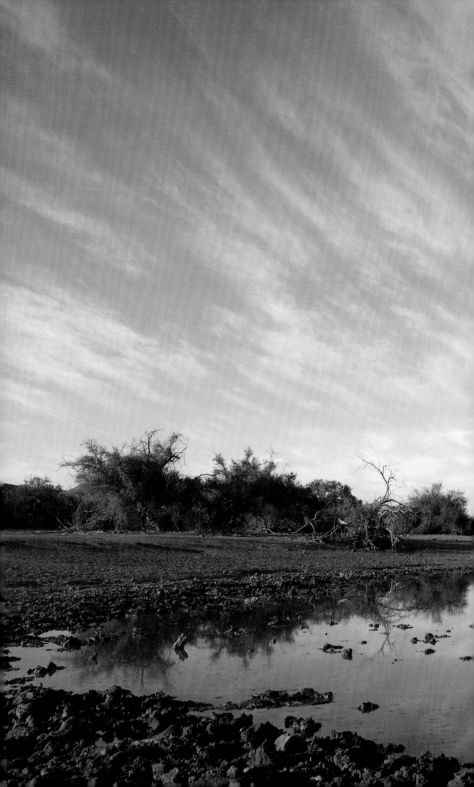

# Northern Cape

|Ai-|Ais/Richtersveld
Transfrontier National Park

Kgalagadi Transfrontier Park

Tswalu Kalahari Private
Nature Reserve

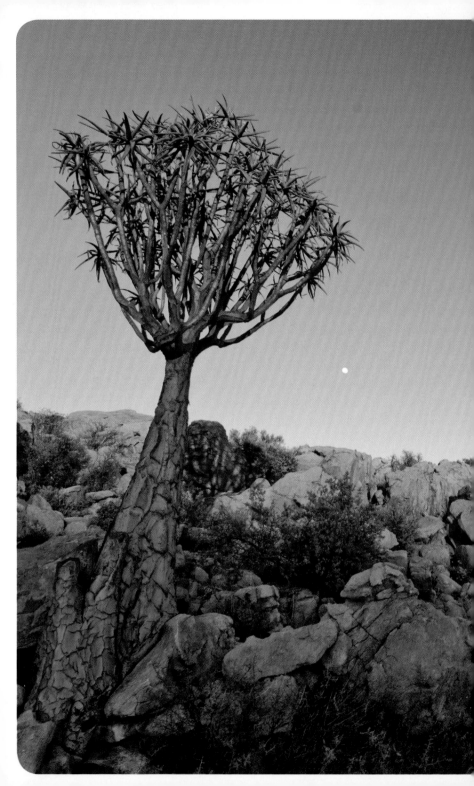

# |Ai-|Ais/Richtersveld Transfrontier National Park, North-west of Northern Cape

# The Kokerboom Kloof

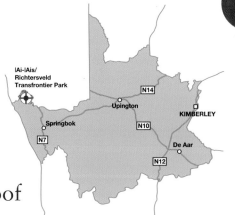

## Background

Tucked away in the far west and north of South Africa lies this harsh, but unique area. It may be remote and difficult to reach, but the Richtersveld is one of the wildest landscape destinations in the country – and this is its main attraction.

in 2003, the park was declared a transfrontier park with the Fish River Canyon on the Namibian side of the border and the Orange River forming the common boundary between them. The South African side is quite noteworthy in that it is managed in partnership with the Nama people.

Mammals, reptiles and birds are fairly common, but it is the plants that are the main attraction here. In such a harsh desert environment, adaptations have to be made in order to survive and the plant life has developed into one of the largest succulent communities in the world. A total of one third of the world's succulents occur in the Richtersveld alone. In one square kilometre, 360 plant species have been recorded, astonishing when one notes that the average rainfall is only 68mm per year! For much of the year these succulents are invisible, camouflaged by the rock and desert.

◀ Expect clear blue skies during your visit – a polariser is a very handy filter to have here.

But after the rains, they produce a dazzling flower show, a spectacular contrast to the harsh environment.

A visit to the Richtersveld is primarily for those interested in landscape photography. The scope is incredible, large quiver trees, succulent plants, shepherds trees and rock formations combine to provide a landscape photographer's dream.

# The park

Far from any cities and towns, the Richtersveld is South Africa's most remote national park. It lies in the far west, adjoining the languid Orange River just before it reaches the Atlantic Ocean. And it is this ocean that brings life to the park, as the fog banks roll in off the sea sustain the remarkable plant life so particular to this area.

As you drive towards the park you are greeted by huge rugged mountains that erupt from the desert floor. It is hard to believe that you will actually be heading into these massifs. You can enter the park through the headquarters at Sendelingsdrift. From this point on it is a remote wilderness experience. Much of the park is very scenic and as you drive over the rocky passes you will be thrilled at all the landscape photo opportunities. There are a number of campsites in the reserve but the one that offers you the best opportunities for excellent photos is Kokerboomkloof (Quiver-tree Valley).

A visit to this valley is a remarkable and somewhat surreal experience. It lies at a shallow angle, in a north-west/south-east direction surrounded by vast rock mountains on the east and west sides. The floor of the valley angles upwards to the south, but the open area is a wide expanse of jumbled rock formations and open plain. Here, on this plain, lies what must be the densest concentration of quiver-trees imaginable – the entire valley is filled with them and they grow from any possible spot. As you first walk around, you may feel overwhelmed by the sheer number of trees and myriad photographic opportunities that are on offer. Once you have established yourself at the campsite, your best way to manage the photographic option is to set out and explore the area on foot. A large, prominent dome-shaped rock acts as a landmark in the valley and is useful as a marker to orientate yourself. The quiver-trees increase in number and density the further you head down the valley,

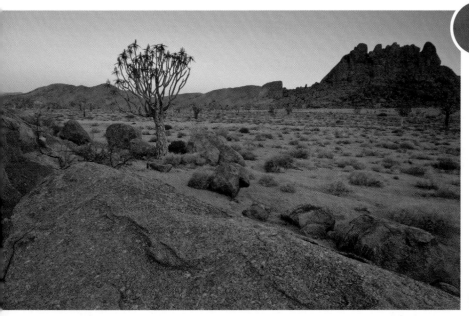

▲ With many rock domes, trees and mountains, your composition possibilities are limitless.

▼ A lone quiver-tree, with the rocky Richtersveld Mountains in the backdrop, sets the scene in this landscape wonderland.

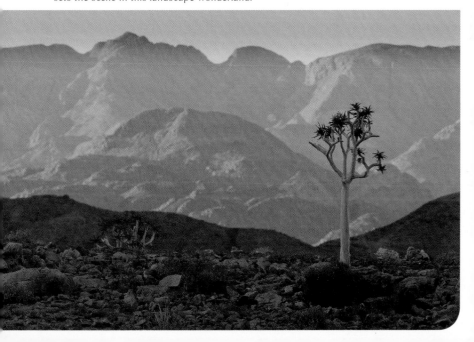

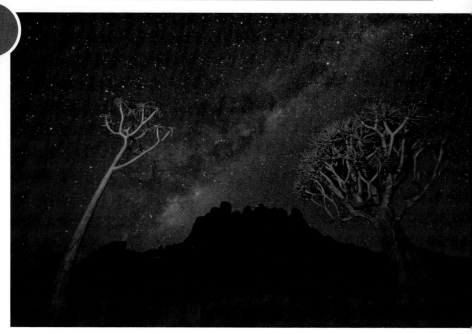

▲  Night-sky milkyway with quiver-trees in the foreground.

▼  The road leading into some very rugged-looking mountains – quite a rough
drive in.

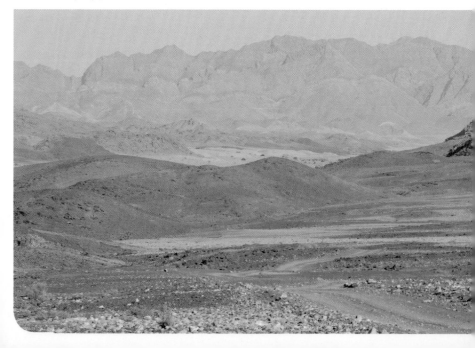

so your exploration can lead you quite far from the camp. The real beauty of this experience is that you are in a vast wilderness area and you are likely to find yourself alone in the valley working on your own landscape compositions. The quietness of the early morning is awesome and it encourages one's creativity. There are very few places in the world where you'll have such freedom to walk about on your own and such opportunities to take photographs in such untouched and pristine wilderness surrounds.

The night skies in the Richtersveld are exceptionally clear and you can enjoy some excellent star-trail and night-time photography. The quiver-trees are perfect subjects to place in your frame for night and star work. The added advantage of being in an environment with the freedom to walk about is the ability to remain out during twilight and into the darkening night, allowing greater creative opportunities for the enthusiastic landscape photographer.

## Photography and equipment

This is a landscape photographer's destination and your choice of lens is based on the wide-angle side of the focal range. Anything from 12–50mm will do. A 70–200mm lens is also useful for tighter framed landscapes where you want to compress the field of view. I always carry this lens with me and find that I use it regularly. A sturdy tripod with a decent tripod head is essential for stability and support of your camera. A lightweight tripod is advantageous as you will be walking around for most of the time.

A high resolution D-SLR camera is recommended to be able to get as much quality from your images. Gradient filters are another feature of the landscape photographer's kit. In order to balance bright skies with dark foregrounds, up to five stops of filtered light are normally needed. Neutral density graduated filters are best for landscapes and they are very useful in this exacting environment. A polariser filter is also an essential tool to use as it adds contrast and colour to certain scenes. Make sure you have a working cable release with you. This is essential to minimise camera shake and also for use at night, when you will need it to take long exposures of star-trails with the camera in bulb mode. Along with the

cable release, a head lamp or hand-held torch is very useful for finding your way about at night.

A comfortable fitting camera backpack bag is essential while walking out in the field. Remember energy bars and, very importantly, water. In this hot environment, you can easily become dehydrated while out walking.

As it is a remote area, your safety is a concern. The biggest dangers when out walking are scorpion stings or snake bites. It is advisable to work in groups of at least two people and to have an escape or rescue plan in place in case anything goes wrong. Good hiking boots and long trousers will help prevent any stings and snake bites penetrating the skin and hiking boots will also give your ankles more support when walking with a camera bag on your back.

The best time to be out photographing is during the dawn and dusk hours of the day. Get out an hour before sunrise to locate your composition. The silence of the pre-dawn hour makes the early wake-up worthwhile and 90 minutes after the sun is up you will be back in camp having breakfast. The afternoon session can extend later into the night and will depend on the phase of the moon. After twilight and your evening photo session, there is an opportunity for star images. If there is no moon, you have a lot of time to get star-trails and star-images. If the moon is already in the sky, your opportunities are limited as the moonlight diminishes the intensity of the stars. This light can also help in a way, as it illuminates the foreground, bringing out detail. What you lose in star intensity, you gain in ambient light for the foreground.

# Getting there/accommodation

The quickest way to get to the park in South Africa is via the N7 turnoff at Steinkopf. There you turn towards Port Nolloth and then north to Alexander Bay. The road continues towards Sendelings Drift with the last 80km being on dirt.

Bookings are done through SANParks. Kokerboomkloof is not on the official website, so make your bookings directly through the reservation

The view from near the campsite – sometimes you don't have to walk far for your images. ▶

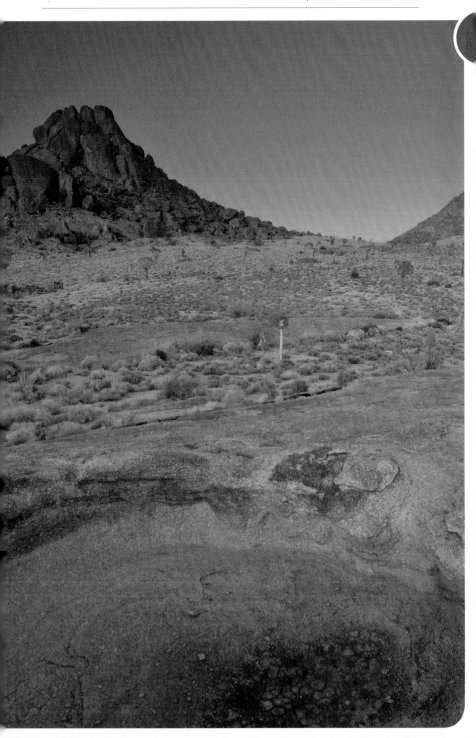

office on the reserve at Sendelings Drift. Telephone: +27 (0)27 831 1506. The campsite has no facilities so you will have to be fully self sufficient, bringing in your own food, water and camping equipment. A 4x4 vehicle with off-road tyres is recommended, especially for getting over some of the passes. A high clearance vehicle with diff lock can also be used.

# Highlights

- Remote location in a true wilderness area
- Exceptional landscape opportunities
- The opportunity to walk around to find the best images
- A vast array of quiver-trees with endless compositions available
- Large rock domes providing good balance to compositions
- Clear skies making for excellent night-time and star-trail photography

# Shem's photography rating out of 10

| Photographic subject | Abundance | Viewing | Photography potential |
|---|---|---|---|
| Landscape | 9 | 9 | 9 |
| Birds | 5 | 3 | 3 |
| Mammals | 2 | 2 | 2 |
| Predators | - | - | - |
| Big 5 | - | - | - |
| Overall experience | 8/10 | | |

# Photographic equipment suggestions

| Photo skill level | Equipment |
| --- | --- |
| Beginner to intermediate to advanced | • 1 pro-sumer camera body: high resolution<br>• Good wide-angle lens: 12–50mm<br>• 70–200mm lens to compress the field of view<br>• Sturdy tripod<br>• Cable release<br>• Graduated neutral density and polariser filters |

# Other information

| Accessibility | Cost value | Popularity |
| --- | --- | --- |
| Difficult; far from nearest town; 4x4 required (at least a high clearance and diff lock) | Cheap | Low to normal |

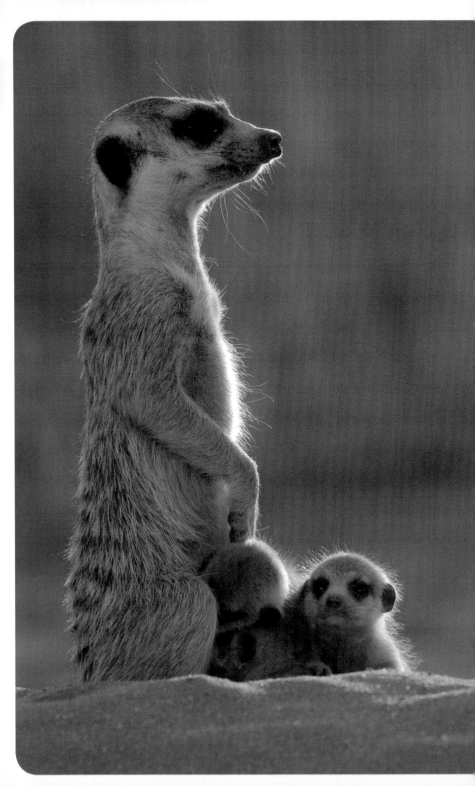

26° 28' 22.39" S
20° 36' 43.26" E

# Kgalagadi Transfrontier Park, North-west of Northern Cape

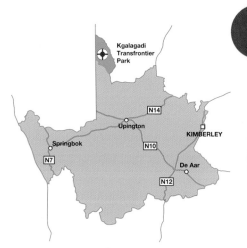

## Background

If predators interest you, then this is the place to see them. The Kgalagadi Transfrontier Park (KTP) is a SANParks self-drive park and it provides a wealth of predators to photograph, from Cape cobras to the martial eagle and from the ever-alert suricats to the largest predator in Africa, the Kalahari black-maned lion. If Kruger National Park is the diamond of the reserves of South Africa, then the KTP could be described as the pearl of the arid west. Fewer people visit due to its remote location but the KTP is one of the favourite hunting grounds for wildlife photography enthusiasts and professionals alike. The original reserve in South Africa, the Gemsbok National Park, was proclaimed in 1931. Botswana, on the other side of the common boundary, also proclaimed the adjacent land a reserve, and since 1948 the two reserves have co-operated informally to conserve a total of 3,8 million ha, one of the largest conservation areas in the world. The parks officially combined in 2000 to create the first cross-border transfrontier park in the world, a remarkable achievement in this day and age.

The word Kgalagadi means "land of the great thirst". This is true for most of the region which experiences less than 200mm of rain on average per year. This aridness adds to the attraction of the area and the park offers a majestic and seemingly infinite desert landscape with migrating herds of wildebeest, gemsbok, springbok and eland.

◀ This is one of the best places in South Africa to spend quality time with suricats.

Two-thirds of the reserve is located in Botswana, but it is the section in South Africa that is the most productive. For most of the year, animals roam over the open grasslands and pans in the north of Botswana. However, during the dry season two ancient riverbeds, the Nossob and Auob, both located in South Africa, attract many animals to their waterholes. Predators follow and the excellent sightings of lion and cheetah provide some exhilarating viewing in the dry riverbeds.

Most of the viewing action happens along the riverbeds. The road network might appear boring, yet this is where all the action occurs. The wildlife offerings of the Kalahari are simply fantastic and it is a place where you will find the small and the large in equal abundance.

# The park

Animal viewing is centred along the riverbeds of the Auob and Nossob rivers that head north in a V-shape from the main camp in the reserve, Twee Rivierien. Two dune roads connect these riverbeds, but animal viewing is invariably sparse along these roads. Along the riverbeds are various waterpoints which vary in their animal and bird popularity, but are the best spots for most of your viewing and photography.

The Kalahari is known for the more unusual animals like bat-eared fox, Cape fox, African wild cat, honey badger, brown hyena, ground squirrel and suricat (meerkat). These are the small wonders of the KTP and the large wonders are definitely the predators. Lions are found in abundance and this is the place in South Africa where you will have prolonged sightings of cheetah. The large mammals are also well represented and springbok, eland, wildebeest, gemsbok (oryx), red hartebeest, ostrich and giraffe are easily photographed. The mega herbivores, elephant, rhino and buffalo, are not found in this area.

A major photographic highlight is the openness of the riverbeds. Even in the wet season, the grass only reaches 30cm at its highest. This makes viewing and photography much easier, and is one of the common attractions of the reserve. Because it is a desert, the Kalahari is very seasonal in nature and this affects what species you will see in each season. The dry- and wet-season animal viewings are listed separately below, as each one has its own particular attraction.

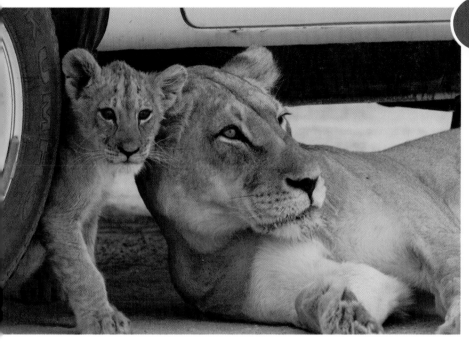

▲  A lioness and her cubs take respite from the heat under a vehicle.

▼  September to November is breeding season for black-backed jackal.

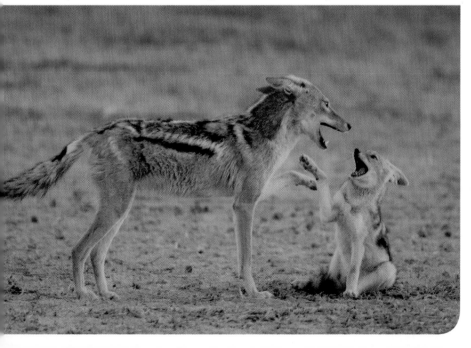

▲ Dust in the dry season makes for atmospheric backlit scenes, such as this camel-thorn tree.

▼ Cheetah sightings are always special – allowing for great photographs.

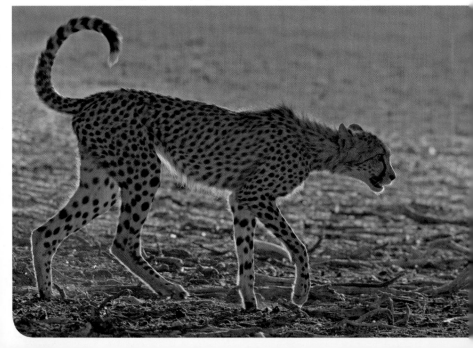

## The dry season, May to October

Due to the low temperatures in the dry season, which can be as low as -2°C in the mornings and 23°C during the day, the vegetation dies off quite quickly, which makes photography a dream. The very cold conditions in the mornings cause many animals and birds to lie very still, trying to warm up in the morning sun. It is a great time to photograph spotted eagle-owls and Verreaux's eagle-owls roosting in camel-thorn trees alongside the road. Other raptors will also be warming up. Watch out for lions lying on the red dunes along the riverbed who will be sunbathing in an effort to get warm.

As the season wears on, more and more animals start to frequent the waterholes, which encourages predators. Check the daily sightings' records at the restcamps for predator movements, as they will often stay near one waterhole for a while. The Auob River, near Mata Mata, is one of the best places to view cheetah. If you stay a few days in this area and follow the movements of the cheetah, your chances of witnessing a kill improve dramatically. Cheetah are also often seen between Houmoed and Monro waterholes, although you could see them anywhere in the reserve. It's been noted that the cheetah enjoy hunting in the riverbeds, as the dune sides hem in their prey. This makes the steep-sided Auob riverbed one of the best places in the world to witness a cheetah hunt and possibly a kill.

Lions are plentiful in the park and can be found throughout the area. As temperatures cool a little in the afternoon, the cats become more active. This is the time to see lions awake and alert. Following a large, black-maned Kalahari lion walking up a dry riverbed is a unique and special possibility at this park. Lions will also be active later in the mornings, after they have warmed up, which is a good time to see them drinking.

African wild cat are often seen resting up in a major fork of a camel-thorn tree. This is the best place to see and photograph these beautiful cats, so keep a special eye open for them. Cape fox, bat-eared fox and black-backed jackal are all easily seen huddled up on the riverbed floor catching the warmth of the early-morning sunshine. Black-backed jackal will be the most active of these smaller predators during the day, particularly when they go digging in search of the Brant's whistling rat. Pale chanting goshawks are the most plentiful dry-season raptor, and

they too are always on the lookout for the chubby Brant's whistling rat. If you stop at some of their burrows and wait a while, you are bound to see one popping its head out. Between October and November the smaller predators, such as black-backed jackal and Cape fox start breeding. Their den sites are often situated close to the road. Look out for fresh diggings, or a jackal or fox frequenting a certain area. If you can find a den, the photo opportunities are endless, with young pups and adults offering great interaction and play. If the den site is close to the road, the animals are likely to be quite relaxed. Please consider their welfare above your photos and try not to disturb them. You don't want to be the cause of a deserted den.

Giraffe are often seen near Mata Mata and are relaxed enough for easy photographing. Kudu too are often spotted in this area. Eland stay further north and rarely come south. You will be more likely to see them near Nossob Camp, where the riverbed opens up and the dunes are less prominent. The landscape here is more savannah-like in nature and not as confined by the dunes as in the Auob. The area around Nossob Camp is famous for lions, especially around the waterholes.

The Kalahari is home to two very charismatic animals, namely ground squirrels and suricats. Ground squirrels have colonised all the campsites and there is a good chance that they will find you before you find them. Suricats are harder to see, but this is one of the best places to spot them. Should you find a burrow near the road, try to get there early in the morning so as to be able to photograph them while they are sunbathing.

One of the characteristic images of the Kalahari is dusty backlit scene with gemsbok or springbok in the riverbeds. This kind of scene tends to occur late in the afternoon as the sun is about to set. The best way to capture this scene is to situate yourself higher up the side of a dune with the animals in the riverbed below. The last 5km of road leading to Mata Mata Camp has a few of these vantage points at places where the road crosses the riverbed. If you find yourself at such a scene, park and wait in the hope that some animals walk into the line of the sun. Such moments are rare, but the resulting photographs are very striking. Gemsbok, wildebeest and springbok are excellent subjects for such scenes. Ostrich who enjoy dusting themselves also produce excellent backlit images.

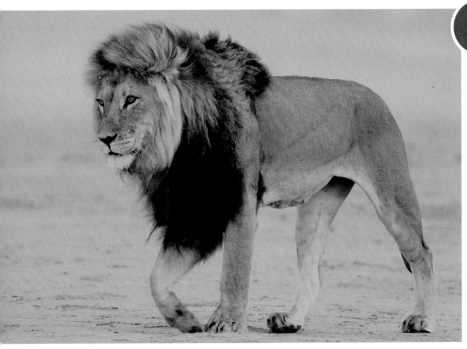

▲ This national park is known for its large, black-maned lions such as this handsome individual.

▼ A Kalahari special is the beautifuly coloured swallow-tailed bee-eater.

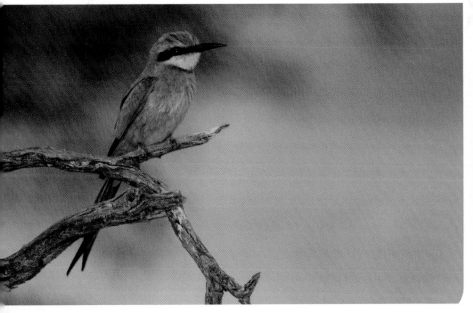

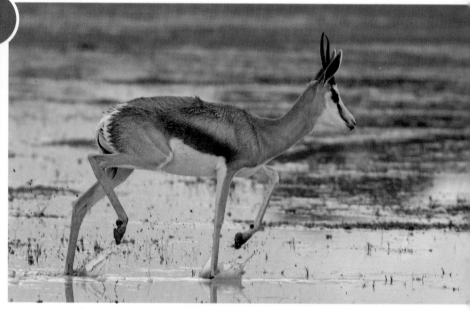

▲ After the first rains in November, springbok play in the water, which makes for wonderful shots.

▼ A high view overlooking the riverbed is perfect for capturing dusty atmospheric images in the dry season.

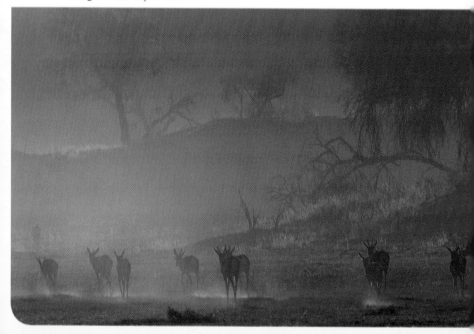

## The wet season, November to April

The change of seasons brings about a vast change in climactic conditions. Wet-season daytime temperatures increase to around 35–40°C in the day with lows of 15°C in the evenings which stifle all movement during the midday hours. Many believe that this is not a good time to visit the park, but the wet season has a great deal to offer the persistent photographer.

Thunderstorms begin building in November. Most are "dry" storms, but a few isolated squalls scatter their precious resources. It is these patches of localised rain that initiate the start of the calving season. After one or two good rains, female springbok begin to drop their young. Usually this happens en masse and within a few days you will suddenly notice a large number of fawns springing among the herds. Keep a look out for the young fawns resting among dead wood under the camel-thorn trees. If you are lucky, you could see a female giving birth in the shadows of a bush. If you are careful and approach the nursery herd very slowly, the mothers should allow you to get very close. It's a wonderful time to be in the Kalahari. Migrant birds have returned and most birds are in full-breeding plumage. The Cape foxes, bat-eared foxes and jackals are all denning, and the predators are happily enjoying the booty. Life is abundant and bountiful.

December is when the heat really starts. By mid-December, the wildebeest have started calving, adding their young to the springbok fawns leaping around the veld. After a few decent rainfalls, the insect life starts. This is the major attraction for the migrant birds as well as for many of the raptors. The riverbeds of the KTP are one of the best places to watch and photograph large birds. The many camel-thorns and other dead trees provide perfect perches for you to photograph them on. You can expect to see the following raptors: bateleur, Wahlberg's, martial, lesser spotted and tawny eagles; black-chested and brown snake-eagles; gabar and southern pale chanting goshawks; shikra (little banded goshawk); pygmy, lanner and red-necked falcons; and yellow-billed and black-shouldered kites. Secretarybirds are also commonly seen striding through the grass.

From about 09:00 onwards, the seed-eating birds come to waterholes to drink. Find a bird-active waterhole and scan the tops of the trees. If there are raptors present, sit patiently and you may witness an aerial attack on the seed-eating birds. I've seen six attacks by a shikra in 90 minutes at Dalkeith Waterhole.

The real rains fall in January and February. Real, however, is less than an average of 250mm per annum. This is when the Kalahari really starts blooming. Devils claw, swart storm, senna and devils thorn flowers all bloom in profusion after good rains and turn an apparently barren desert environment into a colourful garden of delight. The Kgalagadi is at its best and becomes more than a photographer's delight, as it is transformed into a wonderland. If it's not animals you are photographing, then it's wonderful landscapes with clear blue skies and white clouds.

Landscape wise, November is the best season for good evening skies. The clean Kalahari light combined with the fast-moving thunderclouds provide some spectacular light shows. Daily cloud build up continues throughout the rainy season.

## Non-seasonal activities

Leopard are common in the desert, but their extensive home ranges make it difficult to spot them. Look out for them on the eroded overhangs of the calcrete ridges just north of Twee Rivieren and on the dune ridges as they watch the world go by. Night drives are a great way to see the nocturnal creatures of the Kalahari, and it is possible to encounter species such as owls, aardvark, African wild cat, lion, bat-eared fox, Cape fox and even leopard.

Many of the birds are very relaxed, especially around the restcamps. In camp you can get decent photographs of sociable weaver, white-browed sparrow-weaver, African scops-owl, pearl-spotted owlet, crimson-breasted shrike, Cape glossy starling, Kalahari scrub-robin, acacia pied barbet and familiar chat. On drives you should see and be able to photograph southern black korhaan, marico flycatcher, ant-eating chat, lilac-breasted roller and fork-tailed drongo. Watch out for the colourful male ground agamas as they perch high up on shrubs to sun themselves. Snakes are regularly seen here in the late summer. The Cape cobra has a bright yellow form that is very striking to see and photograph.

Check which waterholes are being pumped by enquiring at the camps; it's important to know which areas to head out towards.

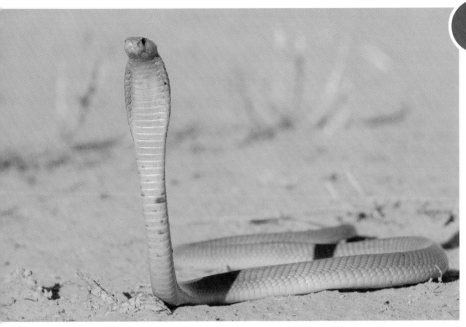

▲ Another predator that is commonly seen is the highly impressive and venomous Cape cobra.

▼ Look under trees after the first rains for newly-born springbok resting in the thick bush.

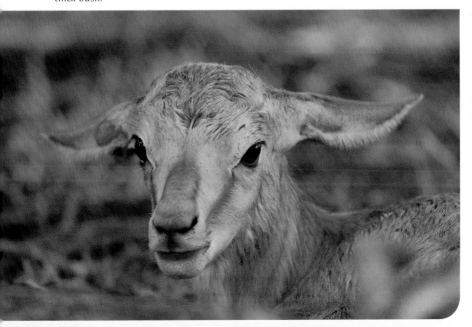

# Photography and equipment

This is a self-drive park, so you will be photographing from a closed vehicle. All types of vehicles are allowed in the park, but it is best to drive a high-clearance vehicle able to clear the deep road erosion found in some areas. Photographing from a vehicle presents you with a few problems to work around. There are a variety of vehicle brackets and mounts that you can use. I'd suggest finding one that works the best for you and then sticking with it. A problem with working from a vehicle window is a lack of mobility. Beanbags placed on top of a window rest offer the best option in terms of stability and flexibility.

There are no ultra large mammals in the Kgalagadi Transfrontier Park, so lens choice becomes a bit easier. As many of the waterholes are a fair distance from the road, a 500–600mm lens is a must. This will allow you full-frame images of most species. Most of the animals are very habituated to vehicles and will allow you close enough for good portraits. Lions may completely ignore you and sometimes come within a metre of your vehicle, so make sure you have a shorter focal length in the range of 70–300mm. You will also need a wide-angle lens for those wide vistas and dramatic skies. In the dry season, the lack of clouds is an issue for landscapes, but the wispy cirrus clouds which herald the cold fronts add to an impression of vastness that isn't achieved with thunderclouds.

A tripod isn't used much while on drives, but it will be useful at the reststops and in restcamps, especially if you find owls in the camps at night.

Dust, especially in the dry season, can be a problem. This can be overcome by having two or more camera bodies, which does away with lens changes. If this is not possible, try to ensure that you change lenses in a confined area.

You may not drive off the roads in the reserve. This rule is strictly enforced. Gate opening and closing times change with the seasons, but are linked to sunrise and sunset. Try to arrive at the gate early in the mornings so as to avoid the other vehicles' traffic and dust.

◄ After the first rains some spectacularly coloured plants bloom within a day, such as this devil's claw.

# Getting there/accommodation

Travelling by car, the KTP is 1 100km (11 hours) drive from Johannesburg and 10 hours from Cape Town. Many people make an overnight stop to break the journey. You can also fly into Upington where you can rent a vehicle. The park gate at Twee Rivieren is 260km from Upington.

The KTP is run by SANParks who manage the accommodation. There are three main camps: Twee Rivieren is at the entrance of the park and is also the park headquarters; Mata Mata and Nossob are the other main camps, although they are smaller than Twee Rivieren. Accommodation is in the form of self-catering chalets and camping. The camps have small shops with limited supplies. You will have to take in most of your food as Upington is the closest town for shopping.

Wilderness camps are also available and these are all situated in wonderful locations in the centre of the reserve. There are particular requirements for each camp, for example, 4x4s, wood etc, so check when you make your booking. One benefit of the wilderness camps is that your distance from the main camps means fewer vehicles in the late evenings and early mornings.

For reservations book online at www.sanparks.org

## Highlights

- Excellent close-up sightings of large predators – lion, cheetah
- Smaller predators – suricat, jackal, Cape fox, bat-eared fox
- Good sightings of large birds of prey
- Waterhole gatherings of various species
- Dusty and atmospheric evenings as animals kick up dust
- Dry conditions mean large gatherings of animals moving through the reserve
- Small mammals like ground squirrels abound in the restcamps
- Dry riverbeds offer stunning landscapes
- Lone camel-thorn trees standing proud against the Kalahari sky with dramatic thunderclouds in the background
- True wilderness

# Shem's photography rating out of 10

| Photographic subject | Abundance | Viewing | Photography potential |
|---|---|---|---|
| Landscape | 5 | 6 | 6 |
| Birds | 7 | 8 | 7 |
| Mammals | 7 | 8 | 8 |
| Predators | 7 | 8 | 7 |
| Big 5 | 3 | 3 | 3 |
| Overall experience | 7/10 | | |

# Photographic equipment suggestions

| Photo skill level | Equipment |
|---|---|
| Beginner to intermediate to advanced | • 1–2 pro-sumer camera bodies<br>• Pro-body if you want to capture action and birds in flight<br>• Long lenses 400–600mm are beneficial<br>• Wide-angle lens is needed for landscapes: 14–70mm<br>• Medium lens for mammals that come closer and also for in-camp work on small mammals: 70–200mm |

# Other information

| Accessibility | Cost value | Popularity |
|---|---|---|
| Easy once there; long drives from major centres; fly into Upington and rent vehicle | Affordable | Very high |

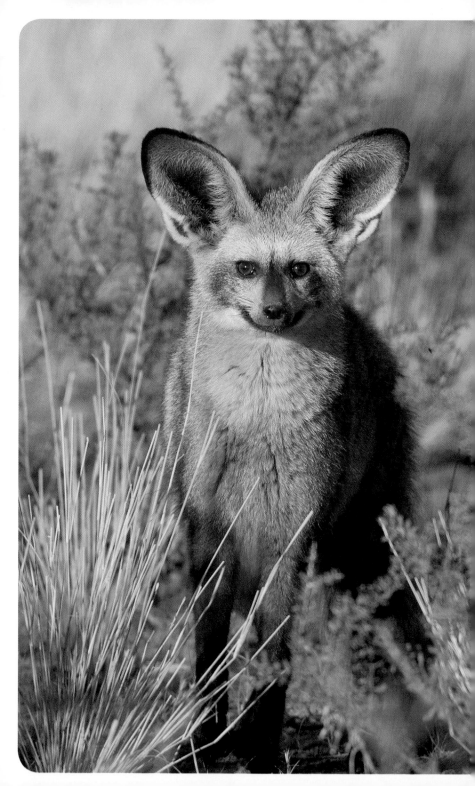

27° 13' 30" S
22° 28' 40" E

# Tswalu
# Kalahari Private
# Nature Reserve,
# Near Hotazel,
# Northern Cape

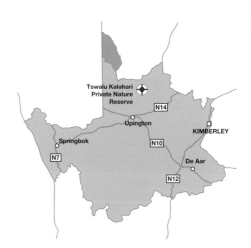

## Background

As with many private nature reserves, Tswalu Kalahari originally comprised of many separate cattle farms. Once the properties were consolidated, the area was used as a hunting farm – this was not very favourable for wildlife viewing or wildlife photography. In 1998 the Oppenheimer family purchased the farm. All hunting was immediately stopped and the area was allowed to recover, or as the Tswalu motto has become: "To restore the Kalahari to itself". A look at photographs from the 1950s will show a huge difference in the landscape and vegetation between then and now. An overgrazed farm of Kalahari sands is now covered in flowing dune grasses. The dune tops are alive with silver cluster-leaf terminalia trees which host the stunning jewel beetles, and the acacias in the dune alleys provide ample nesting sites for the numerous desert birds.

The conservation foresight of the Oppenheimer family is evidenced in the magnificence of the reserve, defined by two main characters: rolling red sand dunes and large camel-thorn trees. When among these dunes and thorn trees, you will know for certain that you are in the Kalahari.

Now over 100 000ha large and with accommodation restricted to two lodges, a visit to Tswalu Kalahari is one of the greatest wilderness

◀ A feature of Tswalu is seeing and photographing the bat-eared fox.

215

experiences you will encounter in South Africa. It is in this unique wilderness area that Tswalu Kalahari reveals its true potential – for this semi-desert offers some excellent wildlife viewing and photography. Suricats, aardvark, ground squirrels, Hartmann's mountain zebra and sandgrouse are some of the unusual species that Tswalu offers.

# The reserve

Tswalu's attraction is both the semi-desert species; and your extraordinary access to them. Accommodation at Tswalu is in luxury private lodges. On its game drives, you may feel as though you own a piece of Africa. This intimate experience, you and the ranger, allows you to encounter the magic of the Kalahari. Another advantage is that, at the discretion of your ranger, you may get out of your vehicle to get a different angle on your subjects. These opportunities are few and far between in reserves and will allow you a huge amount of creative latitude when photographing the smaller animals.

But what to photograph? Tswalu Kalahari is an excellent place to spend time with suricats, also commonly known as meerkats. There are a number of families of these charming characters on the reserve. Most of them are quite relaxed around humans and, as you will have complete flexibility with regard to how long you spend at sightings, Tswalu is a wonderful place for suricat images. In the cooler months from April to September, they spend their early mornings and late afternoons sunbathing. This is the perfect time to photograph them, as the light is at its best during these hours. Ground squirrels, with their beautiful thick tails and large attractive eyes are the other small mammals that steal the scene at Tswalu. They may co-habit burrows with suricats and are often seen together.

During the months November to March, and especially after good rains, Tswalu turns into a floral wonderland. Bright yellow devils-thorn flowers carpet many parts of the reserve. The ground squirrels favour these areas and this grouping makes for one of the most enchanting photographic scenes in nature.

In terms of larger mammals, Tswalu offers the possibility of encounters with some unusual and unique species. In South Africa this is the only

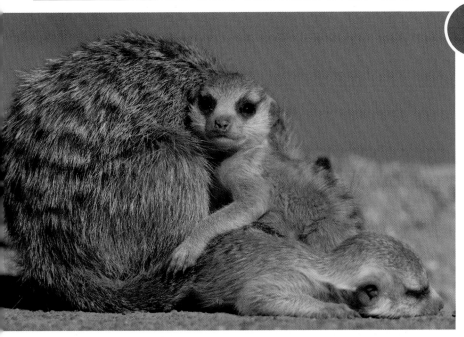

▲ Tswalu offers some of the best and most intimate photography of suricats in South Africa.

▼ After the rains in January to February, the devils thorn flowers erupt in profusion, turning the desert into a wildflower garden.

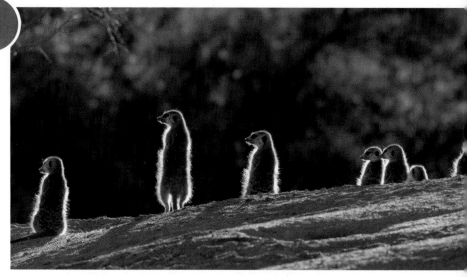

▲ In the cold months, suricats like to sun themselves in the early mornings – perfect for creative photography.

▼ Free-roaming cheetah are easily approachable, allowing for close-up portraits.

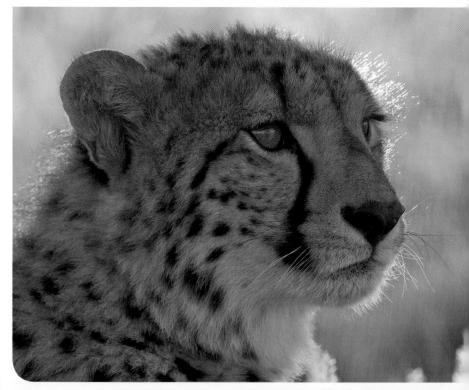

place to find Hartmann's mountain zebra, usually in the mountains of arid Namibia where they are at the eastern end of their range extension. Easily spotted on the rocky mountain slopes, their distinctive dewlaps are their most prominent feature. Photographing them is relatively easy, especially as your ranger is likely to know their movements. In the dry season they are easier to locate as they come to drink at regular times.

You will also enjoy unusually good sightings of aardvark, one of the most difficult animals to locate in the wild. Their secretive nature and nocturnal habits mean that sightings of them are quite rare. However, Tswalu Kalahari is unusual in this regard and from June to August sightings of aardvark in the daytime are relatively frequent. I have seen as many as three in one afternoon! If you are careful and stalk slowly, you should be able to get really close to them which provides the rare opportunity to watch them as they go about their normal business. Observing them as they hop along with their pig-like looks and unique behaviour is a fascinating experience.

Tswalu Kalahari also offers good sightings of lion in a separate 33 000ha reserve. Cheetah, eland, bat-eared fox, steenbok, blue wildebeest, gemsbok or oryx, black rhino, white rhino, sable, roan and kudu are all found in high numbers on the main reserve. Most ungulates are quite skittish and photographing them can be tricky.

The bird photography here is very good. You can easily get good images of Burchell's sandgrouse and African quailfinch when they come to the waterholes, sociable weavers at nest, southern pale chanting goshawk, yellow canary, Kalahari scrub-robin, pygmy falcon, chat flycatcher and white-browed sparrow-weaver. There are many other birds in the park but those listed above are regulars and easily photographed.

Besides the mammals and birds, Tswalu offers some of the clearest night skies you will ever see. Night-time star photography is a wonderful possibility as there is no light pollution anywhere nearby.

# Photography and equipment

You will be photographing from an open game-drive vehicle most of the time. A monopod or tripod for support is very handy here. I find beanbags invaluable when photographing from a vehicle, as you can move them about with ease and they provide excellent support. Photographically, Tswalu will command every lens you can muster. Wide-angle lenses are a must to capture the vast skies and open landscapes. Any lens from 400–600 will be sufficient for the extreme end of your range. The most-used focal length will be between 100–400mm. The suricats and ground squirrels allow you to come close enough for a 200mm lens.

Remember that a wide-angle lens can also be used with the smaller creatures to show the different perspective. Unless you are specifically photographing birds in flight (sandgrouse at waterhole), a normal SLR camera will be adequate for your needs here. The fact that you can get low-angle images of the smaller creatures is a huge creative benefit, and using a beanbag or tripod here is highly recommended, especially if with a long lens.

# Getting there/accommodation

Most guests arrive by a charter flight from Johannesburg, although it is possible to drive to the reserve. It is a 7-hour drive from Johannesburg, and about 90 minutes north of Kuruman.

Accommodation is at one of two lodges in Tswalu, Motse and Tarkuni. You have to book Tarkuni as a complete unit, while Motse operates as a normal lodge. Prices are at the very high end of the accommodation scale but can expect only the best in luxury at Tswalu. Bookings can be made through the reservations office: +27 (0) 11 274 2299; email: res@ tswalu.com

Tswalu Kalahari is a member of the Diamond Route
www.diamondroute.co.za

▲ A lone oryx walks along the crest of a red sand dune.

▼ Hartman's mountain zebra are a localised speciality – this is the only place in South Africa where you can find them.

## Highlights

- Close-up encounters with one of the most charismatic mammals in South Africa – the suricat
- Great photography of ground squirrels
- At certain times of year unparalleled viewing of aardvark
- Decent arid bird photography
- Only place in South Africa to photograph Hartmann's mountain zebra
- Excellent night-sky photography
- Stunning location
- Good Kalahari lion sightings
- Decent viewing and photography of plains animals
- Wilderness experience

# Shem's photography rating out of 10

| Photographic subject | Abundance | Viewing | Photography potential |
|---|---|---|---|
| Landscape | 8 | 7 | 5 |
| Birds | 7 | 6 | 7 |
| Mammals | 6 | 8 | 8 |
| Predators | 2 | 5 | 5 |
| Big 5 | - | - | - |
| Overall experience | 7/10 | | |

# Photographic equipment suggestions

| Photo skill level | Equipment |
|---|---|
| Beginner to intermediate to advanced | • Pro-sumer camera body<br>• Long lenses 400–600mm are beneficial<br>• Wide-angle lens is needed for landscapes and star trails: 14–70mm<br>• Medium lens for close-up work of small mammals: 70–200mm |

# Other information

| Accessibility | Cost value | Popularity |
|---|---|---|
| Easy by vehicle; charter flights from Johannesburg | Top end | Average |

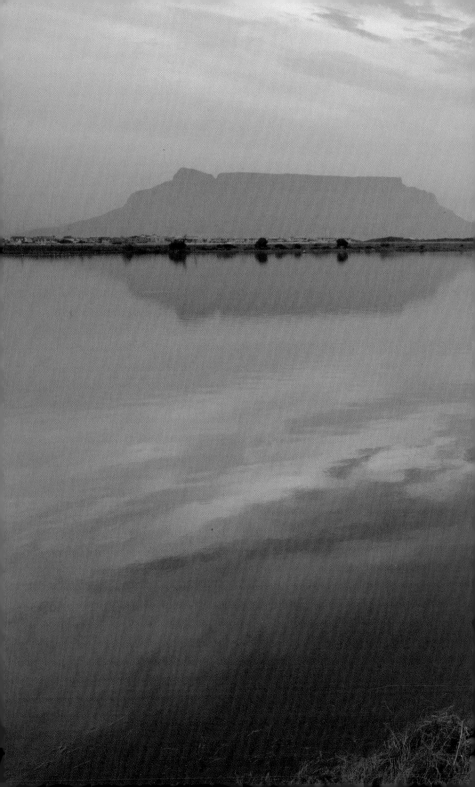

# Western Cape

# Western Cape Introduction

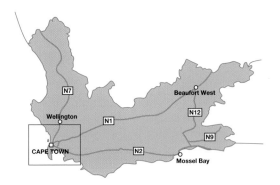

The Western Cape offers a great deal more for the nature photographer than might be originally expected. Although it lacks the numbers of large mammals, it has some excellent avian and landscape photographic opportunities. This chapter details a number of locations, which are top-class wildlife photo destinations.

The city of Cape Town lies in an impossibly beautiful setting and the buttress of Table Mountain is one of the most easily recognised and prominent landmarks known to the ocean-faring world. Before the area was settled, the lower slopes of Table Mountain stretching through to the lower-lying areas held large numbers of wildlife. This all changed once humans came into the picture and Cape Town became the major port on the tip of Africa, and chances of an established animal population declined.

Today the city of Cape Town has spread across the peninsula and stretches as far as Stellenbosch. You would need a certain optimism to think that good wildlife photography could be achieved within the city limits. Yet birdlife within the city is prolific and bird photography can be very good.

◄ As well as good birdlife, the Cape coastline offers some world-class seascape photography.

North of Cape Town itself you will find the only land-based breeding colony of Cape gannets in South Africa. They are within easy reach of your camera and this makes an excellent day trip out of the city.

With much of the province lying among large mountains, landscape photography is high on the agenda. The abutment of Table Mountain is an excellent feature in landscape photos, but if you travel just an hour from the city, you will discover one of the holy grails of landscape photography: Clarens Drive and the "Golden Mile". Here the scenery is spectacular, the ocean is clean and the rocks jut out of the mountains like spires pointing towards the Hottentots-Holland Mountains. The drive along here offers an unprecedented variety of landscapes along a very short stretch of road.

This province is also home to one of the most spectacular scenes to be found in the oceans: great white sharks actively hunting Cape fur seals at Seal Island in False Bay. This is a unique world-class natural history experience and will rank as one of the most exciting wildlife photography events you will ever have the opportunity to capture. This, together with its many excellent and varied subjects, makes the Western Cape a very popular destination for wildlife photography.

Boulders beach provides a perfect setting for photographing penguins.  ▶

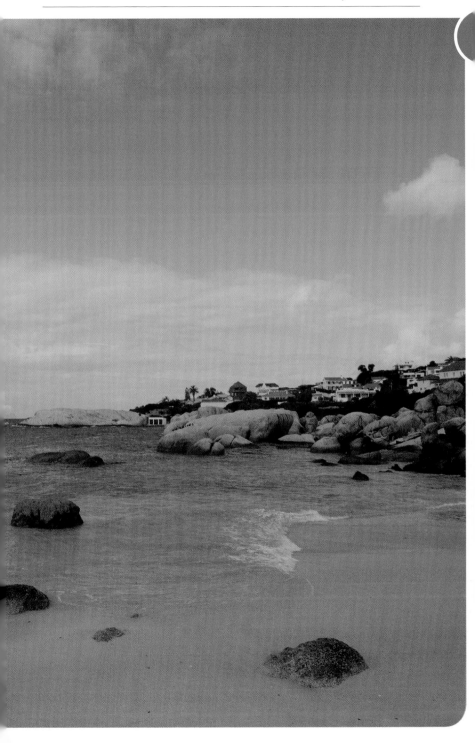

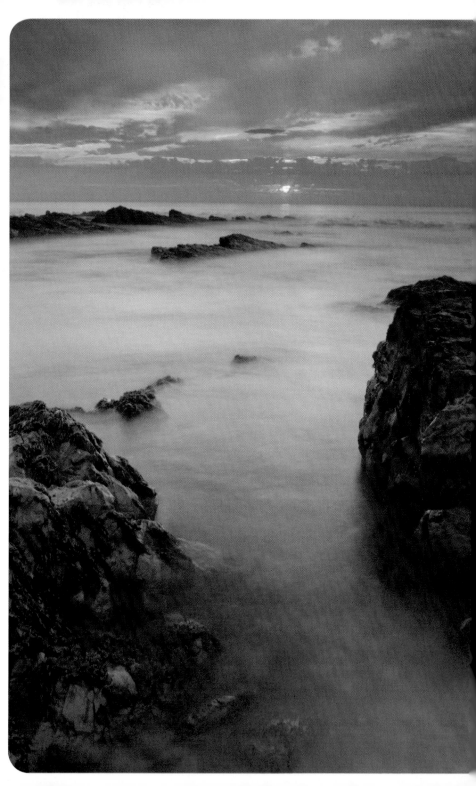

33° 58' 00" S
18° 25' 30" E

# Table Mountain
# National Park

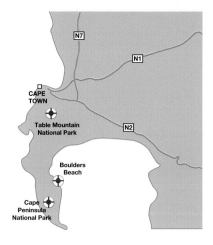

In among the many towns and cities that make up the greater Cape Town, South African National Parks protects and conserves a series of special and significantly important areas along the Cape Peninsula. These include Table Mountain, Boulders Beach, Cape of Good Hope Reserve, Silvermine, Lions Head, Signal Hill and some indigenous forests and beaches. These are all beautiful areas to spend leisure time in, but two of them stand out from a wildlife and landscape photography point of view – Boulders Beach and Cape of Good Hope Reserve.

## Boulders Beach/Reserve   34° 11' 49.2" S   18° 27' 3.6" E

Situated close to Simon's Town is a series of beaches dotted with large boulders. It is a protected bay, the sea is relatively calm and the vegetation grows right up to the beach. The soft soil and the cover the vegetation provides, is excellent for African penguins to breed in. Since 1982 this colony has grown from two breeding pairs into a now permanent population of 3 000. Formerly known as jackass penguins due to their loud, donkey-like braying call, these birds make excellent photographic subjects. They have charisma, are good looking and they waddle around on land in a very humorous fashion – all characteristics that provide great photographic opportunities. They are present all year round and are the only penguin species to breed in Africa. Breeding activity happens mainly in January although they can breed any time of the year.

▼  Look around Cape Town and you will find seascapes are on offer everywhere.

You enter the reserve through the SANParks gate, where an entry fee is required. It is best to get here early in the morning, when the light is still soft and shining over Table Bay. A series of boardwalks leads you down to Foxy Beach, where you will find the highest concentrations of penguins. Many of the paths the penguins use pass right below the boardwalk and as these paths are quite steep, you are able to place yourself at eye level of the birds. If you sit quietly, the birds will come waddling right past you, which allows for some fantastic close-up portraits. A wide-angle lens can also be used to show them in their environment.

At the beach itself you may, if you are lucky, spot some penguins in the surf. However, this beach is popular with visitors and consequently there aren't many birds here. A penguin swimming through the surf onto the beach, is a special sight, especially in the crystal clear waters of the Atlantic Ocean.

## Photography and equipment

A medium-length focal length will be adequate for portrait images of the penguins: a 70–200mm will be perfect. You can use a wide-angle lens to get really close and show a different perspective of the birds in the environment. The steep-sided sand dunes allow you to get nice low perspectives on the penguins as they come out of their burrows and down the paths. If you have the opportunity of photographing them coming out of the surf, a longer lens will be handy. A 400mm on a tripod will be adequate for that type of image.

## Getting there

Follow the M4 through Simon's Town going south. As you pass through the town, you will see signs pointing left down Seaforth Road to the reserve. The road turns right into Kleintuin Road, which leads to the actual reception and entrance.

The reserve's opening times are based on the hours of sunrise and sunset and change with the seasons. April–September 08:00–17:00; December–February 07:00–19:30; and October–November 08:00–18:30.

The penguins walk so close to the boardwalk that you can get an eye-level shot. ▶

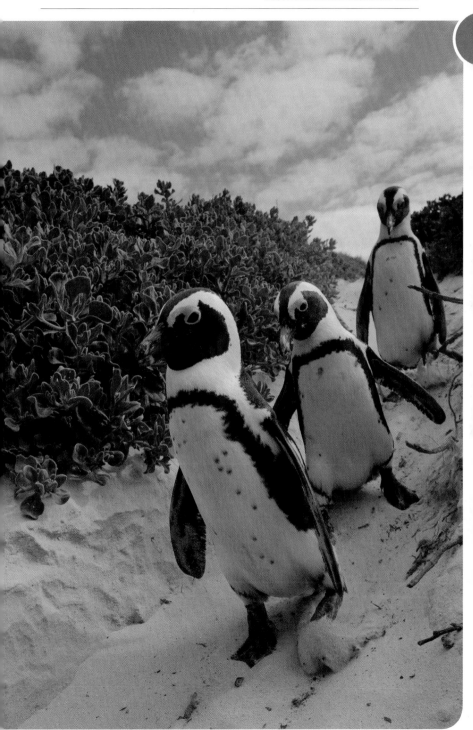

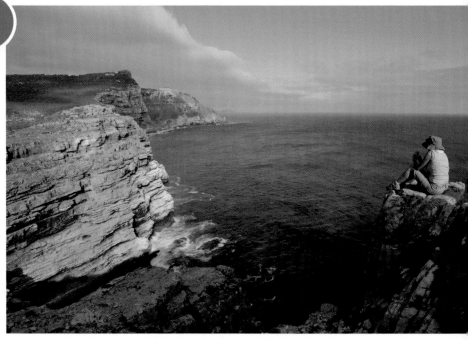

▲▼   Views from Cape of Good Hope Point give different perspectives than from Cape Point.

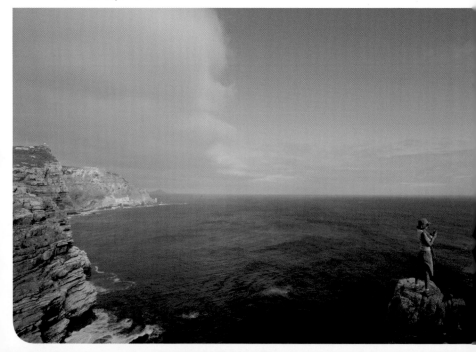

# Cape of Good Hope Reserve

34° 15' 29.85" S    18° 27' 20.14" E

Situated at the southern-most tip of the peninsula is the Cape of Good Hope Reserve. The highlight of this reserve is its fantastic beaches and the spectacular Cape Point, which juts prominently out into the Atlantic Ocean. The reserve differs from most others in that it allows for recreational activities, such as fishing and surfing, and weekends can be busy with both tourists and locals.

Beaches, such as Buffels Bay and Diaz, are magnificent with their untouched white sands and often crystal-clear waters lined with rocks on either side jutting out into the ocean. The reserve has gate times that limit your twilight sessions and mean you are not able to use the last sunlight. This is overcome by staying in one of the accommodation facilities on the reserve where you will have the freedom to stay out later photographing landscapes.

Cape Point is a highly recommended visit. The popular walk up to the viewpoint offers some great seascapes over the Atlantic Ocean with the tip of Africa protruding into the vast sea. After this view, drive to the Cape of Good Hope section and walk up the less-traversed rock pathway to the walkway on top of the point.

This view offers you a different perspective of Cape Point, the rocky boulders in the ocean and the white sands of Diaz Beach below make for strong compositional elements in your landscape photographs. I find this area better for good land- and seascapes than the more popular Cape Point. You are able to locate good compositions without having any tourists walking into your image. The natural curve of the bay leads strongly towards Cape Point, making it compositionally quite easy on the eye. The boulders and sheer cliffs also add another element to the composition of your images.

## Photography and equipment

If you are unable to stay here for the twilight, plan to take your images in daylight. By using a polariser filter you will be able to cut out the glare from the water and also slow down your shutter speed, which will blur the water. A neutral density filter will also help you to get a slower exposure. However, for this you will need a tripod to stabilise the camera. Wide-angle lenses are very useful and I would recommend anything from 12–50mm as adequate. Your camera body can be a consumer-prosumer SLR as you won't need any high-speed functionality. As you will be walking up rocky paths, a comfortable day-camera backpack is recommended. The nature of the landscape at the Cape of Good Hope presents great photographic opportunities and result in some very striking images. Cloudy weather will not help your experience. A clear, calm day with some clouds is the ideal scenario for excellent images.

## Getting there

The reserve is very well sign posted from the southern-most towns on the peninsula. Coming from Simon's Town on the M4, continue south until you see the reserve sign posted on your left. You can also follow the M65 out of Simon's Town, which will lead you to the reserve. If you are travelling from Kommetjie/Scarborough, follow the road south until you see the reserve on your right. There is a self-catering guesthouse and cottage accommodation inside the reserve which you need to book through SANParks' reservation office.

The reserve offers excellent seascape photography if you book to stay in the accommodation on offer. ▶

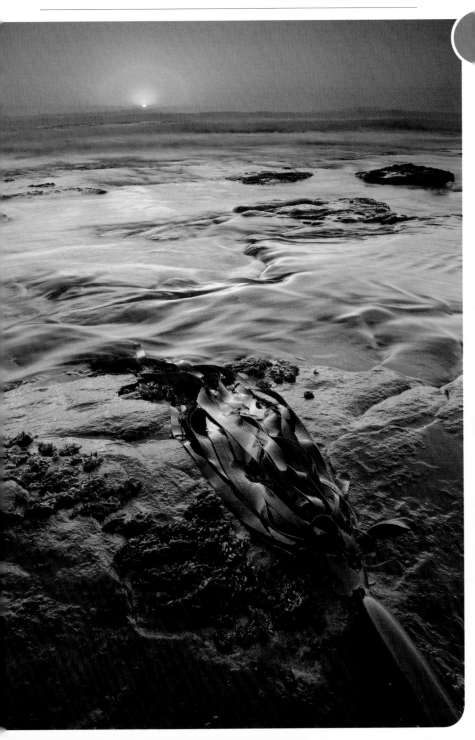

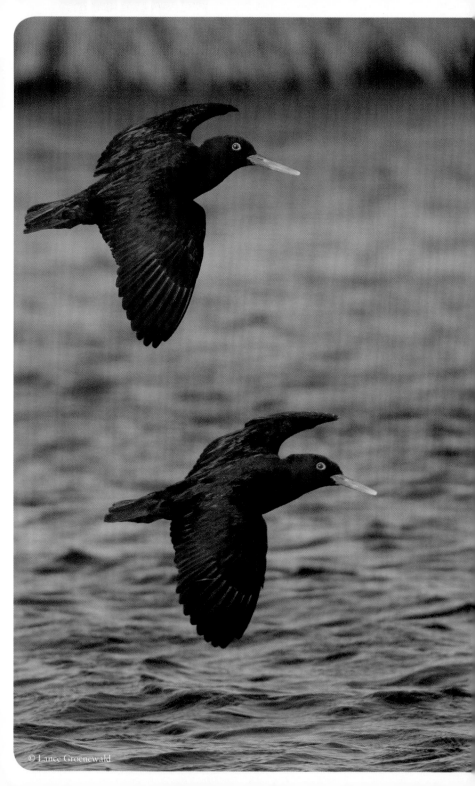

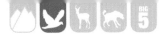

33° 52' 51.94" S
18° 29' 26.96" E

# Milnerton
# Lagoon,
# Milnerton

Bordered on one side by a golf course housing estate and the busy Marine Drive on the east, Milnerton Lagoon does not appear to offer the bird photographer much promise. Indeed, the water doesn't always look that clean and there is some litter around on the banks. But if you know the secrets of the place, it can offer some spectacular waterbird feeding and bird-in-flight images.

The lagoon lies in a north/south direction and as you can't get access to the golf course side, you are only able to photograph from the eastern shore, meaning it is best for morning photography. Along with that, you will also need to time your visit to coincide with low tide.

Connected as it is with the ocean, the lagoon is tidal. At high tide, many of the birds either move away, or roost in the trees on various islands or along the banks and their distance makes photographing them difficult. However, at low tide the water drains away just enough to trap fish in some shallow pools. These pools become feeding ponds for the waiting birds. It is then that Milnerton Lagoon shows her true potential.

Little egrets, grey herons, African darters, white-breasted cormorants, malachite, pied and giant kingfishers, swift terns, and kelp and Hartlaub's gulls all take part in the feast, ignoring any photographers sitting quietly on the bank. The water reflects the blue of the sky and makes an excellent backdrop, and the way that the colourful birds are warmly lit by the

◄ A pair of African black oystercatchers provide a great photographic challenge as they fly down Milnerton Lagoon.

239

morning sunlight makes a truly "zinging" image. Be sure to visit on a sunny morning as a bright blue sky and sunlight are needed to make your photos look great.

Look out for perches along the bank. By sitting quietly near to them you should be able to get close-up images of pied kingfishers, who are the most frequent users of these perches. There is an island on which many of the birds roost. As the birds fly to and from the island this is a great spot to get incoming flight photographs.

# Photography and equipment

You will need your long lenses and 500–600mm lenses to get full-frame images of the birds on the perches as well as in flight. If you want to get high-action images of birds in flight, you will need a pro-sumer/professional camera. This will ensure your equipment can focus fast enough and also have a high frames-per-second count, enabling you to capture every motion of the bird. A tripod with fluid head/Wimberley is also essential to support your lens and pan with the birds as they fly past.

To avoid disturbing the birds a small portable hide or camouflage netting is a way to break the silhouette of the human form. The grass is often damp and slightly muddy so wear old clothes that you won't mind getting dirty. Be aware of the golf course in the background to avoid having a golfer swinging his club in your photograph.

Taking all factors into consideration, this is a spot for intermediate and advanced photographers.

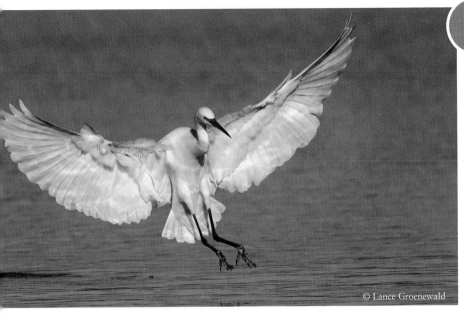

© Lance Groenewald

▲ At low tide, the water in Milnerton Lagoon traps fish, attracting waterbirds like this little egret.

▼ The perches alongside Milnerton Lagoon are favourites of pied kingfishers.

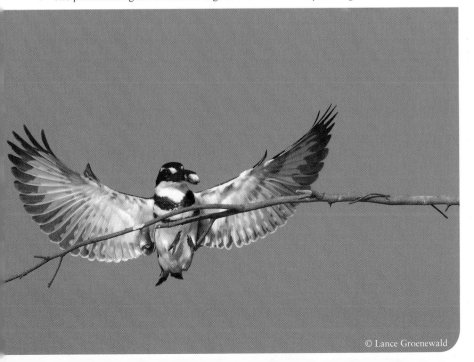

© Lance Groenewald

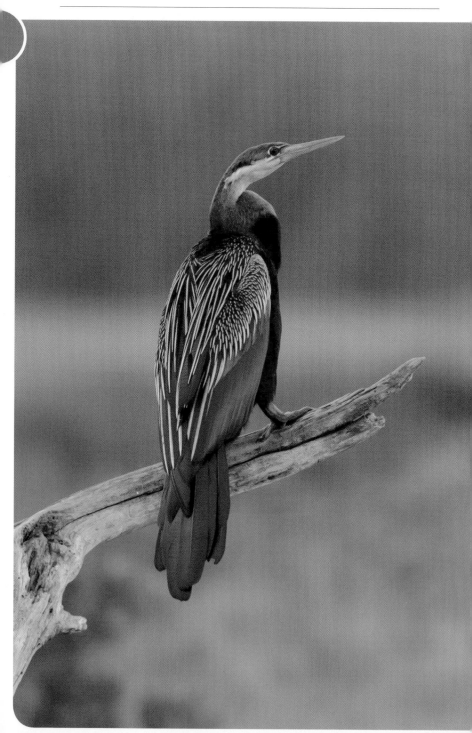

# Getting there

Take Marine Drive (R27) north from Paarden Eiland (it becomes Otto du Plessis as it runs north). You will notice the lagoon on your left (western side of Marine Drive). You will pass "Woodbridge" which crosses the lagoon. You can start photographing anywhere north of the bridge for about 2km.

The area is open to the public and you can park your car anywhere along the side of the road. On the corner of Broad Street and Otto du Plessis, about 2km north of Woodbridge, you will see a pump house on the left. This is a very popular spot for birds to feed during low tide.

You could also try another area, about 500m north of the pump house, where a small concrete bridge leads you onto an island. This brings you to the main part of the lagoon. Here another small island holds many roosting birds and some breeding birds. This is a good spot as a lot of bird activity happens here.

There are no formal pay facilities. As anyone can walk through the area, be aware of personal safety.

◄  An African darter peches in Milnerton. Taken with a 600mm lens.

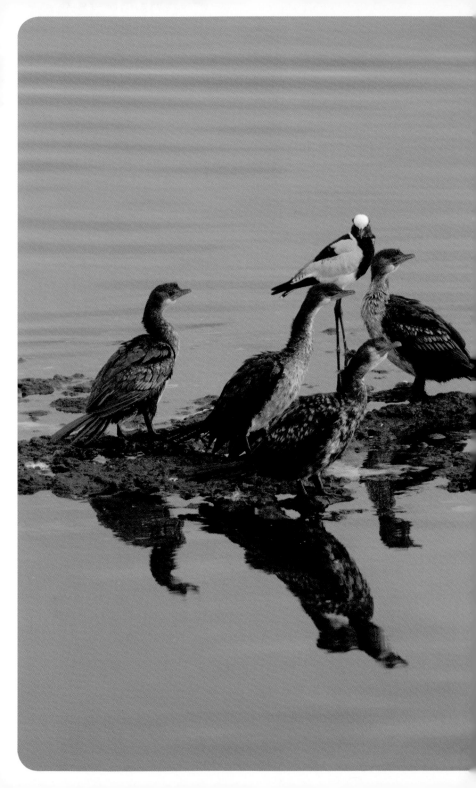

33° 50' 8.25" S
18° 29' 35.45" E

# Rietvlei Nature Reserve, Milnerton Table View

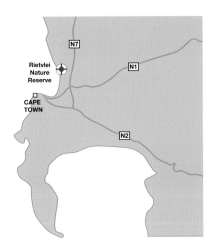

Rietvlei is situated on the fresh water Diep River that flows through a wetland into the saline Milnerton Lagoon. It is a protected area and certain parts of the water are set aside for sailing and fishing. As with Milnerton, the birdlife is very abundant and diverse with as many as 10 000 birds being counted in the summer. Unlike Milnerton's shallow water space, here one finds a large expanse of water which makes photographing a lot more difficult and more dedication is required to get good results. It does however offer the opportunity to see and photograph greater flamingos and pink-backed pelicans which are often seen in the waters.

Although there are two bird hides that overlook the reserve's water expanses, the most productive way to get photographs is to patrol the shoreline along the paths towards the hides. Here birds perch on old trees and dead branches and fish in the shallow waters. This allows for some great photo opportunities, albeit a little random, so could result in a frustrating morning's photography. However, the large number of birds moving through the reserve means you should have at least a few opportunities to photograph birds flying past.

Expect to see grey heron, yellow-billed duck, swift tern, cape spurfowl, little egrets, kelp gulls, white-breasted cormorant and Hartlaub's gulls along the water's edge as you walk along. Rietvlei caters for the dedicated, advanced photographer who has time to spend studying the behaviour of particular birds in order to get their photos.

◀ You can find a multitude of bird species fishing in the waters.

245

# Photography and equipment

Due to the nature of the photography at Rietvlei, you will need a long lens in the line of 500–600mm with good pro-sumer/professional camera body to be as accurate in acquiring focus as possible. As you will be walking along the shoreline, a monopod could come in very handy here. A tripod can also be used, but it is not as easy to carry around. A small portable hide or camouflage netting may be handy to stake out some of the prominent perches. You will be on your feet for most of your photography time here so good walking shoes will be helpful.

# Getting there

The reserve wetland is next to the west coast road (R27). Coming from the city, drive north on the R27 (Marine Drive becomes Otto du Plessis). As you pass the wetland on your right, you turn right into Blauuwberg. Follow this until you again turn right into Grey Avenue, which will lead you to the entrance of the reserve where you pay a small entrance fee.

There are fixed open and closing times, based on sunrise and sunset.

Where else do you find greater flamingos withhin sight of the city? Taken from Rietvlei with the city as a backdrop. ▶

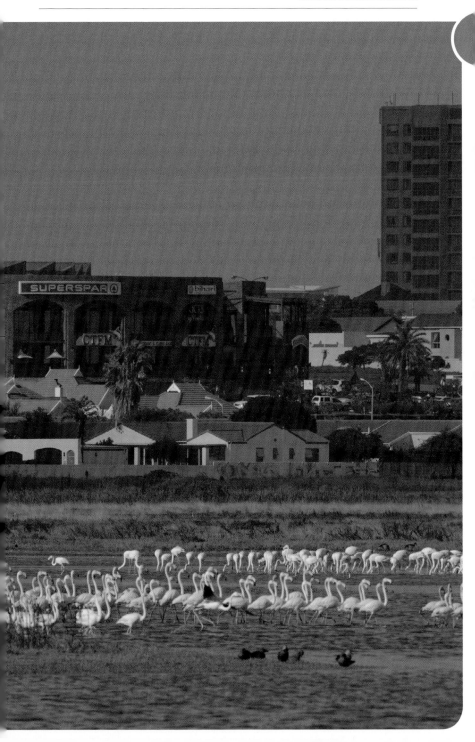

33° 53' 21.95" S
18° 30' 52.22" E

# Intaka Island, Century City

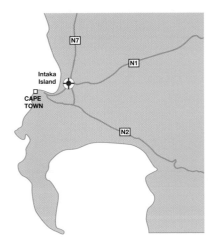

Situated within the confines of the large Century City shopping complex, Intaka Island is an artificial island created on a river that runs naturally through the area. The whole wetland is 16ha in size, with 8ha having been reconstructed, providing a green lung in the midst of the buildings. The islands in the water are perfect perches for birds to roost and breed, and many birds now nest there annually. The 2km walk through the waterways provides excellent access to many species of birds, particularly waterbirds. The heronry is the highlight, especially in the breeding season when the birds are in full plumage and there is constant activity.

You can expect to see southern red bishop, white-breasted cormorant, African spoonbill, sacred ibis, purple heron, red-knobbed coot, Egyptian goose and African purple swamphen. Many of the birds fly out to feeding grounds in the early morning and then return in the afternoon, and these are the best times to be here for photography. The advantage of photographing here is your proximity to the birds which can sometimes fly right over you! Being in a built-up area, you will need to take care so as not to get buildings in your images.

There is a nominal entry fee to use the walkways and it is open from 07h00 to 19h30 seven days a week.

◀ A great white pelican glides gracefully on one of Intaka islands' ponds.

# Betty's Bay and Surrounds, Clarens Drive to Kleinmond

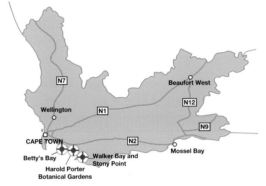

## Background

Clarens Drive starts just outside Gordon's Bay and seems to hug the mountainside precariously just above the ocean. It is one of the most scenically beautiful roads in South Africa and extends all the way to Kleinmond. This total distance is only 50km, yet within this short distance one finds some of the most photogenic landscape and seascape locations in the country. If ever there was the "Golden Mile" of landscape photo opportunities, then this is it.

Setting off from Gordon's Bay the road hugs the western side of the mountain, the Atlantic Ocean rolls in below and offers stunning views over False Bay. After 15km, the road rounds the shoulder of the mountain towards the east and the scene that greets you is one of sheer delight. The enormous bay that lies before you leads towards the Hottentots-Holland Mountains and on towards the massive landmark at the southern tip, Hangklip or Hanging Rock. This scene invites photographs, but it is only the beginning of a series of magnificent views. Driving further along, Kogel Bay Beach appears dwarfed by the mountains above, allowing great difference in scale in your scenes. The surf line of beach is littered with smooth rocks, offering further temptations to stop and photograph. Driving further, you turn towards Pringle Bay and then onwards to Betty's

◀ Silverstroomstrand's clean beach and turquoise waters are perfect for composing seascapes.

251

Bay where you will find the beautiful beach of Silverstroomstrand with its talcum powder white sands and large sand dune on the eastern side. As you head towards Kleinmond, the road veers inland. Although this is the end of Clarens Drive, Kleinmond has a series of small lagoons that offer some beautiful reflection scenes: a fitting end to a beautiful drive.

The Golden Mile of Clarens Drive is one that invites photographs at almost every corner. It attracts landscape photographers from all over the country trying to capture its wild oceans, large mountains and white beaches. This combination of factors makes it a place that you will want to return to in order to get the best image possible. The way that the ocean, the weather and the sun are always changing increases the challenge. A test of your photography skills will be how you are able to do justice to the scenes in front of you the first time around. The scenes along Clarens Drive are one of the few places that can overwhelm you. That is the sheer beauty of the place.

# The area

The main attraction of the area is how accessible it is. Almost all the photo locations are within walking distance from the roadside. I'll comment on each location going from Gordons Bay towards Betty's Bay.

### Kogel Bay View  34° 12' 11.49" S   18° 49' 20.48" E

The first real photo opportunity is as the road turns east into Kogel Bay. There are a few designated view areas where you can turn off the road and park your vehicle. It is the first one, at almost the highest point in the road, which you want. This viewpoint commands a view over the whole bay, as you look east and south. There is a small path leading down the hill through the fynbos onto a rock ledge. From here, there is a series of rock strata that lead straight out into the ocean and towards the mountains in the background. This is one of the most famous landscape photo spots in South Africa and as you arrive on the rock ledge, you will recognise it. The lead-in lines, the curve of the bay and the mountains in the background offer everything a landscape photographer could require. It is best to be here in the late afternoon with the sun lighting up the mountains in the distance and hopefully any clouds in the sky.

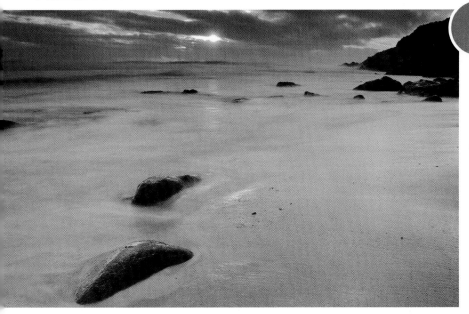

▲ From Kogel Beach you can also photograph westwards to get the sun in your images.

▼ The beach at Kogel Bay has smooth boulders that provide excellent foreground interest leading to the mountains behind.

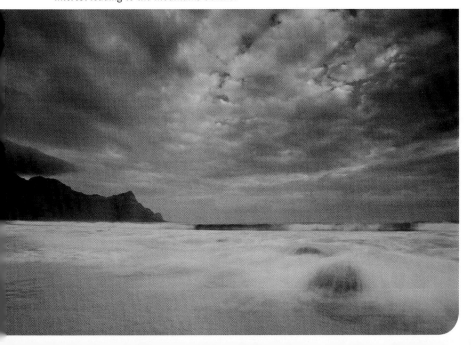

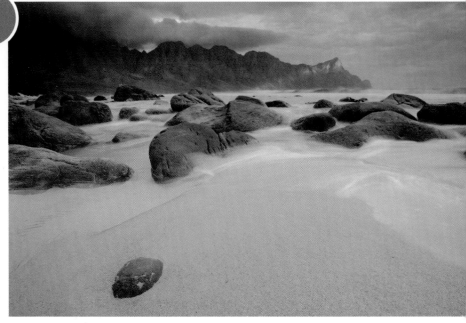

▲ Another view of the Kogel Bay boulders.

▼ The start of the "Golden Mile" of landscape photography in South Africa, with Hangklip in the background.

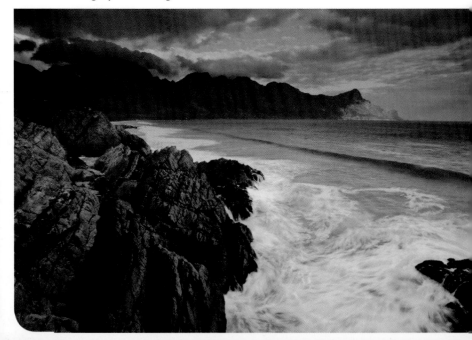

## Kogel Bay and Beach   34° 12' 11.49" S   18° 49' 20.48" E

Driving on the road gets you close to the beach. On the western side of the beach, large boulders are scattered in the sand. A small stream flows down through them and into the sea. The scope for some water-motion blur images around the smooth rocks with the mountains in the background is again very appetising. Be prepared to get your feet and tripod wet. Getting in amongst the wave action will emphasis the motion blur of the water and allow you some strong foreground interest. You are able to photograph east and west here, which helps your selection when choosing a composition.

On the far eastern side of the beach lies a group of tightly grouped, very round boulders. At the correct tide, these are washed over by the ocean. A long exposure creates a beautiful misty effect over them. The composition is more difficult than on the western side of the beach, but the effort is well worth it considering the beauty of the foreground boulders.

The drive onwards to Pringle Pay goes right under the steep side of the mountain. As you enter Pringle Bay, a small beach overlooks False Bay and opportunities exist on looking west towards False Bay and Kogel Bay from where you have just come.

## Betty's Bay   34° 22' 00" S   18° 56' 00" E

As you drive into Betty's Bay you can take any of the small roads to the right. They will lead you to Silverstroomstrand. This is a beautiful beach with white sand and mostly a beautifully turquoise-blue ocean, the combination of which makes for some clean compositions. A large dune on the western side provides a good background to the scene with opportunities for good photos if you walk closer to it, with textured lines and small pieces of grass growing out of its white surface. As the beach faces due south, you can photograph here in the morning and evening, as the sun will come from either side. This is one of the main factors making it such a photogenic beach. Concentrate on the wave action, pieces of kelp, clouds in the sky and shells in the sand to aid your composition. Simplicity is the key here and with the white sand complimenting the colour of the water so well, you should have no trouble in finding inspiration.

## Harold Porter Botanical Gardens   34° 21' 6.3" S   18° 55' 36.8" E

A largely unknown garden, this area holds a few great treasures for landscape and bird photographers alike. There are two waterfalls in the gardens that offer some good landscape images: Disa and Leopard gorges. Both these require quite a walk to get to, but are very rewarding from a photography point of view. They lie in dense forested valleys and there is no problem in getting there in the middle of the day, as hardly any sunlight penetrates through the canopy. If you are heading to Leopard Gorge, you need to leave early in the day. It is a long walk and the garden authorities will not allow you to go after 14:00.

Another attraction of the gardens, other than landscapes, is the Cape sugarbirds. The dense stands of proteas along the mountain edges are actively defended by beautiful male sugarbirds. If you set up your long lens and camera at one of these stands and wait patiently, you will eventually get a sugarbird coming onto the flower stand. They pay no attention to you and go about their business, using favourite perches and flight paths among the various flowers. With some patience and observation, you should be able to easily get to within a few metres of them, making for some beautiful images in among the protea and erica flowers. Orange-breasted sunbirds also visit the erica blooms and are common, but are quite aware of human presence and keep their distance. A tripod and a 500mm lens will be enough to get you close enough for some portrait images of the birds. The gardens are open from 08:00 to 16:40 all year round.

## Kleinmond and Walker Bay   34° 20' 32.05" S   19° 2' 10.30" E

Clarens Drive officially ends at Kleinmond, where it turns inland. Kleinmond has a series of small, shallow lagoons near the ocean. Especially at dawn, when conditions are very still and calm, the reflection along these shallow flats makes for great images. You can include human elements, such as brightly coloured paddle boats or old wooden bridges in the scenes to give them a travel feel. Either way, the reflections just ask for a camera to be brought out.

The photographing does not stop there. All along the coast, from Hermanus to Walker Bay, there are many locations that offer good landscape photography. You do lose the height advantage of the

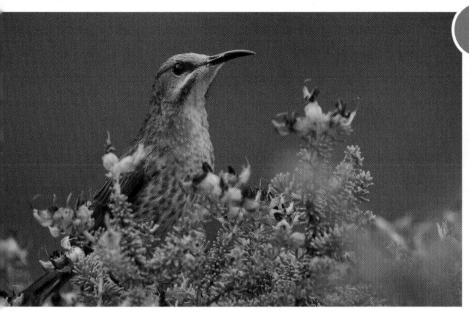

▲ Harold Porter Botanical Gardens offers some great specials, Cape sugarbird at close quarters being one of them.

▼ Grassbird is another species that can easily be found in Harold Porter Botanical Gardens.

▲ Stony Point in Betty's Bay offers some great close-up photography of African penguins.

▼ Rock hyrax at Stony Point are common and very relaxed, especially when sun bathing.

mountains in the background, but the whole area is very productive with good photo opportunities.

## Stony Point/African penguins   34° 22' 21.11" S   18° 53' 37.24" E

While most people head to Boulders Beach in Simon's Town to see penguins, Stony Point on the western side of Betty's Bay offers even better viewing of these curious birds. It costs only a small nominal fee to enter the reserve along which you walk on elevated boardwalks to the rocky point.

The penguins nest in the bushes all along the pathway, often crossing right in front of you. A 70–200mm lens is more than enough to be able to get portrait images of these very relaxed birds. Take your time and sit near one of the paths that intersect with the boardwalk. If you stay still, they will waddle right past you, giving you ample opportunity to get some great photos. Rock hyrax (dassies) are also commonly seen along the paths sunning themselves in the mornings and afternoons. The actual point is a favourite place for cape cormorants that are continually flying in and out.

Not many people visit Stony Point compared to Boulders. From a photographic point of view, this is favourable as there are fewer disturbances and it is one of the few less-known places where you can get really close to the penguins. The point is maintained by CapeNature and is open from sunrise to sunset.

# Photography and equipment

If you work along this coastline, a vehicle is very important. The ability to move about to the various locations for changing light conditions is a big bonus and a normal sedan is perfect for getting around. Landscape photography requires a few very important pieces of equipment, all of which you will need while photographing here.

Windy conditions and wet sand cause all manner of vibration and movement when taking photographs. A sturdy tripod will be a great boon. You will most likely get your tripod wet or in wet sand at some stage. It's important to clean it with fresh water afterwards so as to prevent the sand scratching the tripod legs and making them stick.

A good wide-angle lens is appropriate to capture the best of your scenes, as is a filter set. Gradient filters are a part of the landscape photographer's kit and in order to balance bright skies with dark foregrounds, 3–5 stops of filtered light are normally needed. Neutral density graduated filters are the best for landscapes and they are very useful in this environment. A polariser filter is also an essential tool to use in your images as it adds contrast and colour to certain scenes. It is also very helpful in slowing down exposures in order to get motion blur in the water, with the longer shutter speeds giving that lovely silky effect. Over water, a polariser is probably one of the most useful filters for the landscaper.

A high resolution D-SLR camera is recommended to be able to get as much quality from your images. Make sure you have a working cable release with you, as it is essential to minimise camera shake.

Be prepared to get wet when doing seascapes and wear old shoes with good rubber soles for walking over wet rocks. Working close to the ocean poses one risk: waves. Tidal surges and large waves are common on this very active coastline. The best way to avoid any potential problems is to always keep your eyes towards the ocean and be aware of changing tides and swell conditions.

## Getting there

From Gordon's Bay, follow the R44 signs and signs to Betty's Bay. From there it is one winding road all the way to Kleinmond.

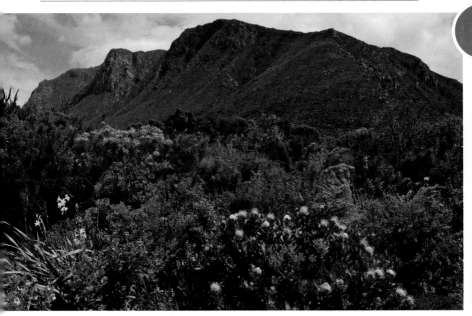

▲ The indigenous flower gardens in Harold Porter provide excellent foreground for landscapes of the large mountains.

▼ The view of the bay and the Hottentots-Holland Mountains from the top of Clarens Drive.

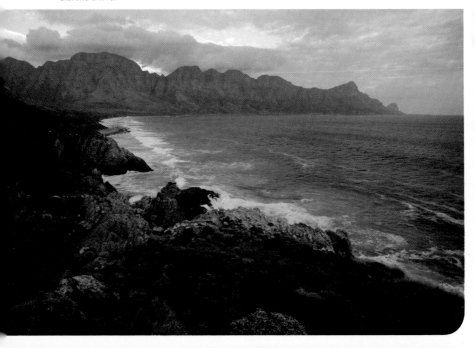

## Highlights

- Some of South Africa's most iconic landscape and seascape vistas
- Many excellent landscape scenes condensed along a 50km route
- Stunning mountain backdrops
- Beautiful foregrounds of polished boulders in the tidal zone on the beach
- Stony Point for African penguins
- Harold Porter Botanical Gardens for waterfalls and sugarbirds
- Kleinmond for its shallow lagoons
- Silverstroomstand with its white sands and turquoise waters

## Shem's photography rating out of 10

| Photographic subject | Abundance | Viewing | Photography potential |
|---|---|---|---|
| Landscape | 8 | 8 | 8 |
| Birds | 2 | 6 | 5 |
| Mammals | - | - | - |
| Predators | - | - | - |
| Big 5 | - | - | - |
| Overall experience | 8/10 | | |

# Photographic equipment suggestions

| Photo skill level | Equipment |
|---|---|
| Intermediate to advanced | • 1 pro-sumer camera body or high-resolution camera body to capture as much detail as possible<br>• Wide-angle lens: 17–35mm<br>• 24–70mm<br>• Waterproof camera covers<br>• Sturdy tripod<br>• Cable release<br>• Warm and waterproof clothing |

# Other information

| Accessibility | Cost value | Popularity |
|---|---|---|
| Very easy | Cheap/free | Normal |

# Bird Island,
# Lamberts Bay,
# West Coast

## Background

Gannets are enigmatic birds. For most of the year, they are out at sea, chasing shoals of fish. When they do come to land, it's normally only to breed. And what a breeding ritual it is! Crammed onto a small island, the courtship ritual of sky pointing and wing flapping make them excellent subjects. Add to that their striking markings and blue eyes and you have a beautiful bird that just asks to be photographed. Luckily, South Africa has one of the most accessible places to do exactly that. Of the six breeding colonies in South Africa, Bird Island is the only one connected to land.

Lamberts Bay is a small fishing town 280km north of Cape Town on the west coast. It is surrounded by long white beaches and wild seas and has historically been known for its lobsters. The fishing industry may be seasonal in its success, but the island attached to the harbour that houses thousands of birds is not. This is the famous Bird Island, 2.2 ha in size, the last breeding colony for sea birds before the Namibian coastline. And what a colony it is: 4 000–6 000 Cape gannets are the main attraction, along with numerous Cape and crowned cormorants, breeding Cape gulls, African penguins, swift terns, Hartlaub's gulls and many other birds that make this their home through the year.

◀ Crowned cormorants are common on the island and are easily photographed on the rocks and masts where they perch.

265

In the past, guano was collected from the island and this caused flooding in the breeding areas. Subsequently the bird numbers decreased. Today, guano is not a necessary commodity and is thus not harvested. The layer has built up sufficiently to prevent flooding and the birds have returned en masse. It also means that the gannet numbers are now consistently more stable, ensuring great viewing of these fantastic and very photogenic birds.

# The island

The island being so small is very easy to navigate around. If you go in the breeding season for the gannets, which is October to December, the sheer number of birds, the amount of noise on the island and the overwhelming stench of the guano will overwhelm you. It is quite a spectacle to see all the birds crammed into one small space!

The island, which originally was 60m into the ocean, is connected to the shore by a causeway that makes it easy to access for visitors. The island is linked with pathways where you can walk between the various bird areas. The main feature is a viewing hide situated right at the edge of the main Cape gannet breeding colony. The bottom half of the hide has one-way glass through which you can view the birds, literally on the nest. Upstairs in the hide there is an open-air balcony, from where you can get an overview of the whole colony. The pathways, though, offer the best in terms of photography. Sit yourself down and gannets will come right up to the edge of the paths, allowing for close-up portrait images.

The colony is at its most active during the breeding season and numbers can reach up to 6 000 pairs. The courtship ritual of the gannets is especially curious with sky pointing and waddling. This makes photographing them even more pleasurable as you try to capture their curious nature. Most of the gannets tend to leave the island by March. However, there are some birds all year round, but the numbers get as low as 200 birds in June to July.

A causeway from the island leads onto the harbour breakwater. Along here you will find most of the gulls, either perched on the rocks, or on the boats moored in the harbour. The crowned cormorants actually nest on masts of the old boats in the harbour. They also like to perch on the

▲ The upstairs viewing platform offers some possibility for photographing the gannets in flight.

▼ Position yourself with the wind at your back to get the birds flying directly towards you.

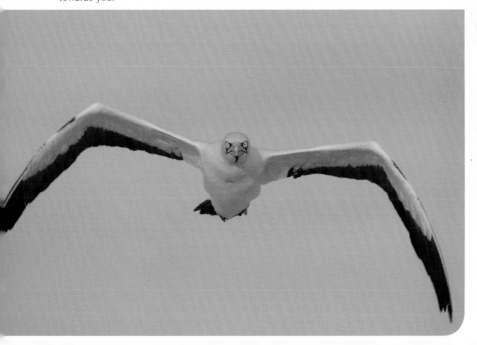

▲ The viewing hide that overlooks the colony – I find it best to position myself next to the hide for more photographic flexibility.

▼ Cape gannet portrait – a 600mm lens with 14 converter was used to get this close.

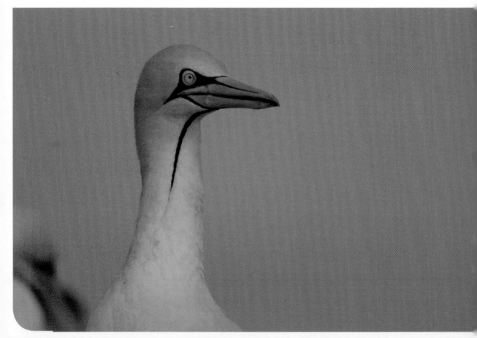

rocks at the sea side, where a nice blue background makes them stand out. African penguins used to breed in profusion on the island, but now there are only a few that inhabit the rocks far from the hide, making photography very difficult. There are also some Cape fur seals that breed on the island. This population does fluctuate and has at times caused a problem with the gannets, but generally they are based on the far end of the island.

The beauty of Bird Island is that you are in among the birds, with them calling, flying and displaying all around you; that in itself is quite a sensation! In a morning's session, you can easily photograph seven species of birds. The creative scope is immense and being in among the birds allows you all types of experimentation.

## Photography and equipment

As you will be walking, you will need a backpack to take all your equipment.

A 300–500mm lens will be adequate to get full-frame photos of the birds on the island. A 600mm lens can be used, but it will most likely be overkill considering your proximity to the birds. If you want to get bird-in-flight images, then a fast frame-per-second camera with excellent auto focus speed is necessary. For all the other portrait and scenic type images, a consumer/prosumer camera is more than adequate.

A wide-angle lens is very handy to capture the scope of the breeding colony. Flying birds also add some interest to the top half of the image. It is best to position yourself along the pathway next to the viewing hide. This allows you a low angle to get a nice perspective on the gannets. If you are using a long lens (400–600mm), a tripod will be essential to support your lens. Additionally a fluid tripod head or Wimberley will ensure you can easily pan with the birds as they take off to fly. Being large birds, gannets need to take off into the wind. If you position yourself with the wind at your back, you should get the gannets flying over you, allowing for some great flight images.

The sheer number of birds on the island ensures that you will have more than enough subjects to photograph. With the harbour being on the

eastern side of the causeway, you also have the opportunity for some colourful travel photographs. Early morning is an excellent time to be on the island, as the gannets start waking up and heading out to sea. Your most likely position is to be photographing west, ensuring the light is fully on them. The afternoon poses some interesting light scenarios, with the birds being backlit by the sun. This can provide for some very creative images with the setting sun in your photos.

## Getting there

Lamberts Bay is 280km north of Cape Town on the N7. At Clanwilliam, take the Lamberts Bay turnoff and drive until you are in the town. Bird Island is badly signposted, but the town is so small you can't miss the harbour. The entrance is on the southern side of the harbour where the causeway joins the land.

CapeNature manages the gate and opening time is 07:30. Closing time is 18:00 October to April and 17:00 May to September. There is a small entrance fee to pay at the kiosk.

## Highlights

- Close proximity to 4 000–6 000 breeding pairs of Cape gannets
- Only gannet breeding colony attached to land and accessible to the public
- Up to 3 000 breeding Cape cormorants
- Breeding crowned cormorant and kelp gulls
- Many other birds species
- Courtship and breeding behaviour of Cape gannets
- Excellent for many species of birds in flight
- Good travel photos in the harbour
- Animals in the environment with the birds roosting and breeding on the boats in the harbour

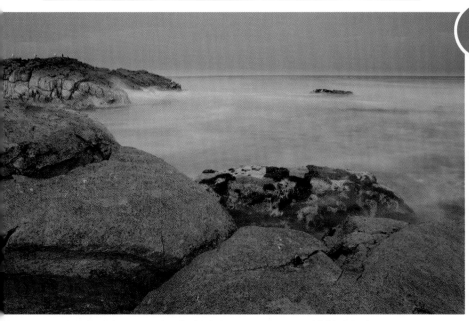

▲ The island does not only offer bird photos – seascapes with birds in them are also available.

▼ The rising sun provides for some creative backlit images.

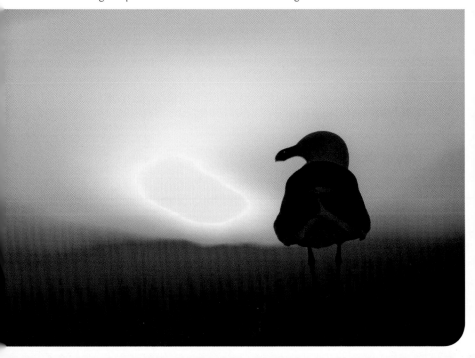

# Shem's photography rating out of 10

| Photographic subject | Abundance | Viewing | Photography potential |
|---|---|---|---|
| Landscape | - | - | - |
| Birds | 9 | 8 | 9 |
| Mammals | 1 | 1 | 1 |
| Predators | - | - | - |
| Big 5 | - | - | - |
| Overall experience | 8/10 | | |

# Photographic equipment suggestions

| Photo skill level | Equipment |
|---|---|
| Beginner to intermediate to advanced | • 1 pro-sumer camera body for portraits<br>• Pro-camera body for birds in flight<br>• 300–500mm lens<br>• 600mm for extreme close ups<br>• Wide-angle lens to show whole colony: 17–35mm<br>• Sturdy tripod |

# Other information

| Accessibility | Cost value | Popularity |
|---|---|---|
| Very easy | Cheap | Low to normal |

The view from inside the hide. Note the glass windows. ▶

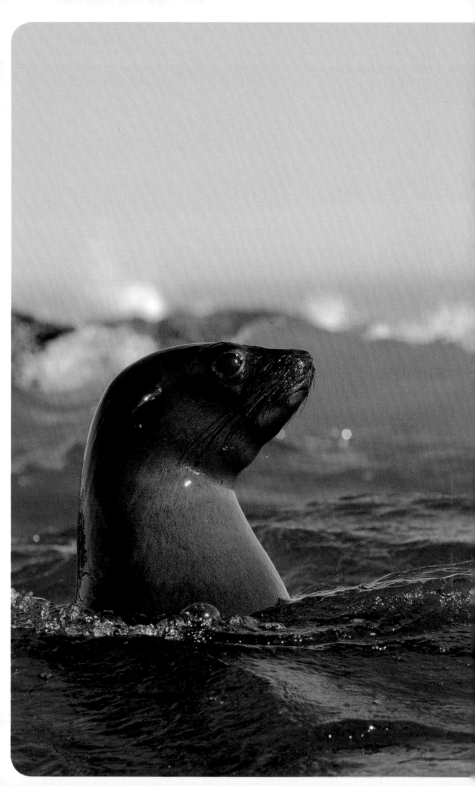

Simon's Town: 34° 10' 60" S   18° 25' 60" E
Seal Island: 34° 08' 1273" S   18° 34' 46.64" E

# Seal Island/ Great White Sharks, False Bay, Simon's Town

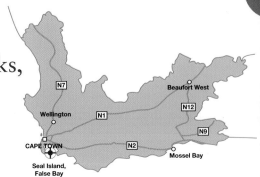

# Background

For most photographers, Cape Town isn't associated with one of the most exciting natural predation events in the world. Yet just off shore, near a small island in False Bay, some of the most spectacular predatory hunting occurs – and all easily within reach of your camera.

Humans first took note of this behaviour when researchers discovered a vey high percentage of great white sharks around Seal Island during the winter months of May to August. The researchers thought this a normal phenomenon, as sharks usually follow prey sources, especially young seal pups venturing out to sea for the first time. What they didn't expect to see was the most spectacular manner in which the sharks hunted the seals.

The area around Seal Island has steep drop offs into deep ocean. The great whites lurk in these deep waters waiting for the young seals to venture above them, then rush upwards for the kill. In an often very acrobatic display, they leap completely out of the water in their attempt to catch a seal. Being over a ton in weight and 3–4m long, it is one of the most exciting natural history predation events you will ever witness. Luckily, the boats that have licences to view this activity cater for the photographer, allowing for a thrilling morning's photography.

◀ A curious seal in shallow water makes for a great portrait image.

In addition to photographing the great whites, a trip to Seal Island offers an array of other subjects. Seals, birds and penguins are easily photographed, while whales and dolphins are commonly seen.

# The activity

There are two licensed tour operators that are allowed to take people out to view great white sharks hunting. The most popular of these depart from Simon's Town early each morning. The height of the shark activity occurs just after dawn, when the seals are returning to the sanctuary of the island after a night at sea. The night protects them while out foraging, but as dawn breaks, they stand out against the bright sky. This is what aids the sharks in hunting the seals and why they lurk in the depths of the water – so they can see the dark seals against the sky.

The boat operators are excellent in reading the signs of potential activity. The crew on the boat work together to spot lone seal pups or seagulls hovering over the surface. The skipper then homes in on the action with the possibility of seeing the climax of the event – a great white in full breach while trying to hunt down the seal. As spectacular as breaches are, they are often unsuccessful. This then results in a chase between shark and seal, which is an enthralling contest to witness. It pits the sheer ferocious power of a large predator against the nimble and more agile seal. The seal often outwits the shark in the chase, but the photo opportunities are still top class, with lunges, jumps and the thrill of the chase all part of the scene played out in front of you.

Shark activity dies off as the morning wears on. The operators read the level of activity accordingly, and once it stops, they move on cruising around Seal Island. This in itself presents a number of good photographic chances as the boats can get really close to the island: African penguins; seals jumping up onto the rocks from the water; and some inquisitive seals coming right up to the boat.

Hartlaub's, kelp and lesser black-backed gulls are always around the boat allowing for some good bird-in-flight photography. Subantarctic skua's are also common, flying in for scraps of meat on the water. The cruise to and from the island often reveals other interesting ocean mammals, such as bottlenose dolphins and whales.

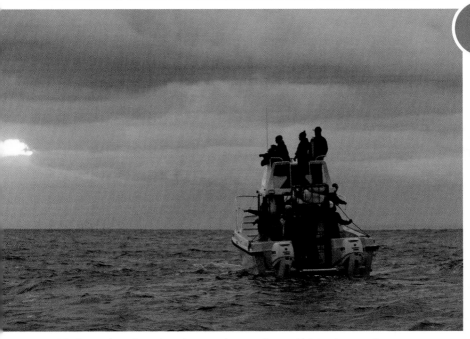

▲ The boats that take you out have ample space from which to photograph.

▼ A great white shark lunges upwards – an impressive display of power and speed.

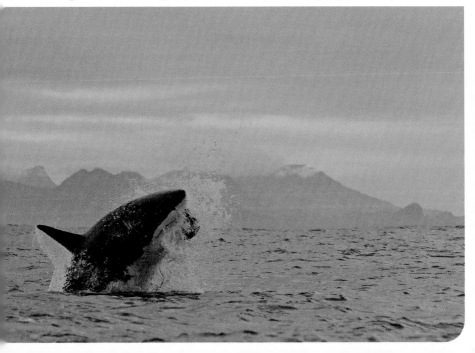

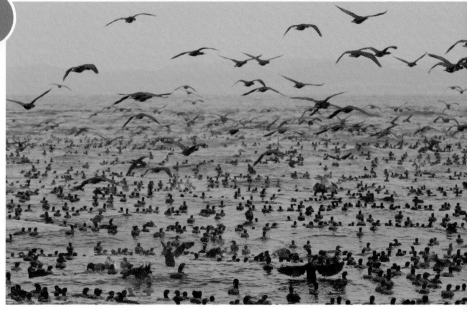

▲  A day out on the ocean brings all manner of wildlife – here 60 000 Cape
cormorants bathe in the early morning.

▼  Coastal and pelagic birds come and inspect the boat – a white-chinned petrel flies
close enough to be photographed.

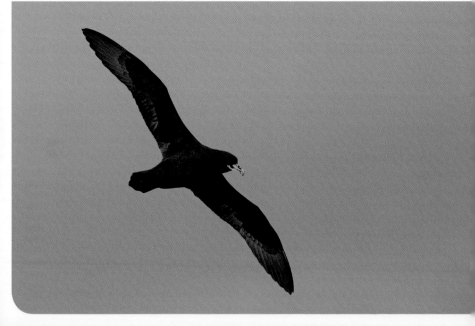

A highlight of the morning is the seal decoy that is pulled behind the boat. This is where most photographers get their photos of a great white launching out of the water. A soft rubber mat decoy is pulled about 20m behind the boat. The skipper knows which areas are favoured hunting grounds for the sharks and works his way across them. The operator will only allow one pass by a shark on a decoy. Even if the shark comes to inspect it or only nudge it, they then consider that a "take". The reasoning is based on energy expenditure; they don't want the sharks to waste lots of energy on something that won't feed them. The decoy is then reeled back into the boat. If you are lucky to get a breach on the decoy, it is the most fantastically fearsome sighting of a predator you will ever see.

Considering that many people do not get out onto the ocean for wildlife photography, the accessibility to this phenomenon and the ease in which the sharks can be photographed make the experience one of the top natural history events in South Africa.

## Photography and equipment

You will be on a boat on the ocean and will need waterproof covers for your equipment. Seawater corrodes metal and electronic equipment very quickly, so protecting your equipment from sea spray is very important. There is a large, protected cabin in which to leave your bag and cameras, but out on deck you need to be aware of the spray.

Due to the rocking of the boat, you cannot use a tripod and all photography is done hand holding the camera. Thus large lenses are ruled out due to their heavier weight. A 100–400mm lens or a 70–200 with a 1.4 converter are very good options. They give you a relatively light weight set up, but also the ability to focus fast and zoom out when the sharks get really close to the boat.

To capture the action of a shark breach, you will require a fast-focusing camera that can take many frames per second. These cameras are generally also more weather resilient and will withstand the rigours of the ocean better than entry-level cameras. A wide-angle lens is useful for scenic images showing the boat in context with the wide ocean. Take plenty of memory cards for the morning's outing as the activity

can get frantic at times. The diversity of subjects also makes for lots of photographs, so you tend to take many more than expected.

The early mornings can get cold, so a beanie and some soft gloves are recommended, as is a water- and windproof jacket. If you are prone to motion sickness, take preventative pills. Motion sickness is exacerbated by looking through a viewfinder, so it is better to be precautionary and photographing, than being unwell and lying in the cabin.

# Getting there

All the licensed operators launch from Simon's Town harbour, which is easily signposted in the actual town off the main road (M4). Apex predators http://www.apexpredators.com/ are one of the operators that take tours out. Tours depart each morning at 07:00 from the harbour and return at 13:00. They run from April to mid-September. There are tours that run in the afternoon, but the mornings, photographically, are the best.

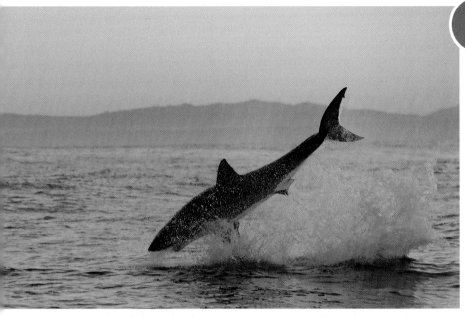

▲  Most natural predations take place at dawn – make sure you're on time as you don't want to miss this.

▼  A young Cape fur seal plays in the shallow waters of Seal Island.

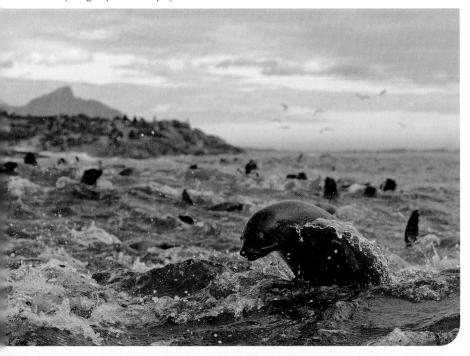

## Highlights

- Witness and photograph one of nature's most exciting natural predation phenomenon – great white sharks hunting Cape fur seals
- Breaching by the great white sharks
- Easy access to photographing them
- Tour operators who understand how to position a boat for photographers
- High diversity of subjects – seal, penguins, whales and dolphins
- Sea birds come close to the boat allowing for birds-in-flight photography
- An added chance to photograph a breaching great white shark when pulling a decoy

# Shem's photography rating out of 10

| Photographic subject | Abundance | Viewing | Photography potential |
|---|---|---|---|
| Landscape | - | - | - |
| Birds | 4 | 6 | 5 |
| Mammals | 2 | 5 | 6 |
| Predators | 8 | 8 | 8 |
| Big 5 | - | - | - |
| Overall experience | 8/10 | | |

# Photographic equipment suggestions

| Photo skill level | Equipment |
|---|---|
| Intermediate to advanced | • 1 pro-sumer camera body or pro-camera body with high frame rates<br>• 100–400mm zoom range or 70–200 with 14 converter<br>• Wide-angle lens: 17–35mm<br>• Fast-focusing lenses and high frame rates<br>• Waterproof camera covers<br>• Warm and waterproof clothing |

# Other information

| Accessibility | Cost value | Popularity |
|---|---|---|
| Very easy | Mid-range to expensive | Very high |

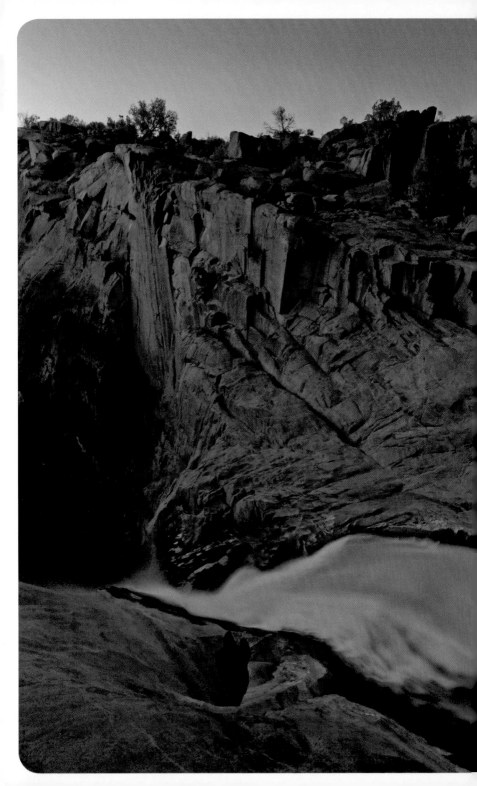

# Other Photographic Highlights

## Augrabies National Park

28° 66' 83" S   20° 42' 63"

### Northern Cape

The Orange River, being compressed into such a large and powerful waterfall, is a reason alone to visit this park. The landscape opportunities along the boardwalks are wonderful. The park itself is excellent for klipspringer. Go out in the early morning to find them sunning themselves on top of rock perches.

## Blyde River Canyon/God's Window

24° 307' 14" S   30° 50.2' 14" E

### Mpumalanga

The drive from Graskop to the Three Rondavels along the top of the escarpment is one of the most scenically fantastic roads in the country. Landscapes abound around every corner, and the scale and sheer drama of the scene will overwhelm you. There are various options from where to photograph. The most obvious is from on top of the escarpment, from where all the clichéd images are taken.

◄ Augrabies National Park offers excellent landscapes with its large waterfall as the main feature.

For a different perspective, take a walk down into the Blyde River Canyon and you will be rewarded with unique and dramatic scenes. Another feature of this road is the Bourke's Luck Potholes, large holes bored out by tumbling water. For a landscape photographer, it offers some really creative images. The multitude of waterfalls in the area also make for very good photography. These are further down the escarpment, but well within easy reach of Graskop.

# Hluhluwe-Umfolozi Park

28° 11' 5" S    32° 0' 59" E

## KwaZulu-Natal

This is the largest reserve in KwaZulu-Natal that holds the Big 5. General wildlife viewing is very good here, with most of the animals being very relaxed, offering a good chance for photos. There are lots of white rhino in the park that are very easy to photograph. However, this is probably the best place to see (and hopefully) photograph black rhino.

Birdlife in the restcamps is also very good with crested guineafowl one of the unusual species that are easy to photograph.

# Madikwe Nature Reserve

24° 46' 28" S    26° 1' 8" E

## North West

Situated in the north-western reaches of South Africa, but only four hour's drive from Johannesburg, Madikwe offers Big 5 game viewing and a good chance of seeing wild dog.

The reserve has a lot of very good general wildlife, but in many areas the vegetation is still very thick. The "Madikwe plains" do offer open viewing and easy photography if your subject is close to you. You are almost guaranteed to see elephant and lion on a stay here, a good enough reason to visit.

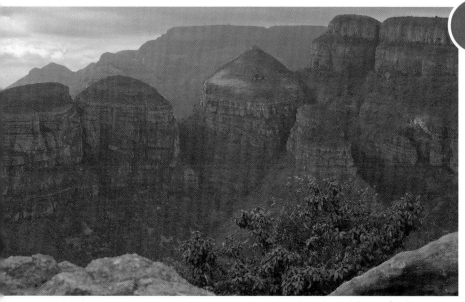

▲  The three rondavels are very prominent in the landscape at Blyde River Canyon.

▼  After the first rains some spectacularly coloured plants bloom within a day, such as this devils claw.

# Namaqualand Daisies

29° 39' 991" S   17° 52' 946" E

## West coast

Every year after the Cape rain season, the dry arid areas north of Cape Town along the west coast burst into flower in one of the natural flowering phenomenons in the world. The amount of rain, combined with a few other factors, determines the extent of the blooms. It can be very localised one year and then the most fabulous blooms the following year. For the avid macro and floral photographer this is a real highlight.

The flowers only open once the sun is out and warm. This is usually only after 09:00, which makes golden light photography difficult. Nevertheless, you should be able to still get fantastic images of the many diverse species of flowering plants.

◀ The succulent plants in Namaqualand are a macro-photographers delight.

# Other titles by Jacana Media:

Beat about the Bush
– Mammals

Beat about the Bush
– Birds

A Delight of Owls

A Landscape of Insects
and other Invertebrates

Sharks
The Perfect Predators

The Coastal Guide
of South Africa

*Garden Route Guide*

*Lowveld & Kruger Guide*

*Roberts Bird Guide*
*South Africa*

*Roberts Bird Guide*
*Kruger National Park*

*Kruger National Park*
*Visitors Guide*

*Find It*
*Your Guide to Kruger*

See a complete list of Jacana titles at www.jacana.co.za